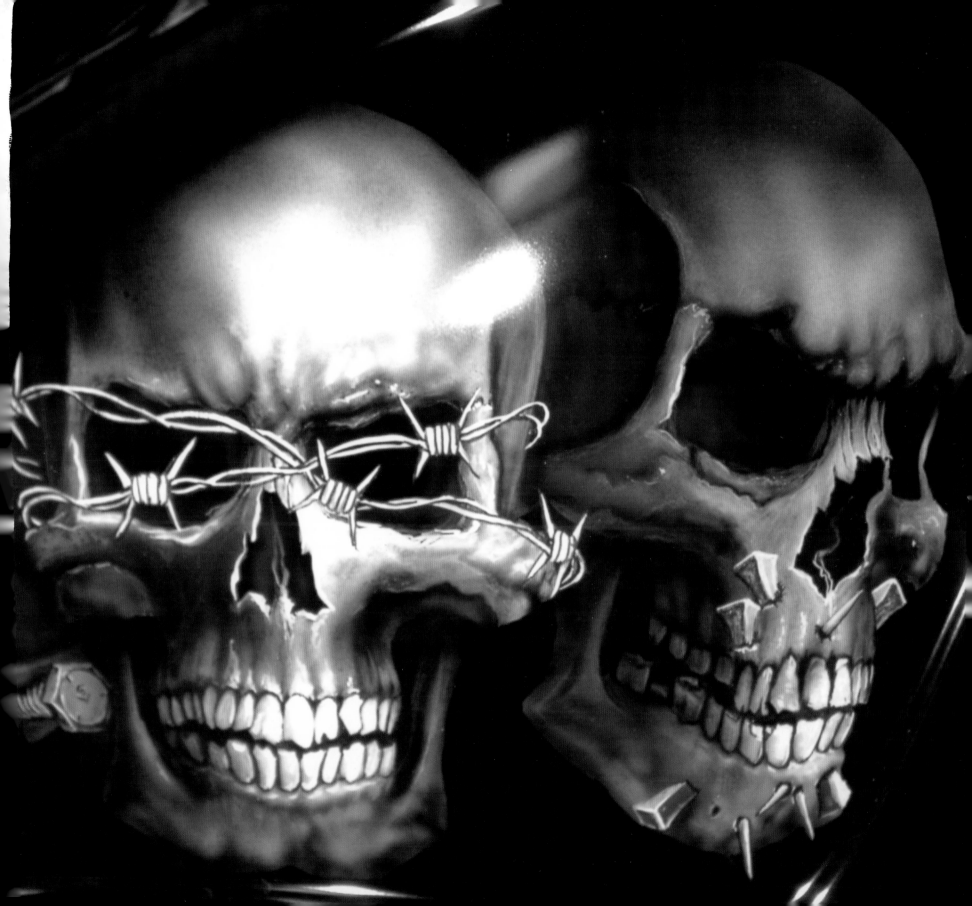

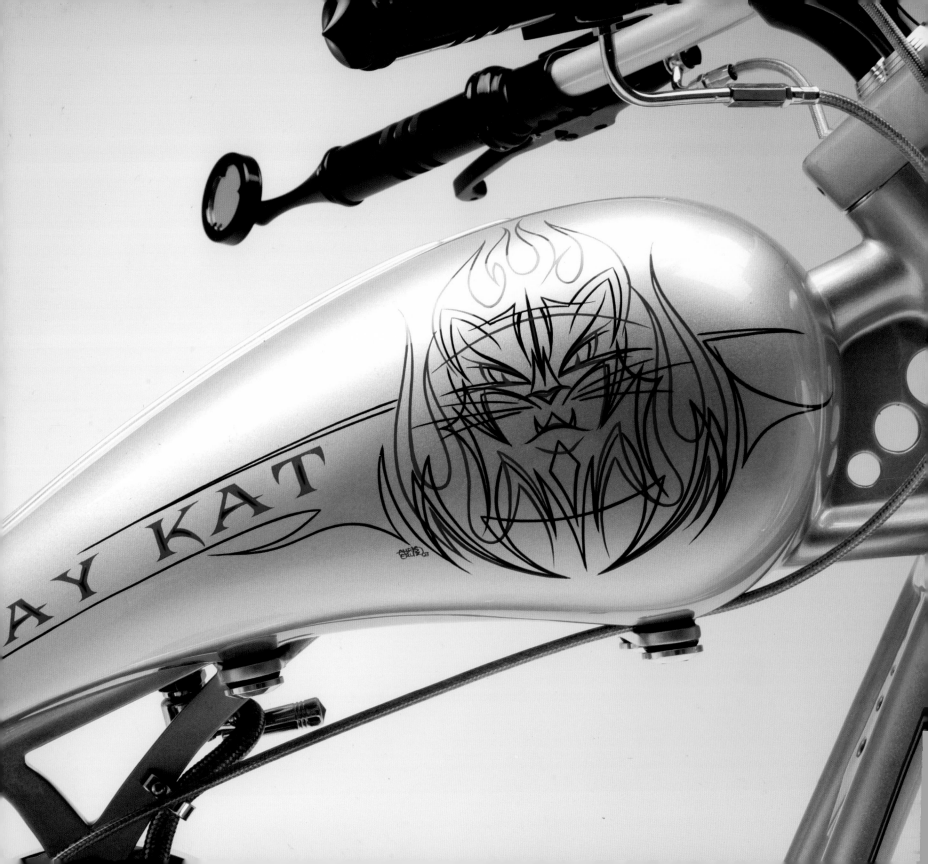

EXTREME

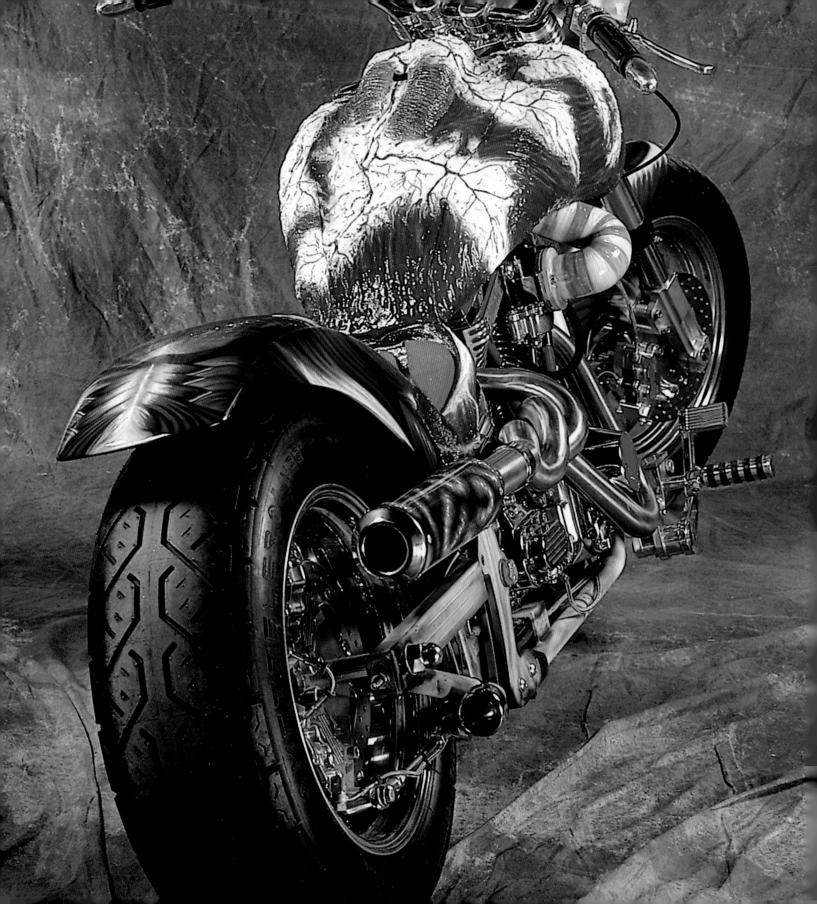

EXTREME

MOTORCYCLE ART

DEDICATED TO THE MEMORY Of
INDIAN LARRY
1949 — 2004

We dedicate this book to a legendary and inspiring motorcycle builder,
Indian Larry. He understood the importance of making each bike a
creative collaboration between builder and painter to achieve a one-
of-a-kind work of art. Indian Larry once described the custom bike as
sculpture combined with painting resulting in art in its highest form.
The painters and builders in this book reflect his spirit.

Judith Salavetz and Spencer Drate

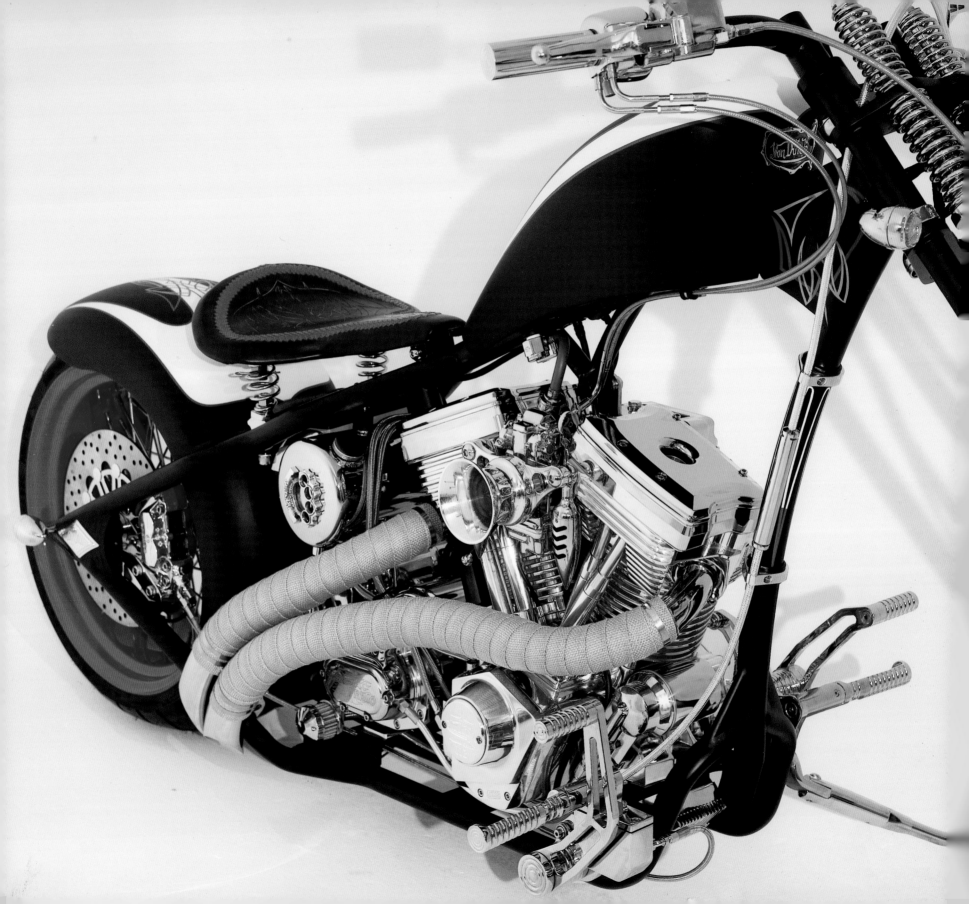

CONTENTS

fOREWORD

In its most basic sense, the paint job on a motorcycle serves simply to identify one bike amid a sea of its brethren. It's not just that simple, though. Like skin over the human body, sheet metal can serve as a canvas for individual expression. And like body art, a paint job can tell tales of the past or pay tribute to the deceased. It can stoke one's orange-and-red-splashed, flaming, fiery need for speed, or fade to a cool black retro style. And while it is true that mechanical components harmonizing in perfect symphony give flight to a bike, it is motorcycle paint artwork that truly christens it custom.

As feature editor of *Hot Bike* and *Street Chopper* magazines and a lifelong rider, I have crossed paths with a multitude of bikers and bike builders. One thing we all have in common is the desire to have our bikes stand out in a crowd. Motorcycle art makes this possible. Many of us see our bikes as a means to escape our everyday lives. If only for a weekend, a day, or even a few hours, we take on a new identity and lead another life when riding. And while it can be relatively quick and easy to bolt on a couple of chrome parts here and there, they really don't set a bike apart quite like the artwork of a paint job. Changing parts and accessories has an effect on a bike's function, but in laying new paint, its feel, status, look, and attitude are profoundly altered. Motorcycle artist Buck, of Buck Wild Design, once told me that it is the paint job on a bike that tells the most about its rider. As you will see in this book, a wide variety of styles and themes is employed by motorcycle artists, builders, and owners.

One such style is the flame job. There are as many different styles of flames as there are bikes that wear them. Covering every last inch of sheet metal, flame jobs run the gamut from basic black with outlined, one-color flames to full-blown ten-color compositions in which every flame tip crosses over and over again. And no matter which particular style is chosen, a rider cannot go wrong. A flame job is as safe as ordering a pepperoni pizza—it is the one topping everyone can agree on.

When looking to the past for style, heavy flake with panels and pinstriping gives a flashback feel, enduring the test of time by continuing to captivate onlookers. I have an early memory of the old man's Panhead covered in an orange flake and striped from top to bottom, front to rear. The paint job was so cool then and now, the sheet metal still hangs in Uncle Ron's garage. That's a classic.

When the 1980s came around, it seemed the style strayed toward graphics and banner paint jobs consisting of one color with a sticker or emblems. Since Harley was essentially the only choice, riders sought to stand out in any way

possible. This was accomplished by making bikes loud, both audibly and visually. The flavor of the era consisted of tear-away graphics, checkerboards, and two-toned scallop paint jobs. I recall one rider taking his favorite Hawaiian shirt and matching the paint on his bike and helmet to it. Now that is love. Sure it was ugly, but talk about standing out. Give credit to the painter that was able to pull it off!

By the time 1990s arrived, the chopper was well on its way back. All styles were fair game, for builders and painters alike. They were given the authority to do anything cool. Classic black represented the cool rider who didn't need to be noticed in a crowd, while bright, exuberant colors screamed, "Can you see me? Here I am!" Still others told a story of the rider's life through murals and pictures. It was a time of diversity with an attitude of "anything goes."

Throughout each era, all styles shared one truth: while polish shines and chrome sparkles, paint contains the profundity of the soul. While some perceive the paint job simply as a cosmetic step toward the completion of a custom bike, it is really the art that breathes life into the machine. The painter/artist uses his spray gun as the catalyst to this genesis. Mixed in with the liquid color of his spray gun is an unseen well of talent, love, and passion.

This book serves finally to give recognition to those artists. Up until now, it was the bike builder being featured on the covers of magazines and getting the girls. Meanwhile, the painter was left with one inconsequential line in the source box and his right hand. So please, bask in the vibrancy, veracity, and vivacity of the talent aglow in the following pages. Each masterpiece radiates with the brilliance of a soul, all due to a wonderful bunch of artists, most of whom go unnoticed in some little backroom shop in the middle of nowhere. The next time you find a bike that grabs you and the paint was the business, ask who did it and give him his credit. I would like to give thanks to a few, like my family, that let me do the job, and the guys that help with the job, such as Nick Schultz.

Thanks.

Ernie Lopez
Feature Editor
Hot Bike and *Street Chopper*

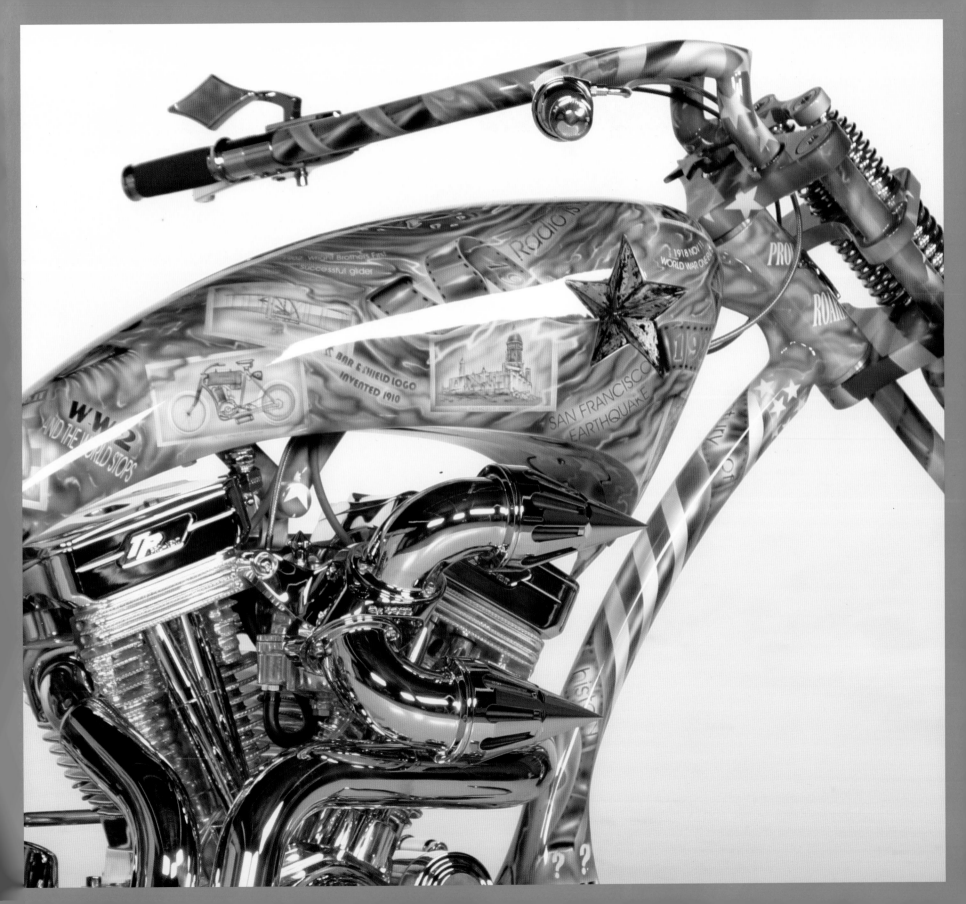

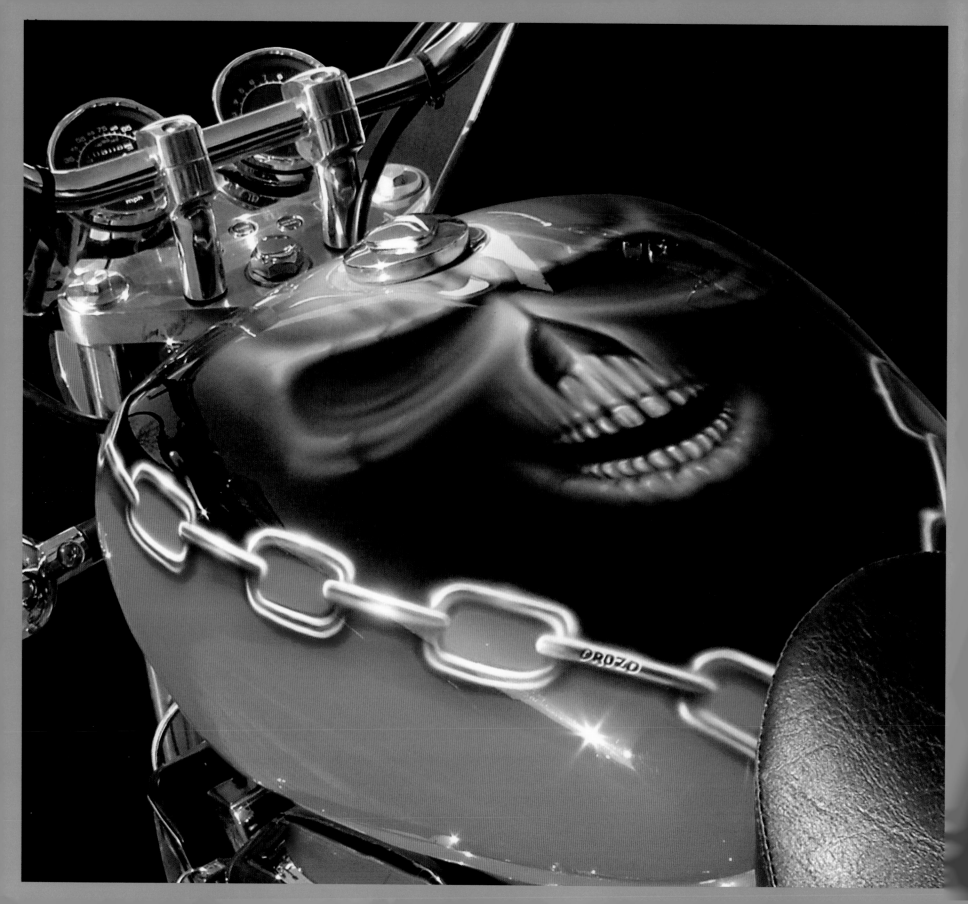

INTRODUCTION

Imagine a bike show on the boardwalk. The builders begin wheeling their bikes out of their vans and setting up their displays. But none of the bikes is painted. Row upon row of bare metal and primer-gray bikes line up for judging. Thousands of fabricating hours have been spent sculpting and shaping super custom bikes into rolling art, but the spectator audience is not thrilled. Custom bikes just aren't custom bikes without exotic paint jobs.

Bike building, like movie making, requires a collaboration of artists. Once a bike is constructed, an appropriate paint job must be applied. If the paint is too fancy, many details of the metalwork may be missed by the casual observer. If the paint is too plain, the bike will not have a striking overall appearance. Except for some notable exceptions such as Dave Perewitz and Joe Martin, who both paint their own bikes, most builders must work closely with at least one other creative person to complete their artistic vision.

As you will see in this book, a wide variety of styles and themes is employed by custom bike painters. Granted, there seems to be a leaning towards the ghoulish. Skulls, demons, flames, and other scenes of perdition are prominent. But many other ideas are worked in as well. Striping, writing, iconography, portraits, and gold leafing are all found on custom bikes. Completing a builder's vision and using the appropriate level of complexity to complement the design and shape of a specific bike is the job of the modern custom bike painter. With the exception of Mike Learn's airbrushing classes, there are very few formal training centers teaching painters how to paint on the wide variety of curved surfaces and unusual metallic textures of every custom motorcycle. Getting a coherent design applied across a curved tank, a rolled-steel frame and a flattened fender is extremely complex. These painters tend to be self-taught and, as you will see, self-made. They are highly motivated and capable individuals, striving to make each motorcycle unique and suited to the peculiar personality and preferences of its owner. It is as difficult, in its own way, as getting proportions and perspective correct on the vaulted ceilings of churches.

Motorcycle painters certainly have not been recognized by the art world in general. But the recent tremendous success of the *Art of the Motorcycle* exhibit at the Guggenheim has brought our medium to the attention of the public. I imagine that a motorcycle exhibit with bikes similar to the ones in this book will be held at another major museum in the near future. And if success is measured by the number of visitors, I think motorcycle art will more than hold its own as an emerging medium of expression.

Mark Barnett
Editor/Publisher
Barnett's Motorcycle Showcase

Belgian artist Airbrush Perre began about fourteen years ago by painting music group names and logos on leather jackets with a brush. At a hobby market show he discovered an airbrush pistol, and while intrigued by it, thought he could never work with it. He bought it anyway and started practicing on model kits. After perfecting the airbrush he wanted a bigger challenge so he talked a friend into letting him paint some Conan the Barbarian images on the friend's car. The result was much better than expected, and was the start of a new passion for Airbrush Perre. He likes to redesign whole bikes into original street monsters. Customers tell him what they want, and he tries to respect their wishes. However, Airbrush Perre must put his signature on all: "I always put my own crazy little twist into the design."

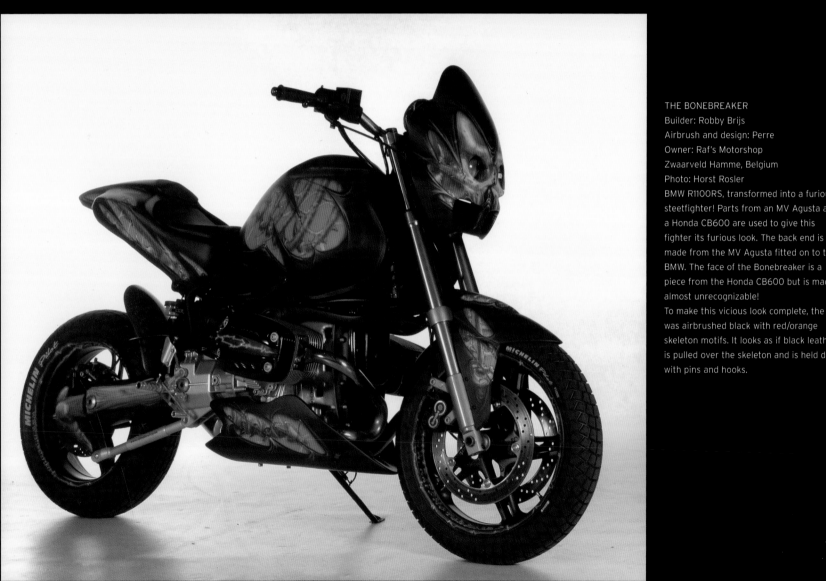

THE BONEBREAKER
Builder: Robby Brijs
Airbrush and design: Perre
Owner: Raf's Motorshop
Zwaarveld Hamme, Belgium
Photo: Horst Rosler
BMW R1100RS, transformed into a furious steetfighter! Parts from an MV Agusta and a Honda CB600 are used to give this fighter its furious look. The back end is made from the MV Agusta fitted on to the BMW. The face of the Bonebreaker is a piece from the Honda CB600 but is made almost unrecognizable!
To make this vicious look complete, the bike was airbrushed black with red/orange skeleton motifs. It looks as if black leather is pulled over the skeleton and is held down with pins and hooks.

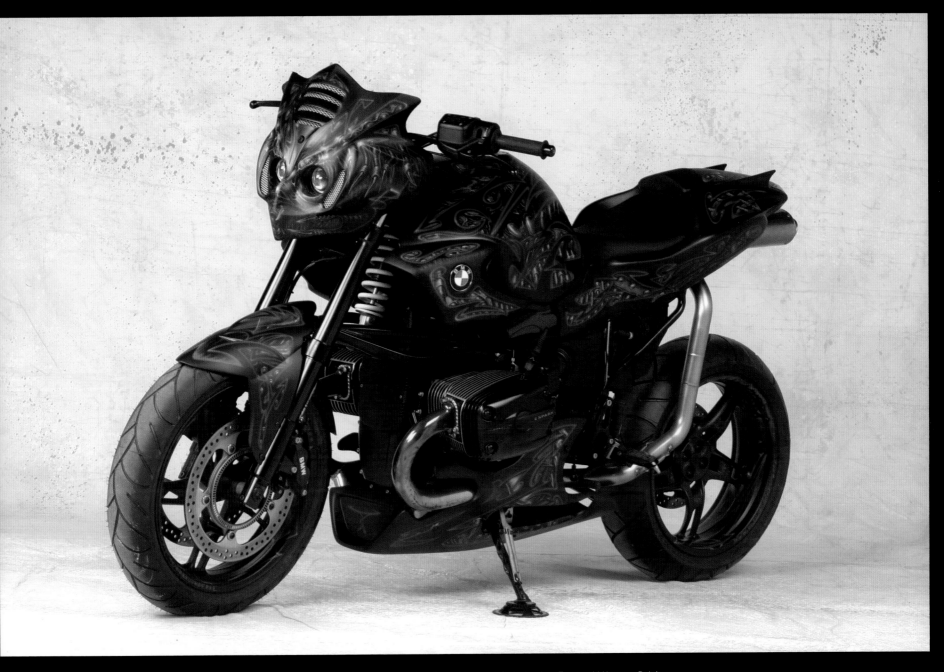

Builder: Robby Brijs. Airbrush and design: Perre. Owner: Raf's Motorshop Zwaarveld Hamme, Belgium.
A threesome between a BMW R1100R, a BMW R1100S, and a BMW GS. Robby engineered the rear end of the 'S' on the BMW R1100R and also put on the tank from the BMW GS.
For the paintwork the bike is given a robust metal look with a lot of details.

AIRBRUSH WORKZ

Self-taught artist Santiago Perez grew up on the poor side of Hialeah, Florida. He learned to get away from the challenges of the ghetto by feeding his true artistic passion. In high school he turned this passion into a part-time business by painting T-shirts for classmates, while after graduating from high school he found himself painting their cars and bikes. Shortly after starting this business, however, reality hit when he discovered he was going to become a father. He was forced to make a tough decision: gamble with his family's financial security or do the "right" thing and start a career. He took the career path and became a computer guru for several Fortune 100 companies. After ten years of corporate life, Santiago has returned to the vibrancy of art, bringing tantalizing teases to viewers' minds at airbrushworkz.com.

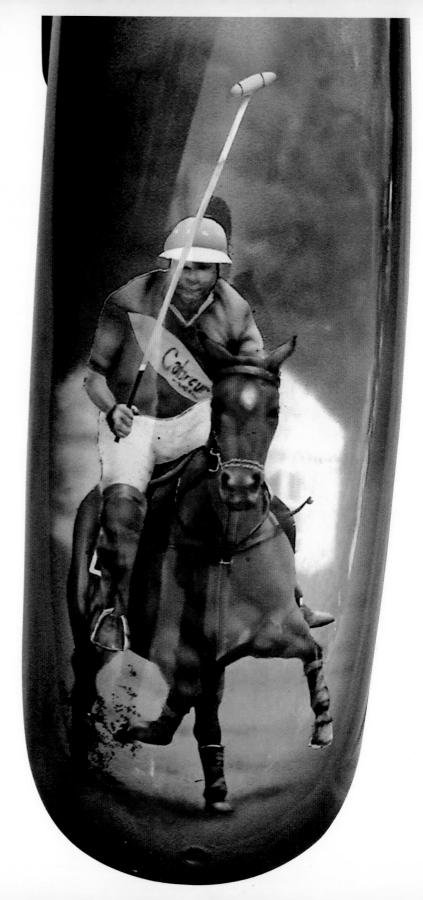

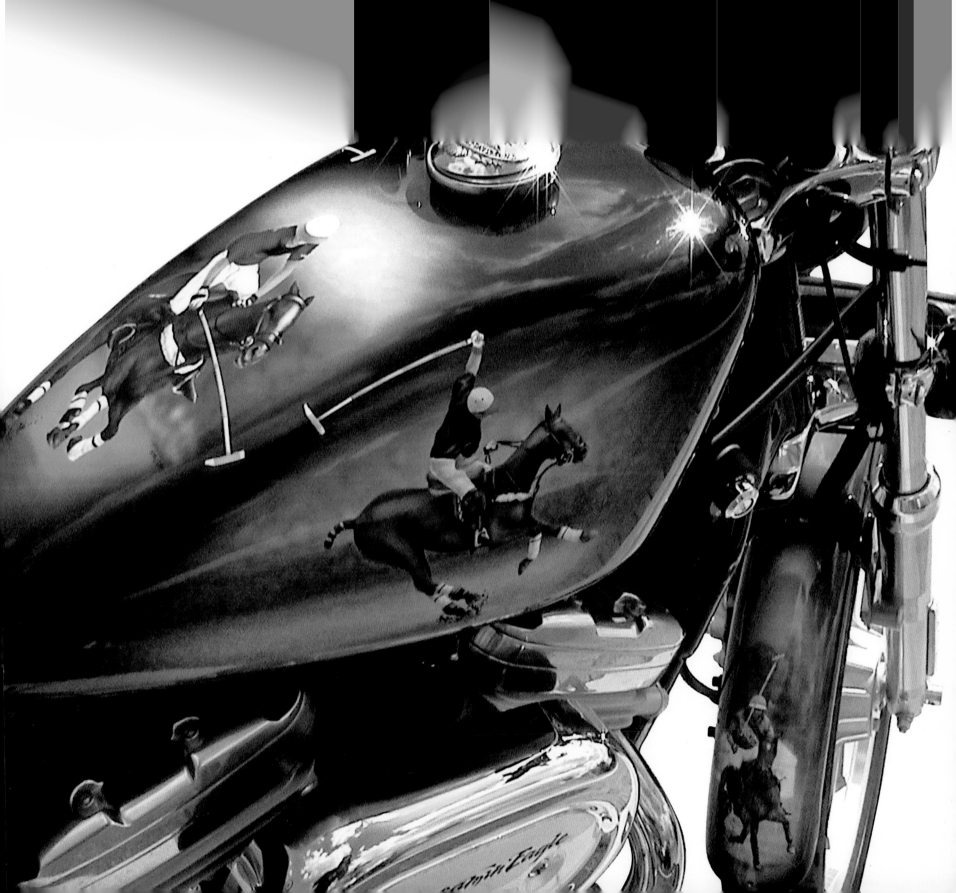

AIREA 5150

Karen and Scott Daugherty of Phoenix founded Airea 5150 in 1999. With twenty-five years of knowledge in the automotive paint industry, and years of management experience, the company is on its way to becoming one of the largest motorcycle paint facilities in the US. Starting out with just the two of them in a garage, Karen and Scott's enterprise has grown to be a 12,000 sq. ft. (1115 m²) facility with twelve employees.

Airea 5150 is a House of Kolor Pro Shop and Karen and Scott are extremely proud of that fact. Their many achievements include *V-Twins* magazine's Painter of the Year Award. They paint for the passion of doing custom work and heavy airbrush and artwork.

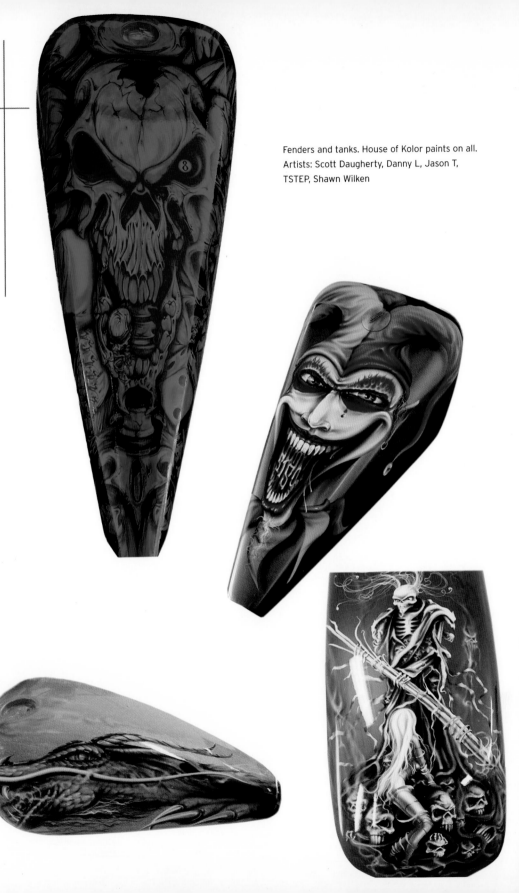

Fenders and tanks. House of Kolor paints on all.
Artists: Scott Daugherty, Danny L, Jason T, TSTEP, Shawn Wilken

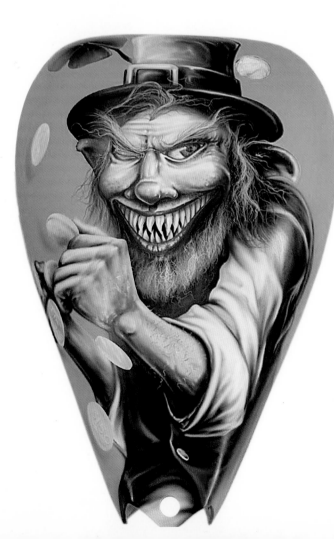

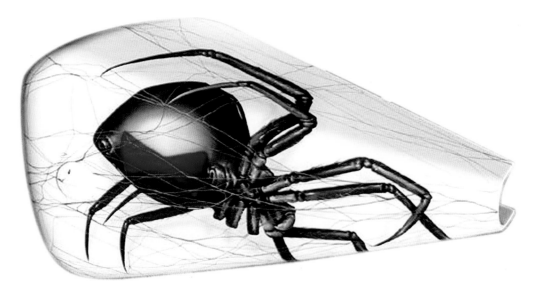

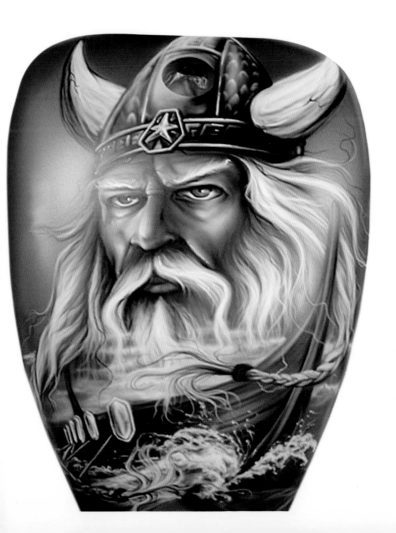

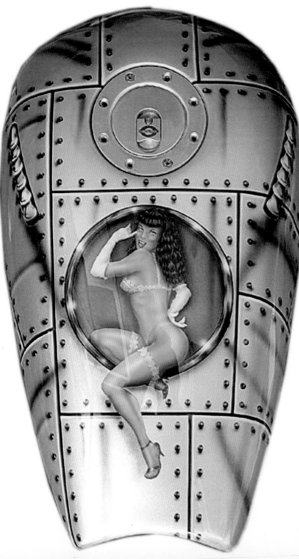

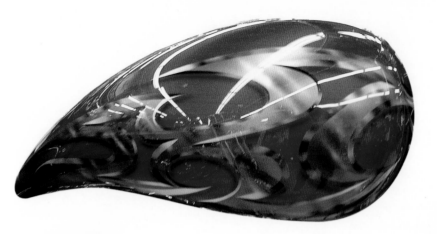

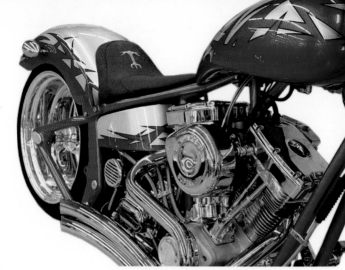

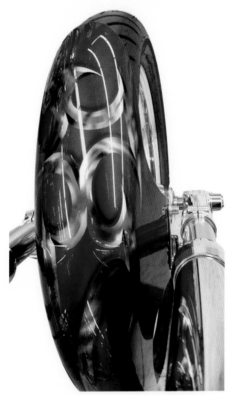

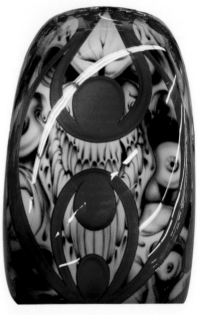

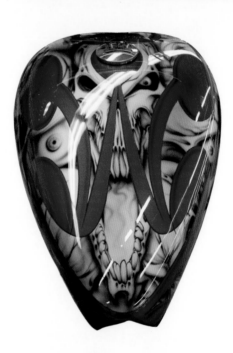

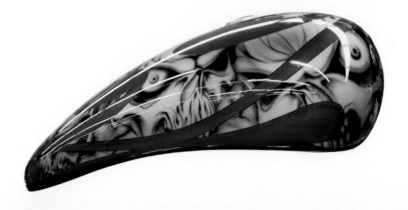

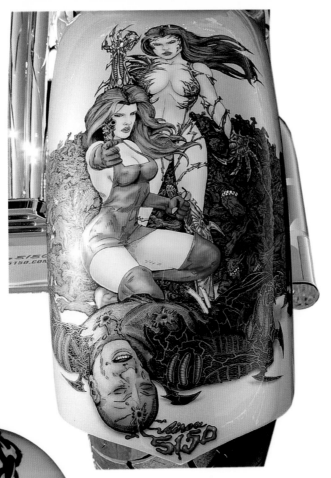

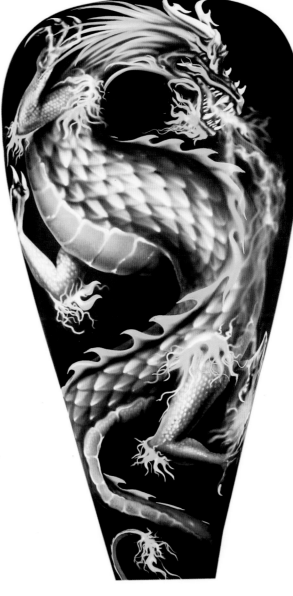

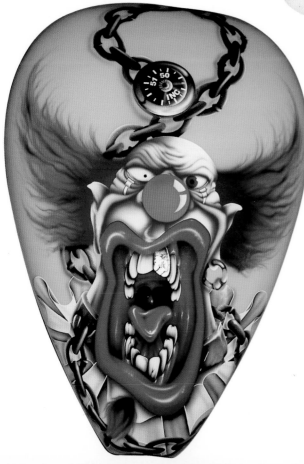

Fenders and tanks. House of Kolor paints on all.
Artists: Scott Daugherty, Danny L, Jason T,
TSTEP, Shawn Wilken

Alligator Bob's Advanced Custom Design is a one-of-a-kind motorcycle leather shop. Bob's shop is unique because of the personal attention and "old world" craftsmanship that stems from someone doing what he loves. During the twenty-five years that Bob has been creating seats and saddlebags, he has received many first-place awards for his leatherwork at custom motorcycle shows around the US. Matching the seats and saddlebags to the customer's motorcycle design is an exciting experience, and Bob works with each customer one-on-one to achieve the exact effect they are looking for.

Bob stocks a full line of exotic skins to choose from, including snake, alligator, stingray, and even hippo. All come in a variety of colors and have their own special flair. Bob custom designs seats and saddlebags for clients nationwide.

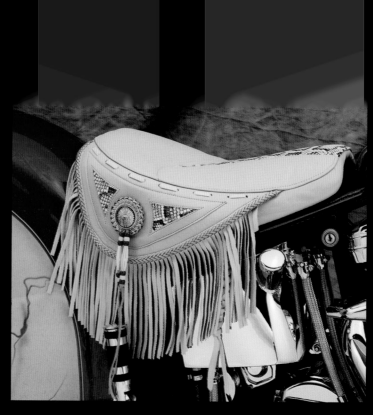

1999 INDIAN CHIEF
Buckskin Scottish leather, kangaroo-skin hand-lacing, sterling silver conchos with bones and beads, python-skin inlays

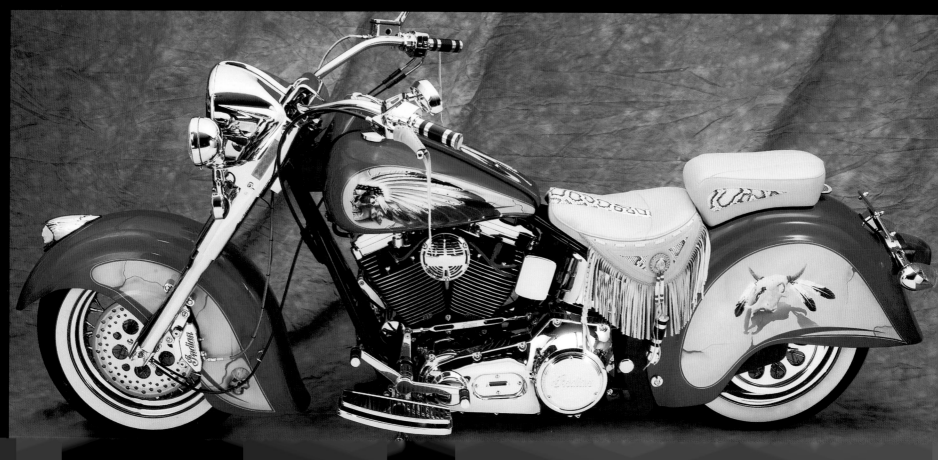

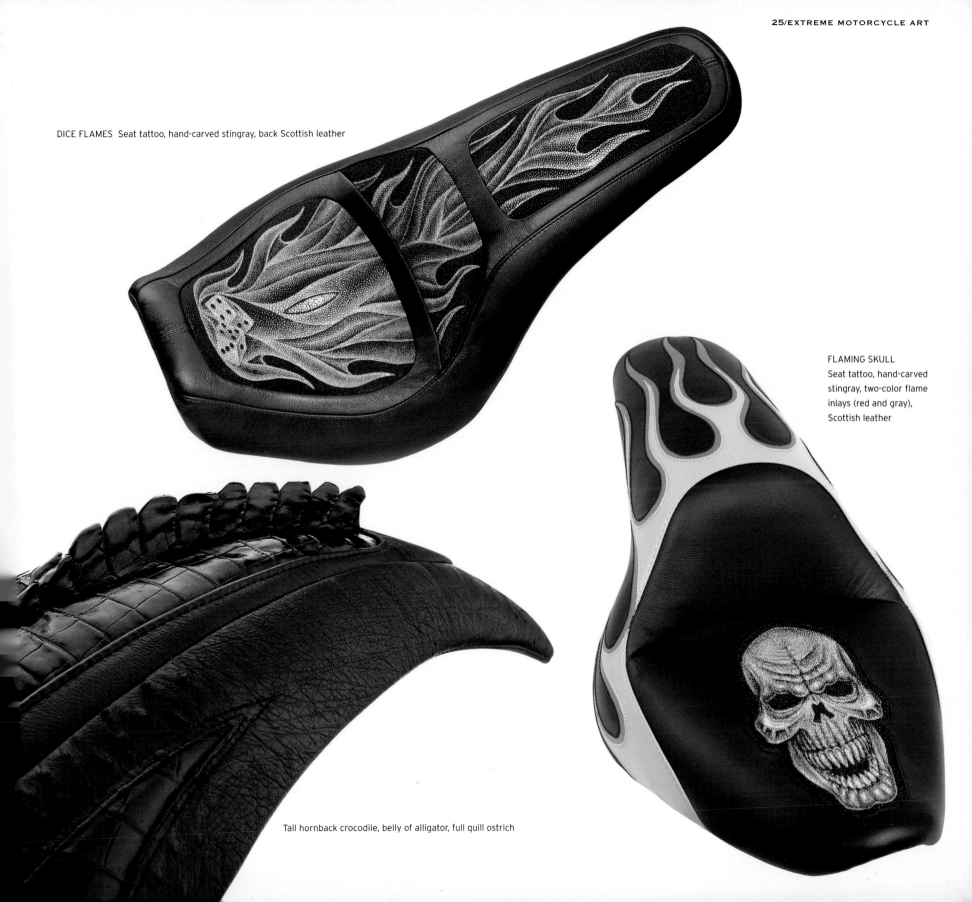

DICE FLAMES Seat tattoo, hand-carved stingray, back Scottish leather

FLAMING SKULL
Seat tattoo, hand-carved
stingray, two-color flame
inlays (red and gray),
Scottish leather

Tall hornback crocodile, belly of alligator, full quill ostrich

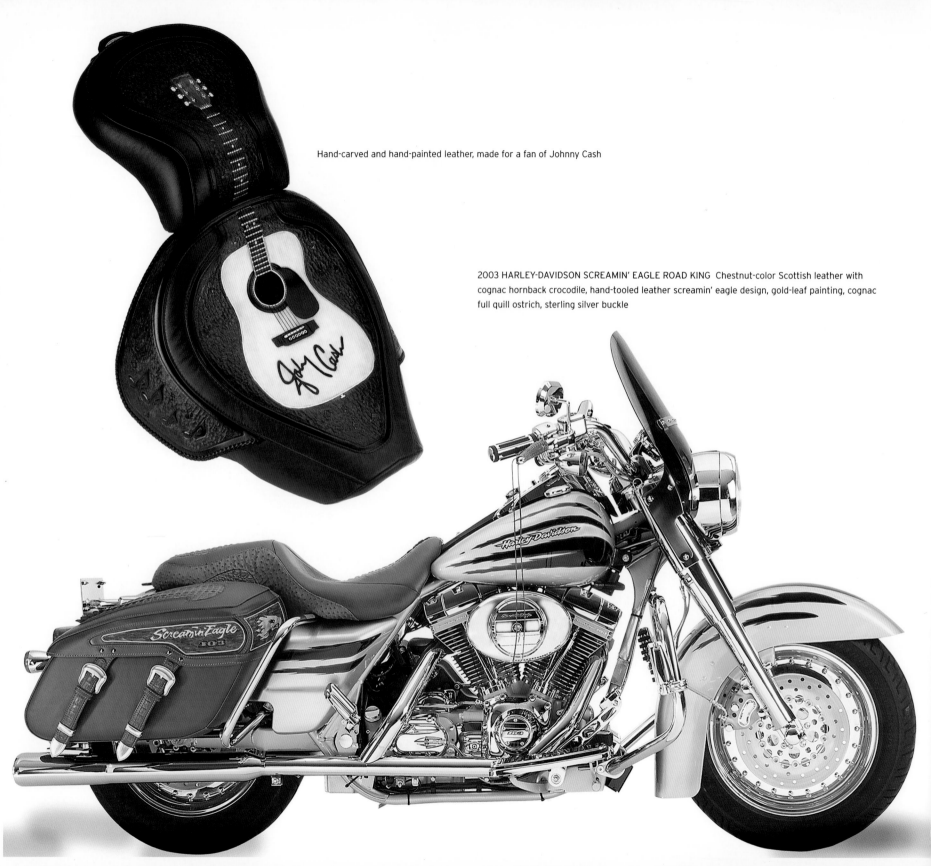

Hand-carved and hand-painted leather, made for a fan of Johnny Cash

2003 HARLEY-DAVIDSON SCREAMIN' EAGLE ROAD KING Chestnut-color Scottish leather with cognac hornback crocodile, hand-tooled leather screamin' eagle design, gold-leaf painting, cognac full quill ostrich, sterling silver buckle

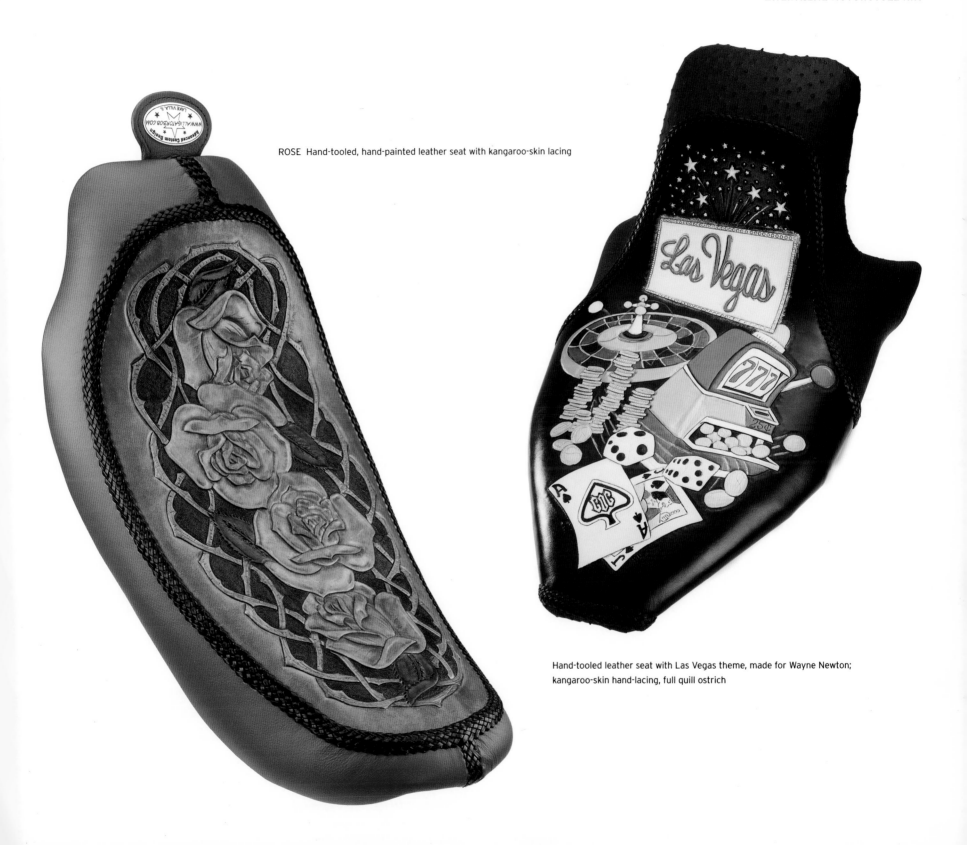

ROSE Hand-tooled, hand-painted leather seat with kangaroo-skin lacing

Hand-tooled leather seat with Las Vegas theme, made for Wayne Newton;
kangaroo-skin hand-lacing, full quill ostrich

BERT BALLOWE

Ballowe Artistry offers a high degree of realism through the use of airbrush illustration. Artist Bert Ballowe has developed a masterly eye for color and design. With more than twenty years of experience, he has established a reputation for creating award-winning custom graphics and murals. Bert's work can be seen in such distinguished magazines as *Easyrider*, *Wing World*, *Big Twin*, *Auto Graphics*, *Airbrush Magazine*, *In The Wind*, *Crossroads Magazine*, and *Auto Weekly*. His artwork has been selected by celebrity clients including Dale Earnhardt Jr., Bill Goldberg, Bill Davis Racing, and Tony Robbins. Motorcycle enthusiasts can also catch Bert in action on the Travel and Discovery channels.

Below left Hot candy-colored tribals

Below Interwoven multiple flames with hot candy colors

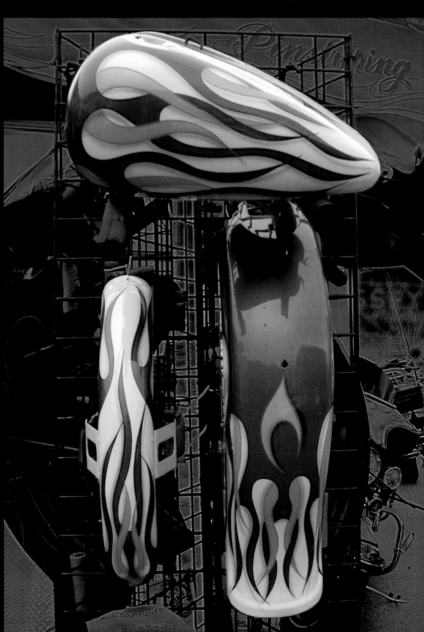

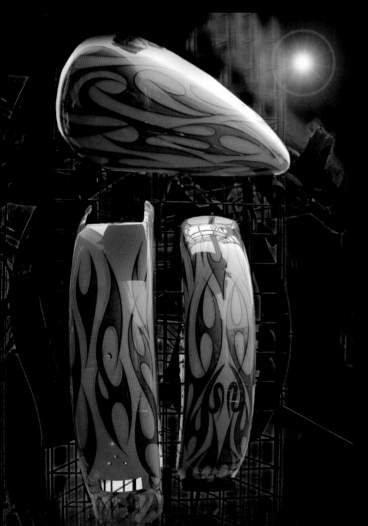

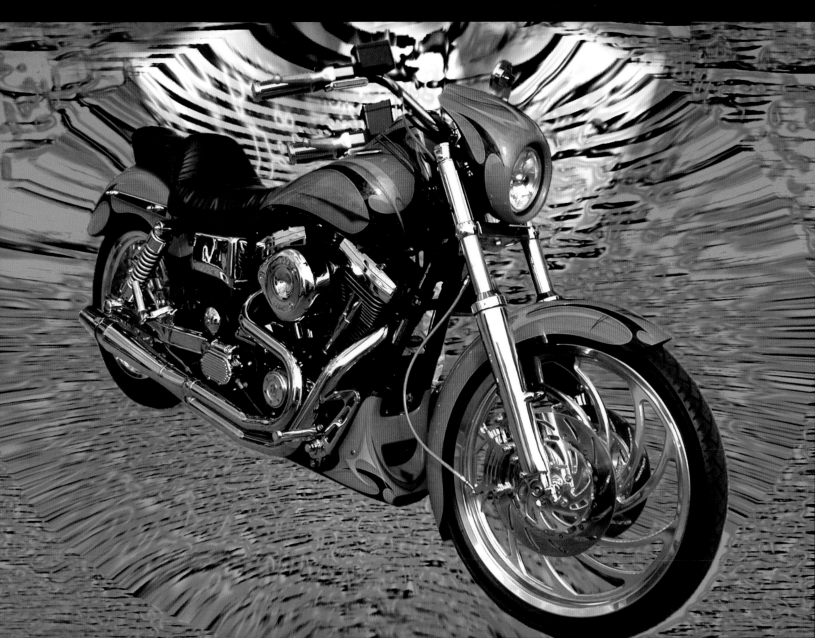

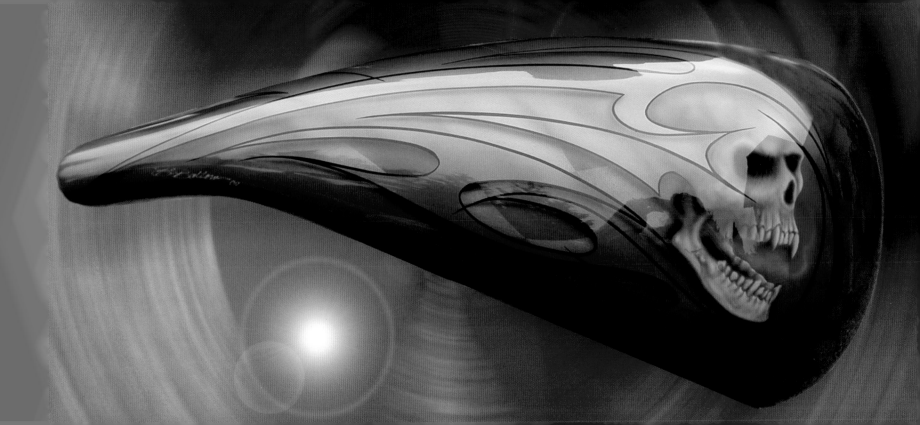

Below, top left Flames with yellow tips

Below, bottom left Realistic flames with a Kandy flaming skull on a black basecoat

Below Custom Kandy flames look realistic on a black basecoat

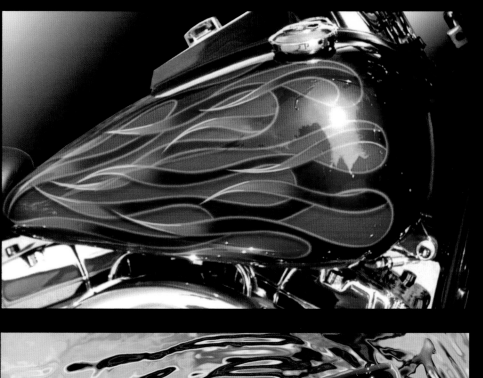

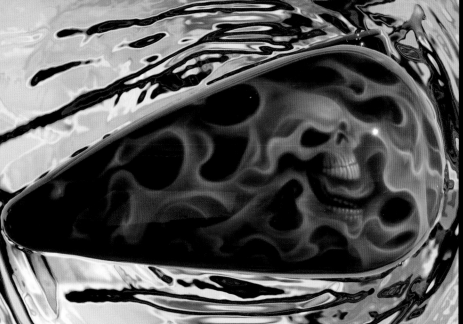

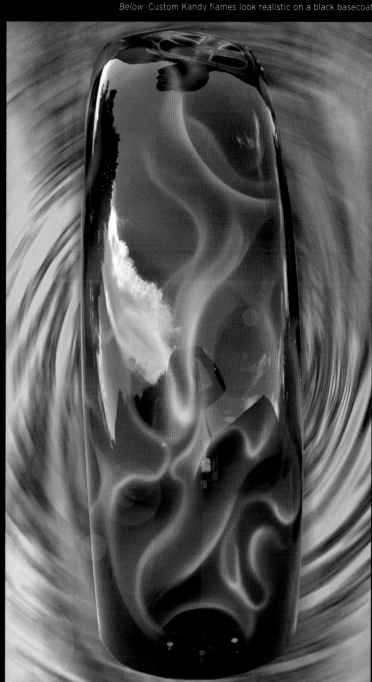

BATTISTINIS CUSTOM CYCLES

Battistinis (known as BattBoyz) is are widely considered to be the Pinin Farina of the motorcycle customizing world. For more than fourteen years, Battistinis have been designing and building stylish one-off custom motorcycles. Battistinis brought the West Coast styled low rider concept to Europe, and, over the years, some of Europe's most famous motorcycles came roaring out of the Battistinis stable. Many of these custom built motorcycles have been on the front covers and inside pages of motorbike magazines throughout Europe. Battistinis works with dreams and aspirations and makes them a reality, producing radical designs and push engineering to the extreme.

A family company, Battistinis was started by Rikki and Dean Battistini in 1990 and has grown through enthusiasm and a flair for design. The company is now run by Mark Battistini who can be contacted by email at mark@battistinis.co.uk

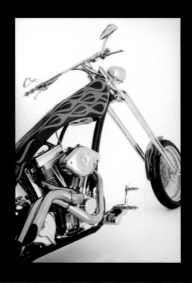

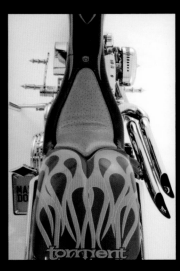

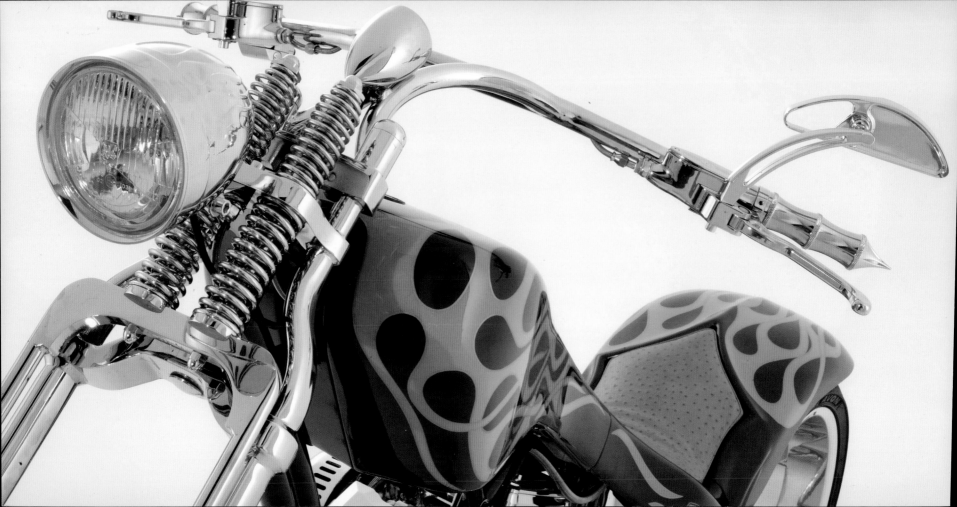

The frame has fairly radical stretches—8 in. (20 cm) in the top tube and 18 in. (46 cm) in the leg. Combined with a 40-degree neck-rake angle, this demanded long forks, and so they are: an impressive 18 in. (46 cm) over stock Springers. The motor is a 113 cu. in. (1852cc) supplied by Patrick Racing.

Torment has a 120 radial-spoke front wheel that is housed in a unique frame made specially for this bike. The complete frame is totally tubular, with a single down-tube. The gothic-style forward controls are by Accutronix. There is also a drive-side brake system, and the carburetor is a twin downdraft Weber.

The proud owner of this radical chopper is extremely tall and therefore smaller bikes and even regular-style choppers seem too small for him. This style with the long forks and stretch frame suits him perfectly—almost made to measure! The bike is painted in purple and yellow flames.

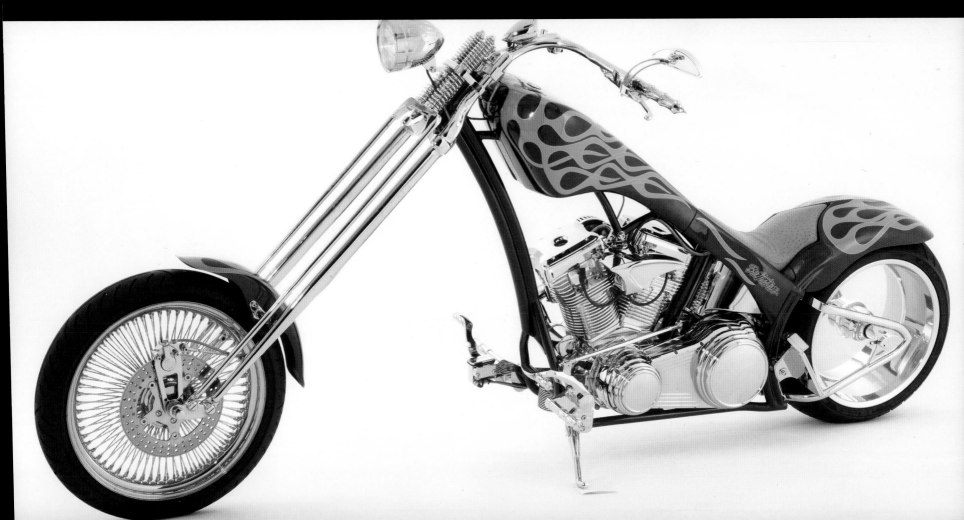

RICK BAZZANELLA

After studying architectural drafting in high school and working as a draftsman in an engineering firm for three years, Rich Bazzanella set his sights on his real passion—art. Studying with illustrator Peter Caras, an understudy of Norman Rockwell at the duCret School of Art, Rich turned his skills to the airbrush. He then learned automotive painting from DuPont Top Gun award-winner and master hot-rod builder Bob Beatty, and moved on to the motorcycle scene in 1996. Soon he became a veteran of bike rallies from Daytona to Sturgis. In 1997 Rich also became a tattoo artist. Beginning in the spring of 2005, he forged his knowledge and mileage into what is now Warpaint by Rich©, located at American Built Motorcycles in Toms River, New Jersey.

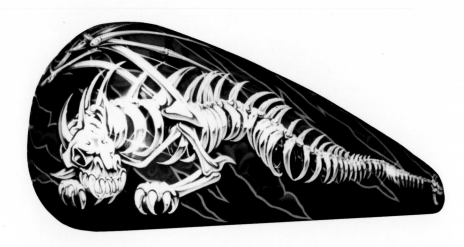

DRAGON Stock Harley-Davidson tank, painted in House of Kolor paint

GREEN SKULL Bourget Bike Works tank with added graphics, painted in House of Kolor paint

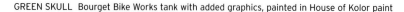

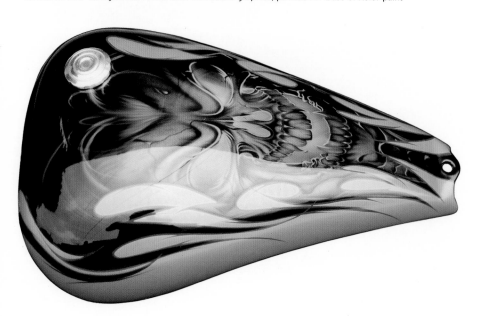

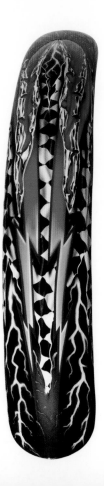

Right REDLIGHTNING Harley-Davidson front fender, painted in DuPont Chroma base paint

Far right Rear view of stretched Harley-Davidson front fender, 3-D R-rated (X-rated) graphics painted in House of Kolor paint

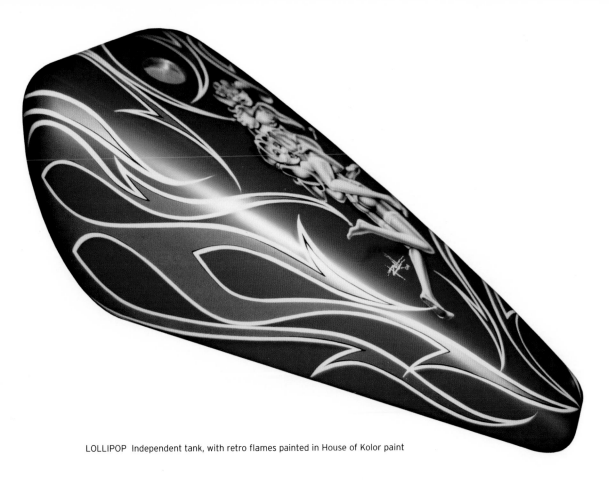

LOLLIPOP Independent tank, with retro flames painted in House of Kolor paint

Rear view of modified Paul Yaffe rear fender, 3-D graphics painted in PPG paint

SMOOTHTANK Independent tank, 3-D graphics painted in PPG paint

Mitch Bergeron has been building bikes now for more than a decade. Back when he started he mainly did metalwork, as in frames and sheet metal. Mitch now specializes in the one-off custom choppers he builds out of his shop in Palm Springs, California. He has been called the Maestro of Metal and the Mozart of Chop. "I've always had a good sense for designing bikes, and a lot of that comes from the ability I have to form metal. The designing and actual making of the bike are two things that feed off of each other. You know right away when something doesn't work or flow right and you have the ability to change it." Mitch also knows that good design and metalwork are not necessarily the final step. "Paint can either make or break your project. You can have a great bike and put a bad paint job on it and it could ruin the whole outlook of the bike." Knowing that pushes him to use the best painters on the planet! Mitch's premier choice is master airbrush artist Fitto. "We work good together. I understand his art and know his capabilities!"

DISCOVERY CHOPPER Built on *Biker Build-Off*. Modern classic chopper.
Featured in *Easyriders*, January 2005, and *American Choppers*, April 2005. Airbrush: Fitto. Paint: Stan Howton. Photo: John Wycoff

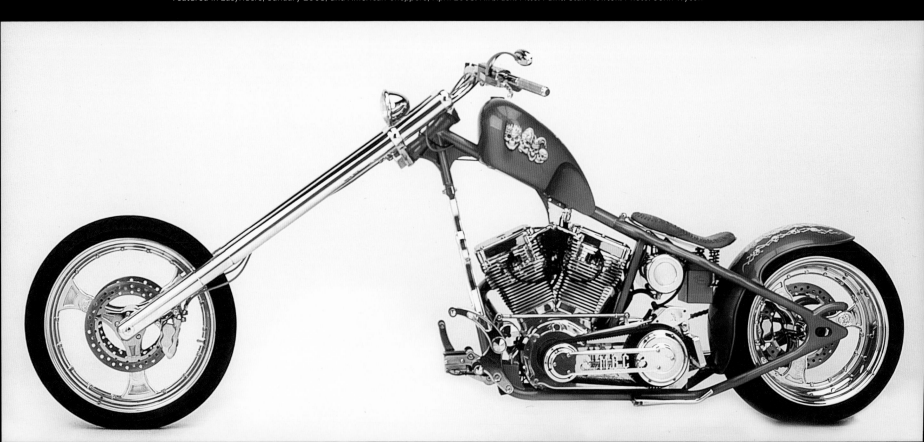

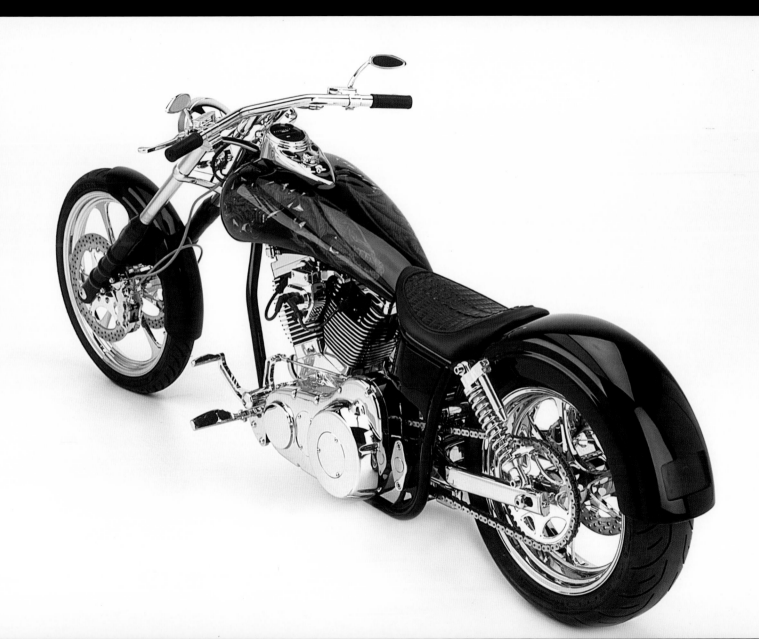

BIG BOAR CUSTOMS

Joe Rubino, owner of Big Boar Customs in Newton, New Jersey, has had a passion for motorcycles for as long as he can remember. He bought his first Harley at age seventeen and never looked back. Always finding new and innovative ways to customize the bikes of friends, as well as his own, Joe followed a natural progression and ended up building some of the most beautiful custom choppers around. His desire to make every bike an individual piece of art makes him part of an élite group of custom chopper builders.

For years Joe earned his living as a carpenter, while building bikes as a secondary hobby. In October of 2000, he opened Big Boar Customs in the quiet town of Newton, New Jersey. Business grew, and soon customers started requesting custom-built bikes.

People love the fact that when they get a bike from Big Boar, it's an original. Pulled up to a bike night or a rally, any Big Boar custom chopper will stand out. Big Boar has made some really amazing choppers, including bikes created for Trimspa and Anna Nicole Smith.

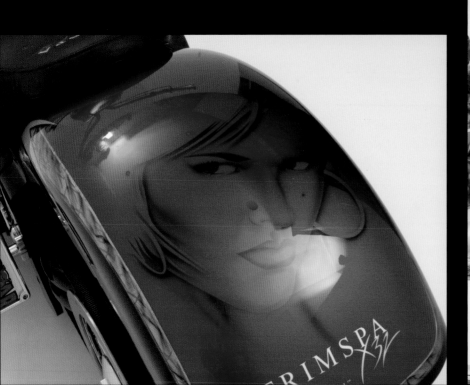

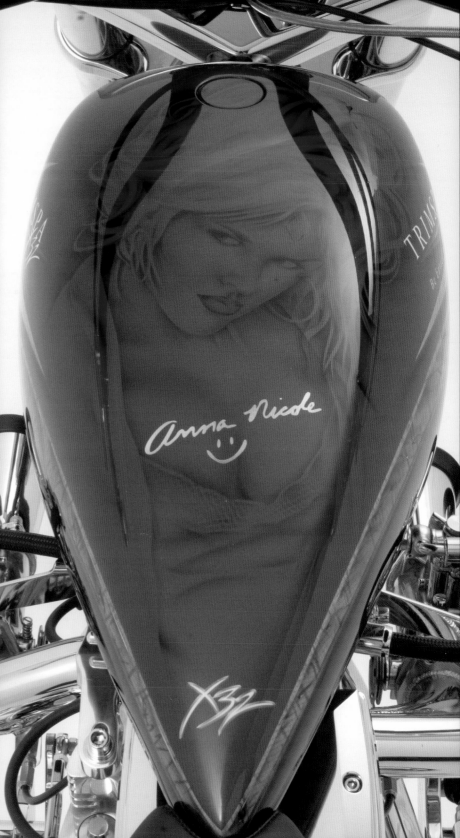

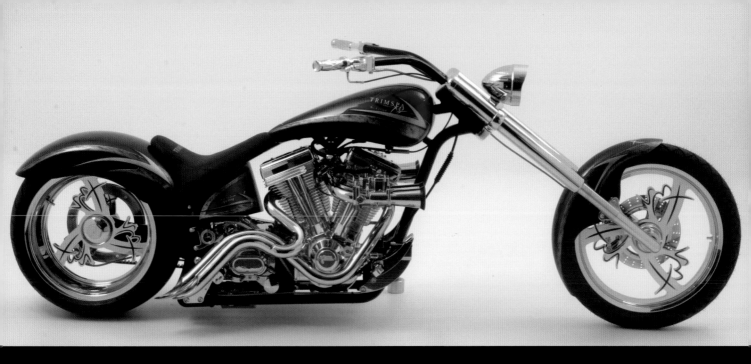

Below Builder: Joe Rubino. Paint: Mike Learn. Owner: Jim McIntyre. Photo: Dino Petrocelli

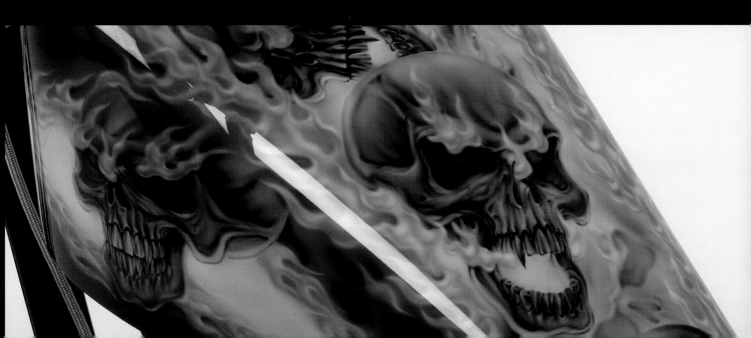

BIKES BY BOYCE

Bikes By Boyce, Inc. was founded by Michael Boyce, who started painting and airbrushing in 1981. Michael combines his experience in refinish work with his skill in bodywork and fabrication. He received certification from the DuPont refinish school program. In 1999 he won the DuPont Top Gun award and one of his creations was featured in the 1999 DuPont calendar. Boyce's artwork has also been featured in trucking and motorcycle magazines. So as to pursue his passion for customization, Boyce opened Bikes By Boyce, Inc., in 2000.

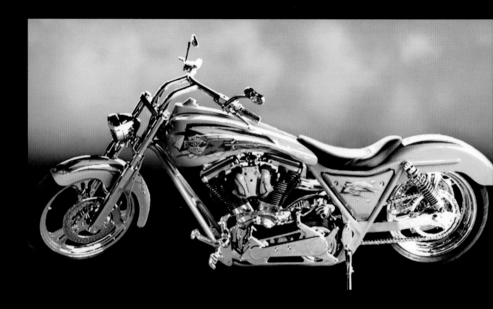

Frame: 991 FXR stretched 5 in. (13 cm) and raked 38 degrees. Motor: 80 cu. in. (1311cc) bored to 103 cu. in. (1688cc) with Magna charger. Rear tire: 200. Base: Kandy Yellow, Lance King. Graphics: Bikes By Boyce. Owner: Randy Overacre

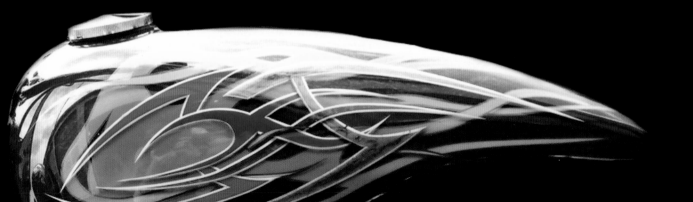

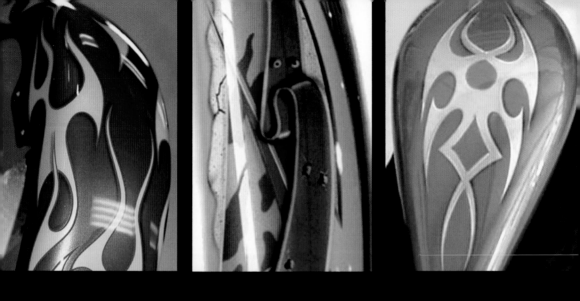

Below ULTIMA SLEDGE HAMMER Starlite Pearl base coat with multicolor tribal graphics and granite insert. Owner: Terrance Cooper

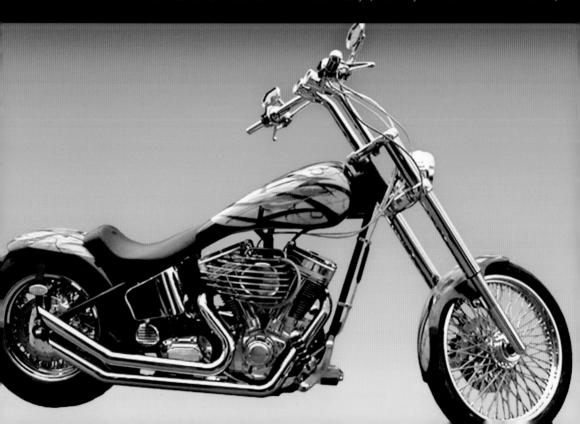

CUSTOM-BUILT PRO-STREET Tangelo pearl base with checkered flag and 3-D tribal graphics. Custom paint and graphics: Mike Boyce

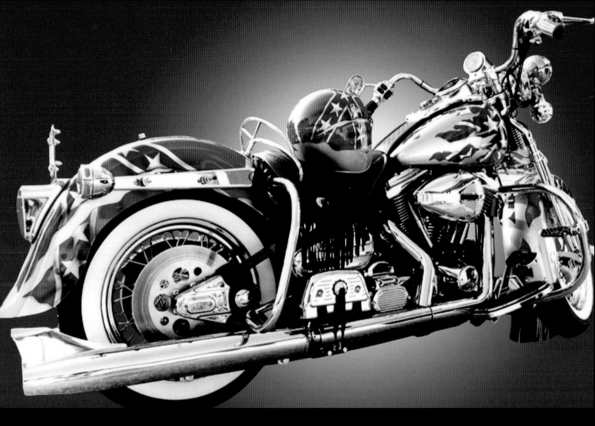

REBEL Heritage Springer, silver base with rebel flag torn and waving. Custom paint and graphics: Mike Boyce

BOLLT/HAMBLIN

Over the past fifteen years David Bollt has established himself as a groundbreaking illustrator and tattoo artist. Thousands of fans around the world have his images permanently etched into their skin, while his airbrush images have been seen in numerous magazines, on CD covers, and in art galleries. In 2002 David started working with Chester Hamblin of Custom World in Tampa to put his exquisite images on show-quality motorcycles. Chester has more then twenty years' experience in custom paint jobs. Together they are producing custom tanks and fenders that are setting new standards of quality and excellence.

Art and design all by David Bollt, with production by Chester Hamblin
Eagle tank by Chester Hamblin

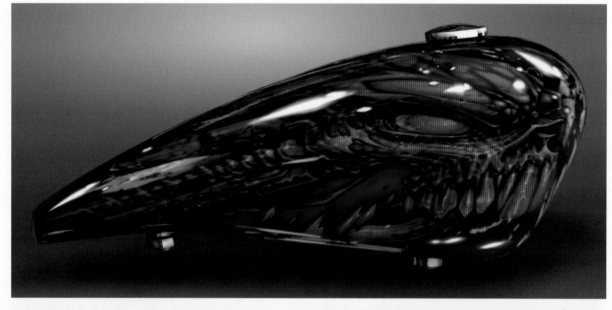

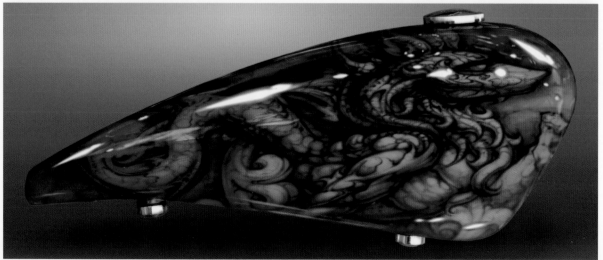

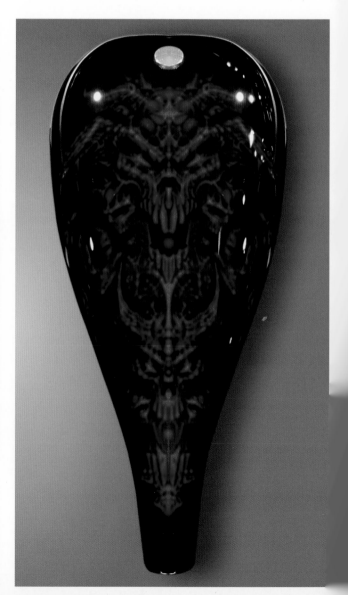

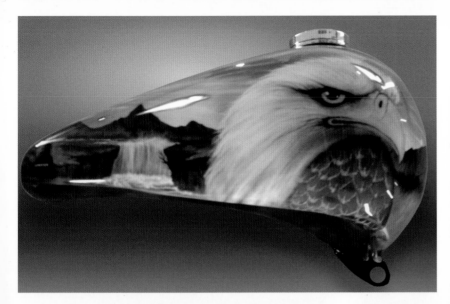

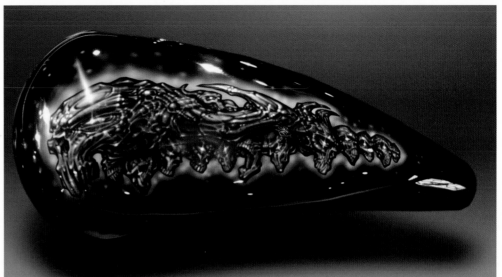

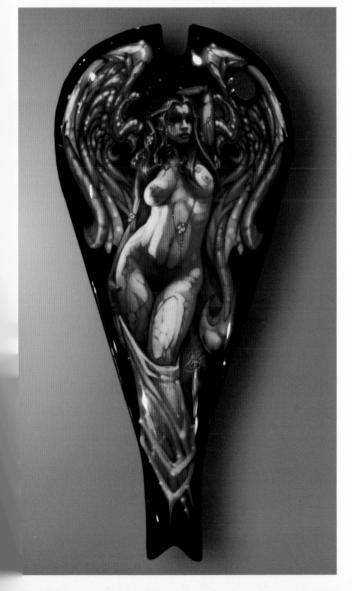

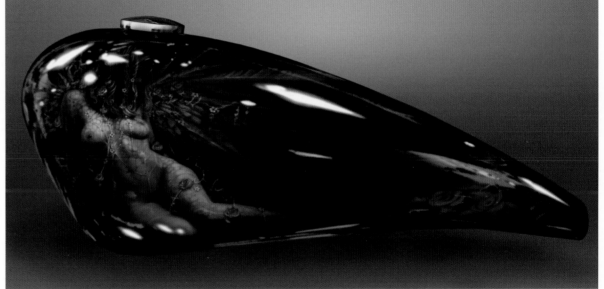

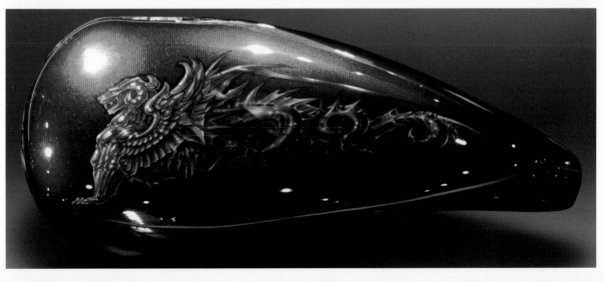

CENZI MOTORCYCLES

Born in 1961 in Rochester, New York, Anthony Cenzi built his first mini- bike at the age of twelve, with his father Vincent. He learned to paint by watching and helping his cousin paint cars in his garage.

In 1996, owing to shortages and the long wait to get a Harley, Anthony decided to build his first bike. Six years later he was able to quit his full-time job and begin building bikes for a living. He opened his shop in Spencerport, New York. During the first full year of business Cenzi built eight bikes. In 2004 the firm completed 28 bikes, including one for Drag Specialties and bikes for a Tampa dealership.

Cenzi Motorcycles also do service and customizing work on any bike brought to them. Anthony's son, Mark Cenzi, is the service department manager.

They are on the list as a contestant for the *Biker Build-Off* series, the Discovery Channel show where two builders compete to build a motorcycle and a winner is chosen at the end of the show.

Frame: Pro-street. Engine: TP 124 cu. in. (2032cc). Transmission: Baker 6-speed. Paint: Cenzi Motorcycles. Owner: Steve Lanning. Photo: Dino Petrocelli

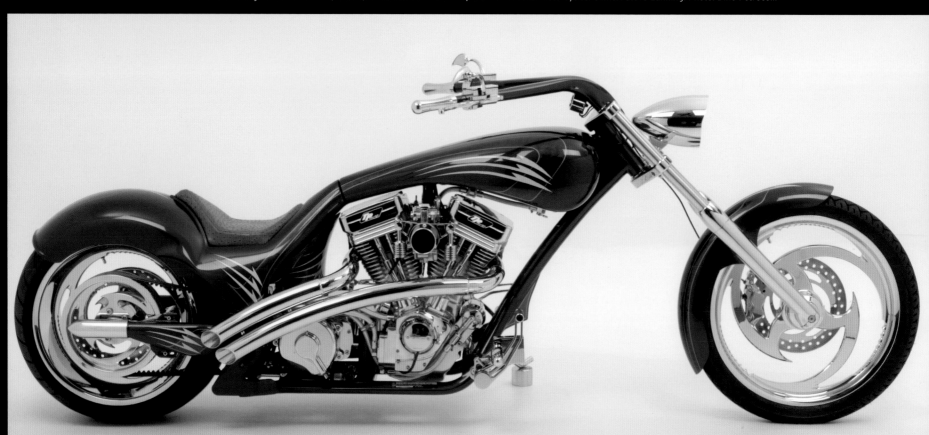

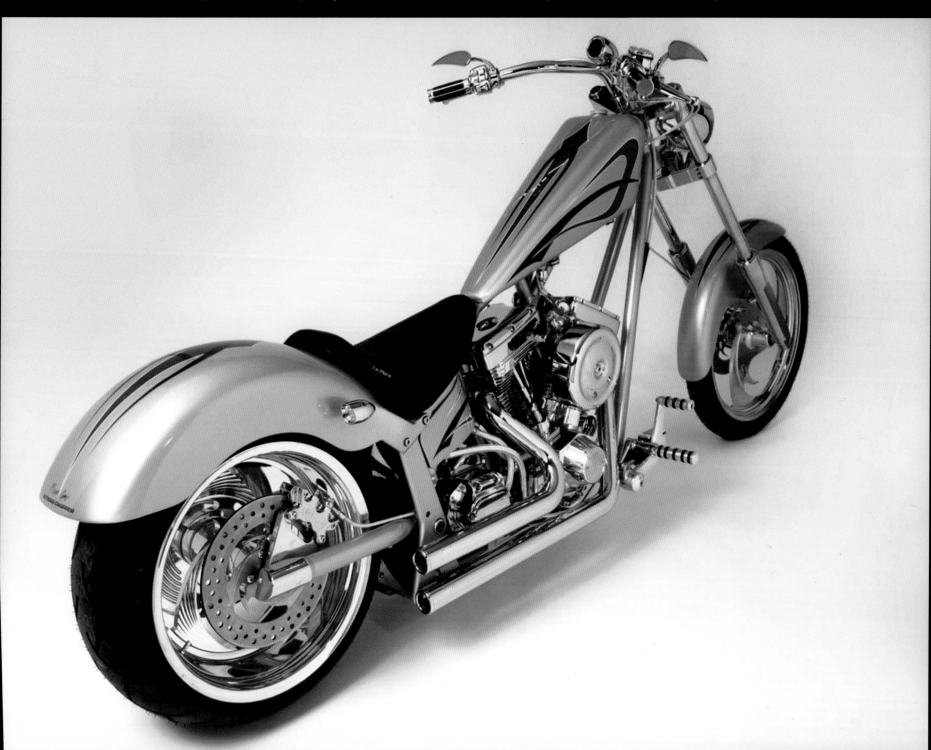

COUNTY LINE CHOPPERS

County Line maintains a state-of-the-art custom motorcycle fabrication facility in Phoenix, New York, just north of Syracuse. It is fully equipped with a machine and welding shop and a hospital-clean station for building high-performance engines and transmissions.

CLC builds some of the most eye-catching and meticulously hand-crafted motorcycles available today. Each bike is designed, engineered and fabricated to accommodate the customer's personal tastes. Owner Pat Briggs has won awards at many prestigious shows, and has a team with more than sixty years of combined experience.

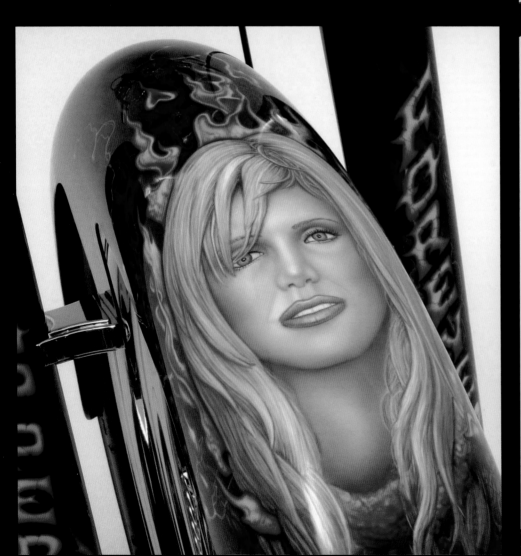

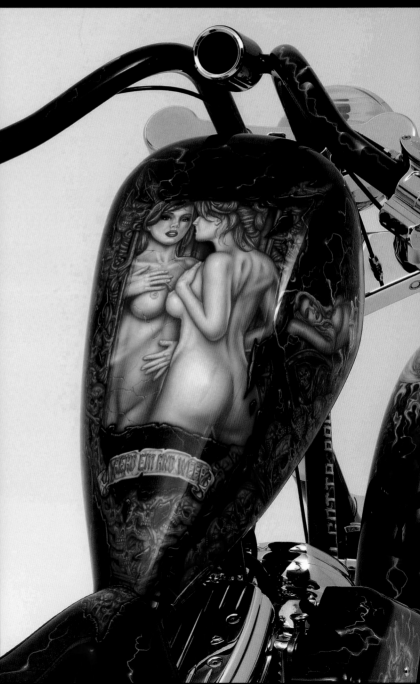

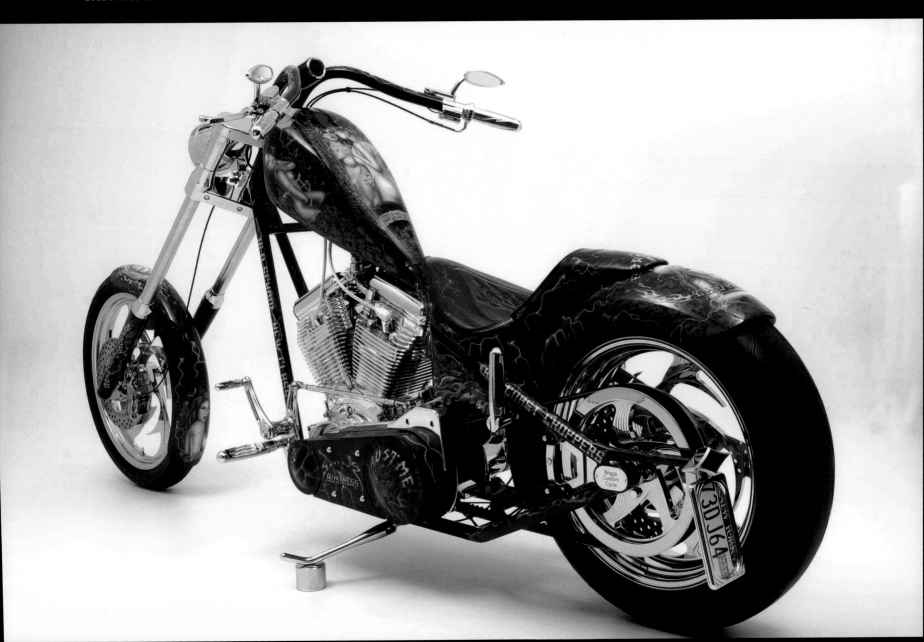

CYCLE BOYZ

Cycle Boyz Customs is a small custom bike shop located in Brandon, Manitoba, Canada. The shop was founded in 2003, and is operated by two brothers in their late twenties. Cycle Boyz Customs specializes in complete ground-up customs, from radical pro-street softails, to rattle can, rigid choppers and bobbers. While Cycle Boyz is becoming known for cranking out radical sheet metal adorned by some of the wildest paint in the country, Brent and Derek will be the first to tell you that their favorite paint is still "House Of Tremclad Flat Black." All Cycle Boyz bikes are built to be ridden hard. The bike seen here is no exception. This bike was not built with the term "show bike" in mind. It just got a little out of hand. A big thanks goes out to Dale at Uncle D's Airbrushing for making this bike look as good as it rides! Cycle Boyz believes that with these combined talents, the sky is the limit!

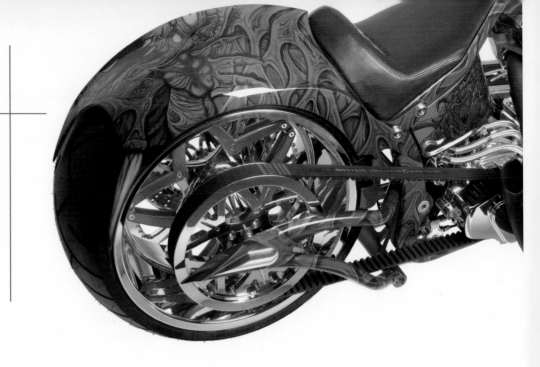

CYCLE BOYZ CUSTOMS PRO-STREET SOFTAIL
Motor: TP 124 cu. in. (2032cc). Transmission: 6-speed right-side-drive. Belt drive: BDL TF2000. Forks: Mean Street 2 in. (56 mm) inverted stiletto forks. Wheels: Pro-One Sinister, 280 rear tire. Accutronix foot controls, PM hand controls. Tricky Air Ride with remote. Cycle Boyz Customs sheet metal. Cycle Boyz "Billy T" pipes. Cycle Boyz seat, handlebars. Airbrush: Uncle D's Airbrushing. Photo: Ian McCausland

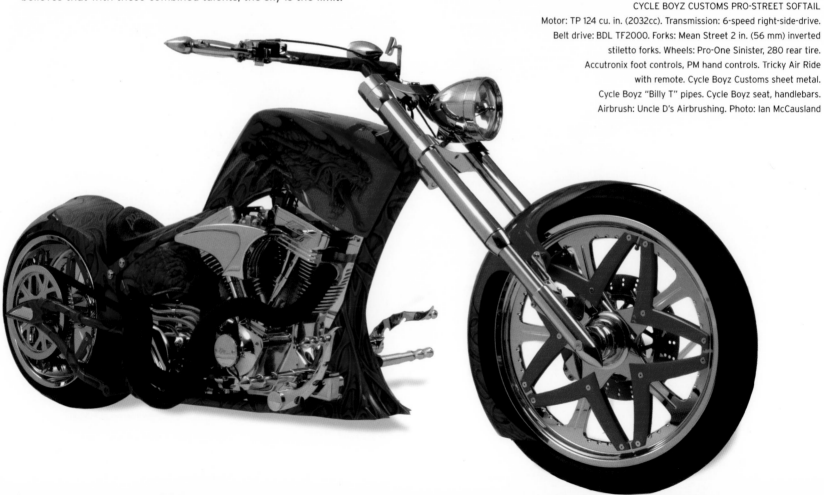

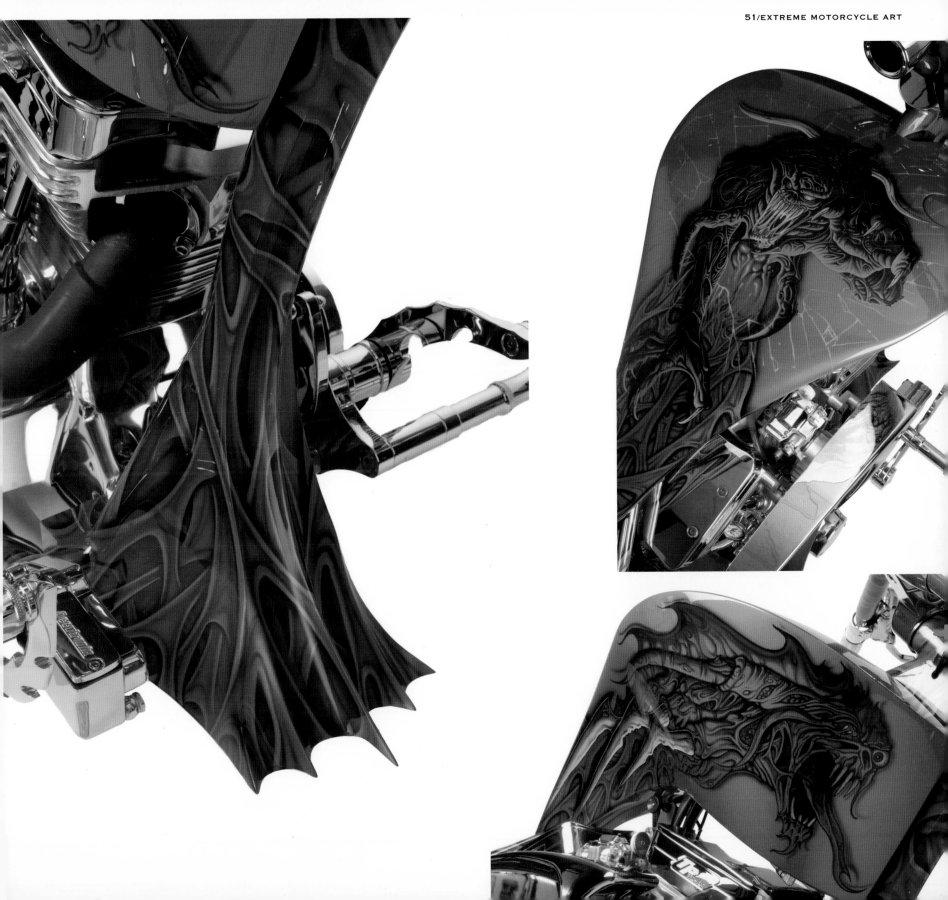

CYCLE-DELICS

Michael Angelo Calderone started painting and airbrushing at the age of thirteen. It all started when he began applying his talents to denim jackets at a local flea-market. Later on Mike worked out of his garage creating paint jobs for the hardcore bikers who trusted him to create a one-of-a-kind ride. In 1997 Michael joined forces with fabricator/bike builder Rio, and opened up Cycle-Delics. With the creative minds of Rio, Mike, and a multitalented crew of masters in the industry, Cycle-Delics are able to create unique individual motorcycles. They make either one-offs or parts of a project, laying on their most outrageous and classy paint designs.

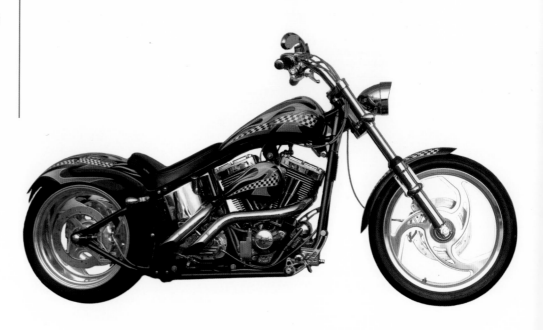

Above 2003 AMERICAN IRONHORSE TEXAS CHOPPER Slate pearl paint, skull and flames. Graphics: Michael Angelo. Photo: Phil Fazin

Below 2002 Cycle-Delics custom Chopper Guys rubber-mount 200 series frame
Motor: TP 107 cu. in. (1770cc) with 5-speed RevTech transmission
Custom metal: Cycle-Delics
Paint and crazy clowns: Ceasar Santos/Michael Angelo
Photo: Phil Fazin

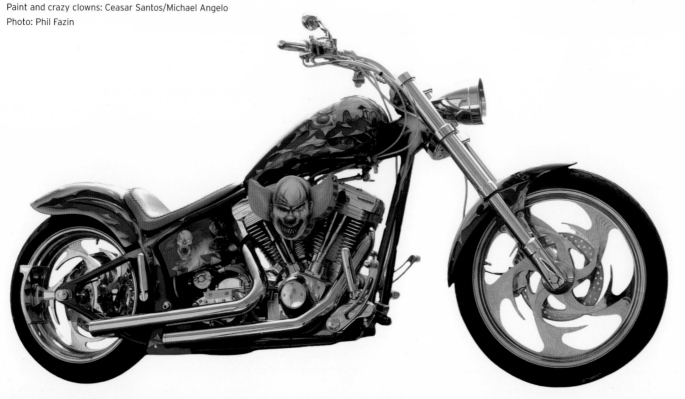

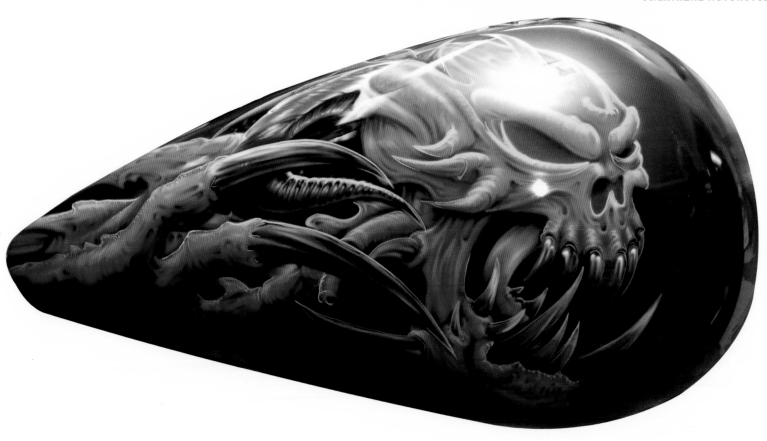

2000 HARLEY-DAVIDSON Dyna tank with candy red base and demon skull. Artwork: Ceasar Santos

2004 Cycle-Delics custom Dakota Thunder frame with 38 in. (97 cm) rake
Motor: 113 cu. in. (1852cc) El Bruto, 250 series tire
Custom sheet metal: Billy Sharpe at Cycle-Delics
Custom paint and artwork: Michael Angelo/Ceasar Santos
Photo: Phil Fazin

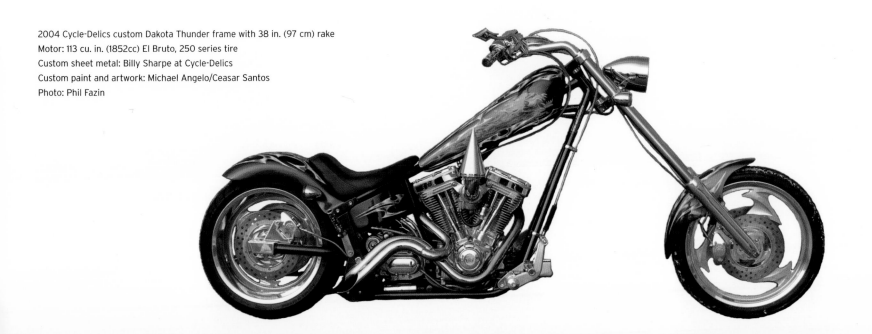

DEANO'S

Dean Calderwood started out more than fifteen years ago as a one-man operation working under a blue tarp between buildings. Currently painting nearly 1000 motorcycles a year, Deano's has expanded into two large warehouse-sized buildings with nearly forty employees, becoming one of the top custom paint shops, recognized around the world for quality and excellence. Deano's has had the privilege of painting for many industry leaders, including Titan motorcycles, Jim Nasi customs, Bourget's Bike Works, and Harley-Davidson. Deano's talented staff offers state-of-the-art computer design technology along with customized consultation to sculpt, shape, and individualize paint jobs.

All bikes: Bourget Bike Works sheet metal
All paint and photos: Deano's

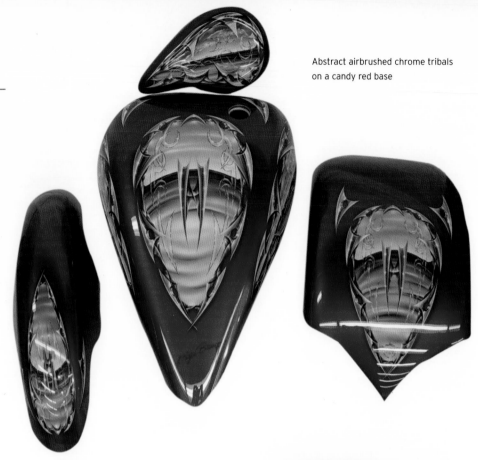

Abstract airbrushed chrome tribals on a candy red base

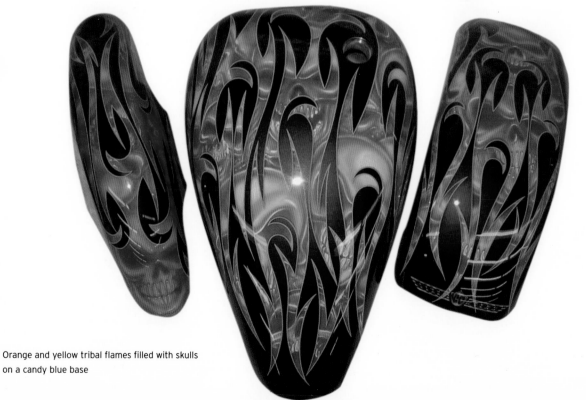

Orange and yellow tribal flames filled with skulls on a candy blue base

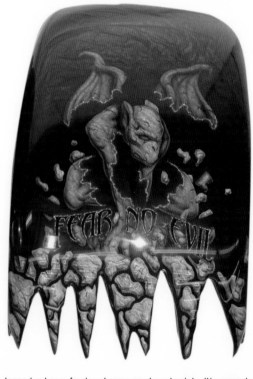

Jagged-cut rear fender, chrome candy red paint with gargoyles

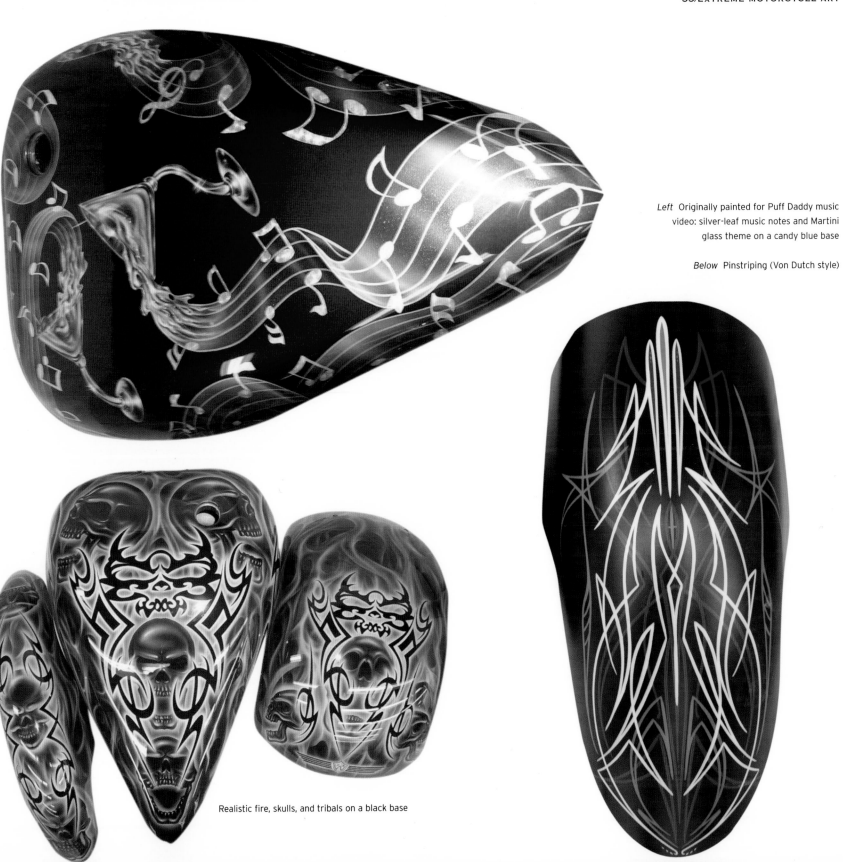

Left Originally painted for Puff Daddy music video: silver-leaf music notes and Martini glass theme on a candy blue base

Below Pinstriping (Von Dutch style)

Realistic fire, skulls, and tribals on a black base

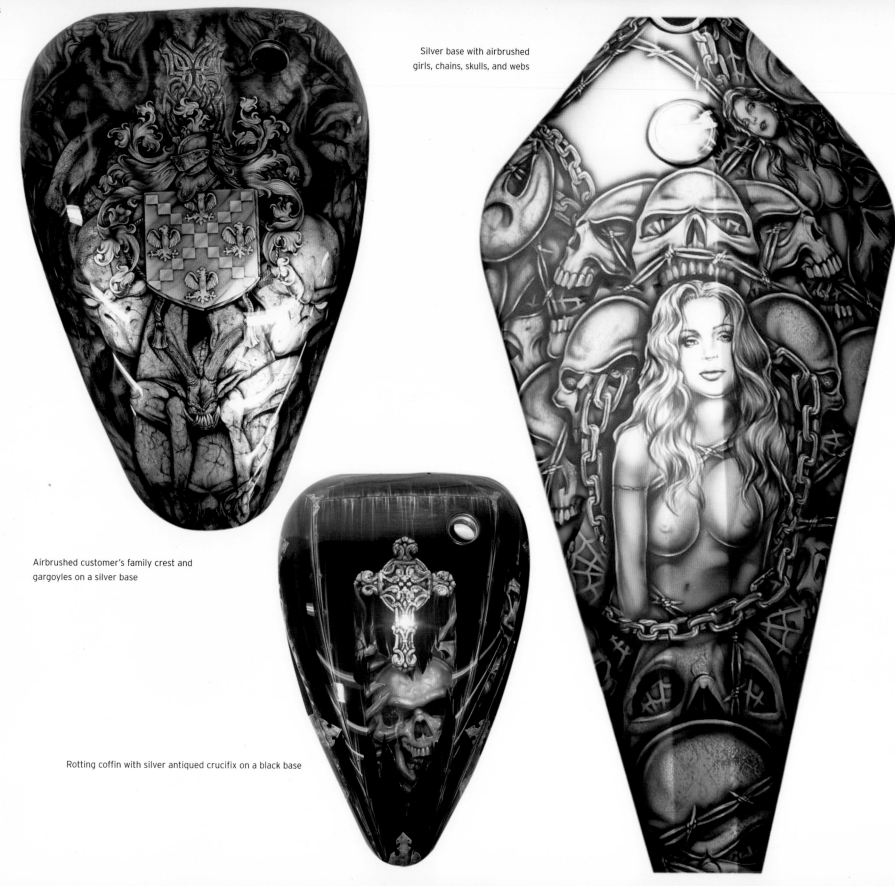

56

Silver base with airbrushed girls, chains, skulls, and webs

Airbrushed customer's family crest and gargoyles on a silver base

Rotting coffin with silver antiqued crucifix on a black base

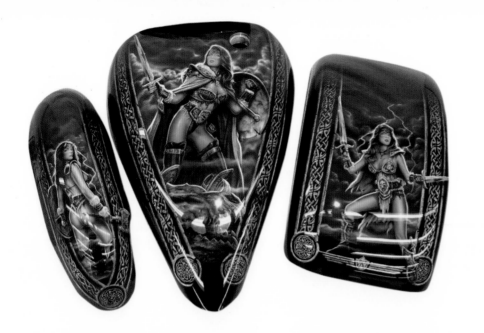

Barbarian women with Celtic tribal bands on a black base

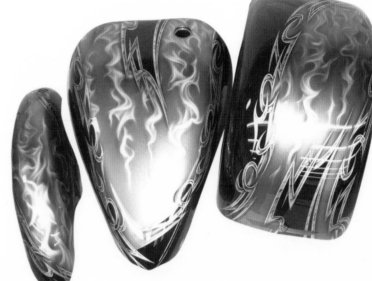

Two-tone design with tribal divider and realistic smoky flames

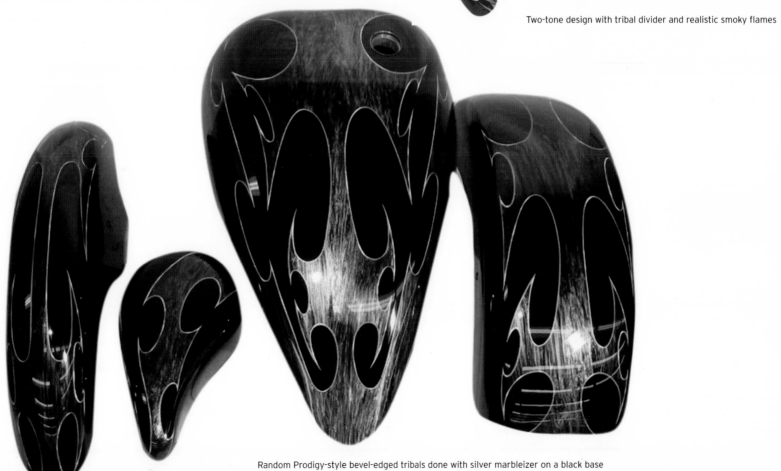

Random Prodigy-style bevel-edged tribals done with silver marbleizer on a black base

DROZD DESIGN

The Drozd Design studio was set up in 2000 by Przemek Drozd, age twenty-five, who took his first steps in airbrush art, together with digital art and oil paintings on canvas, at age sixteen. Later the customizing boom in Poland led him to devote himself entirely to airbrushing. First successes came after nearly four years of hard work and total commitment to this branch of artistic activity. By December 2004 Przemek Drozd had made four TV programs, and started cooperating with customizing companies thriving in the Polish motorcycle market. He uses Paasche and Harder-Steenbeck airbrushes and DuPont paints.

"The most exciting thing about this kind of 'mobile' art," says Przemek, "is that you never know the place and time of the exhibition. It can be a gallery, but also a crossroads, empty freeway, motorcycle events and shows, or a private garage."

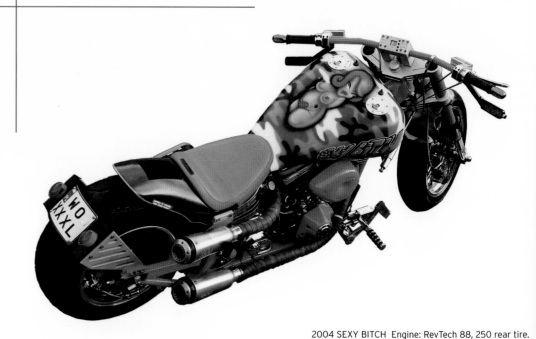

2004 SEXY BITCH Engine: RevTech 88, 250 rear tire.
Builder: Bullet 666. Paint and graphics: Drozd Design.
It took three years to finish building this controversial
machine. The city camouflage as background for a pinup
girl was inspired by World War II fighter-plane graphics.

2005 sheet metal. Yellow flames with miniature skulls coming out.
The main color is red with some fine brocade.

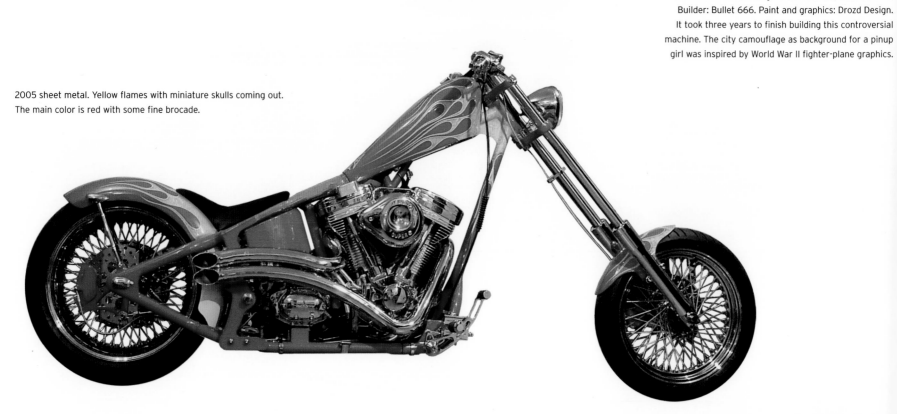

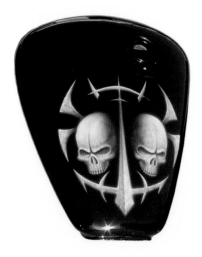
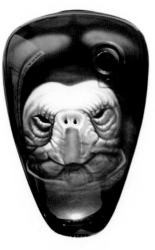
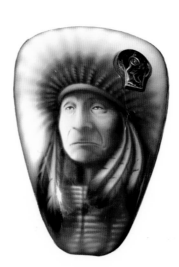
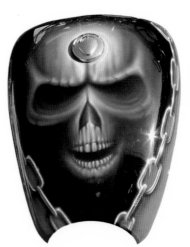
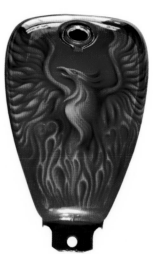

2002–04 tanks. There is a real variety of motifs in these motorbike paintings. All the works were made using DuPont paints.

2005 THE CHOPPER '69 Santee single downtube frame with 6 in. (15 cm) downtube stretch and 4 in. (10 cm) backbone stretch for 250 rear tire. Made on standard Kite-Bike by Custom Chrome. Builder: Free Rider. Motorcycle, paint, and graphics: Drozd Design

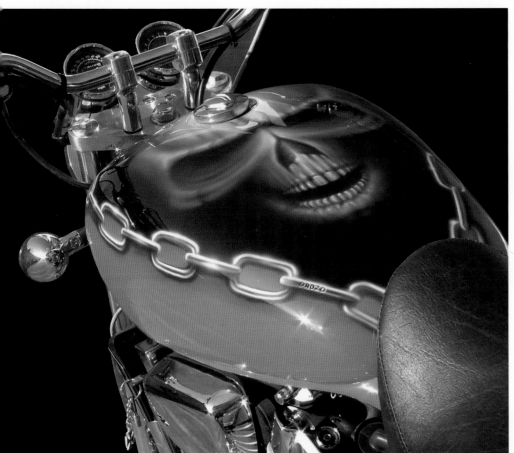

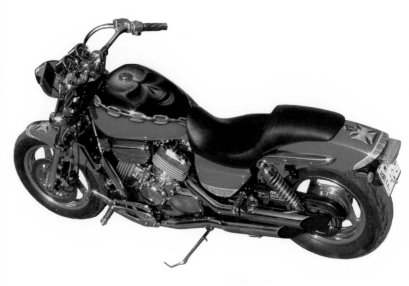

DUSOLD DESIGNS

Established in 1998, DuSold DeSigns specializes in custom paint and metal fabrications on cars and motorcycles. Located near historic Old Town Lewisville, Texas, DuSold DeSigns is a family business and is operated with a unique approach to design and fabrication. Mike DuSold is in charge of the paint shop and has been involved in the shop and painting industry since he was four years old. Steve DuSold is in charge of the metal shop and administration aspects of the business. Steve has been involved in fabrication and body shops since he was eight years old. DuSold DeSigns is a dynamic and growing custom design company and offers many levels of services to its customers.

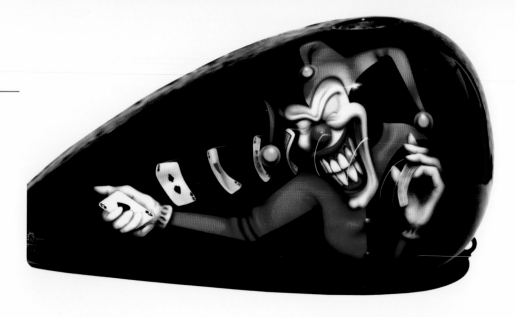

AMERICAN EAGLE HARLEY-DAVIDSON Softail Springer tank with joker. Airbrush and paint: Mike DuSold
Photo: Steve DuSold

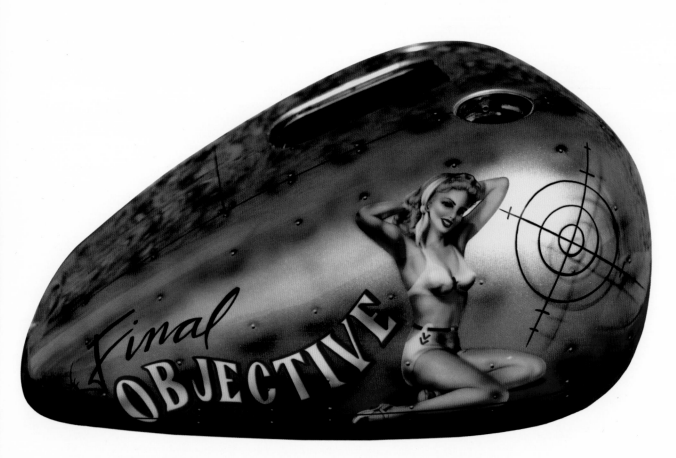

FINAL OBJECTIVE Softail standard tank. Airbrush and paint: Mike DuSold. Photo: Steve DuSold

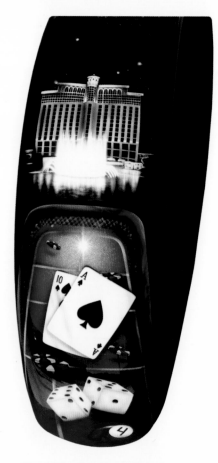

THE VEGAS BIKE Fatboy front fender with Bellagio and
craps table, American Eagle Harley-Davidson
Airbrush and paint: Mike DuSold
Photo: Steve DuSold

VOODOO Design, fabrication, paint, and assembly: DuSold DeSigns. Engine: S&S 124 cu. in. (2032cc), with right-side-drive 6-speed transmission, single-sided side arm. 300 mm rear tire, frame laying custom air suspension. Photo: Steve DuSold

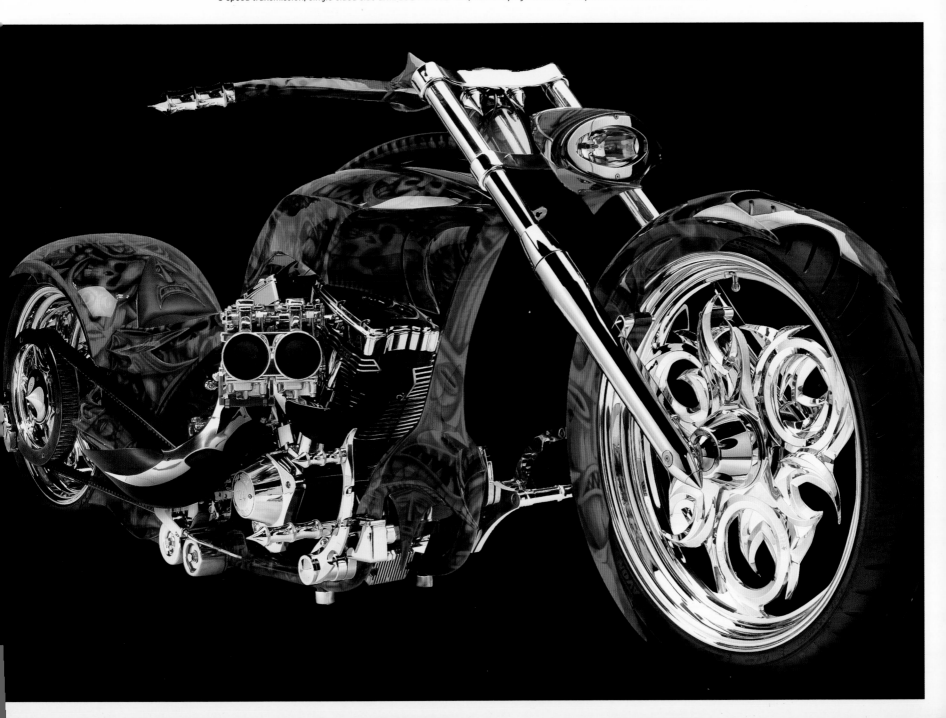

EAST COAST CHOPPER WORKS

East Coast Chopper Works is co-owned by Kevin Bourbeau and Peter Graves, and is located in Greenfield, Massachusetts. The bikes built in their shop are all unique. Peter and Kevin work together with their customers to choose components, paint, and graphics to make their fantasies into realities. Utilizing some of the industry's best talents, they mold their custom bikes into true works of art. East Coast Chopper Works has an affiliate, East Coast Performance Coatings, which is a full service powdercoat and ceramic shop. This lets them keep all of their custom creations in-house for the best possible quality control.

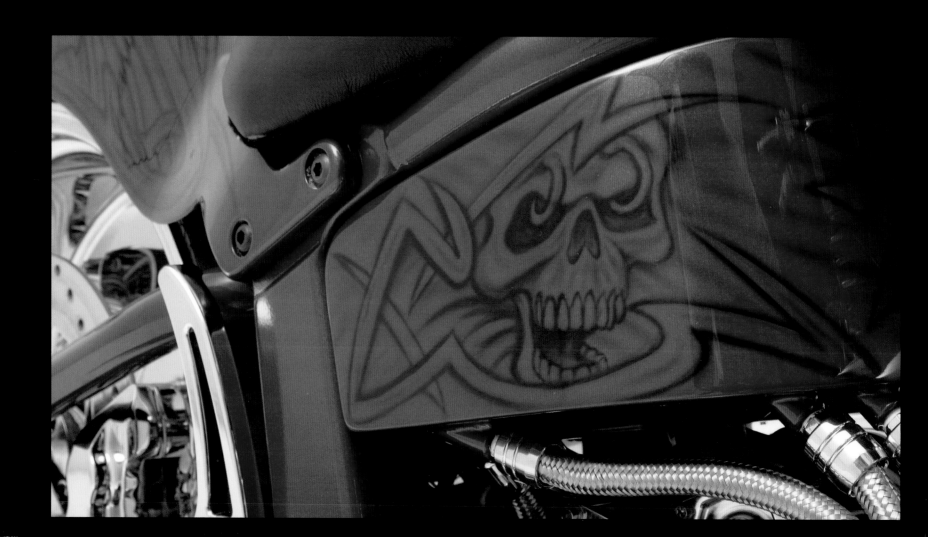

PRO-STREET
Frame: Daytec Goliath 250 Softail with Legends
Air Ride suspension
Length: 8 ft. 9 in. (267 cm) with 42 degrees
of rake in the front end
Engine: polished S&S 124 cu. in. (2032cc) with
Edelbrock Double Trouble nitrous oxide
injection system
Transmission: polished 5-speed Baker
Wheels: Carriage Works with tires by Avon Tires
Fenders: front by Wernimont (Dagger),
rear by Daytec
Tank: Independent Gas Tank Co.
Paint: Mark Picard
Photo: Dino Petrocelli

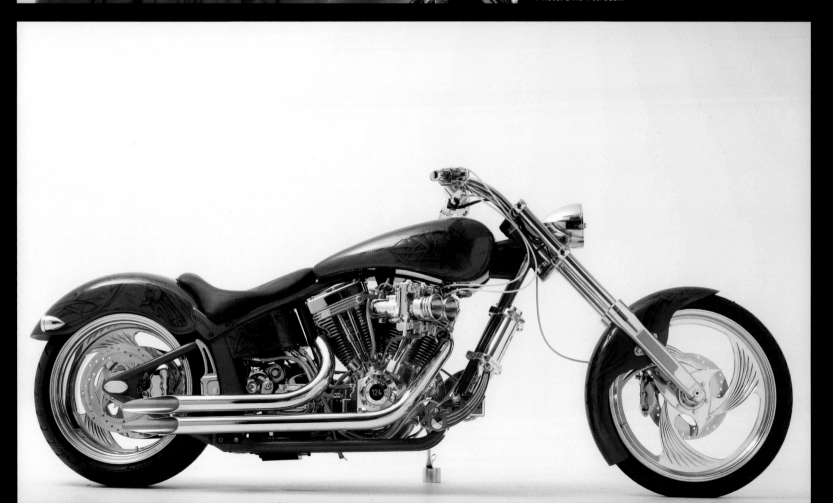

Rick Fairless is a motorcycle designer and entrepreneur who lives in the fast lane. For Rick, it's all about riding life to the fullest and being the best you can be—at everything. A builder for twenty years, Rick has conjured up award-winning works of art and been profiled in major magazines, including *Easyriders*, *Hot Bike*, and *V-Twin*. He's cruised ahead of the trends with a free-thinking style that ranges from long and low choppers to old-school Panheads. Musicians, actors, and major athletes ride Rick's radical bikes. In 1996 Rick created Strokers Dallas, the most happening biker destination in Texas, which was voted the top motorcycle digs in 2004 by *Ride Texas* magazine. But when it comes to family, Rick sets the ultimate example. He's made his motorcycle wonderland Strokers a fun family affair.

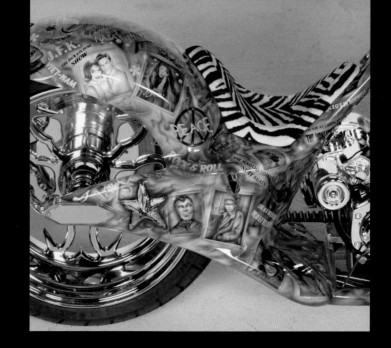

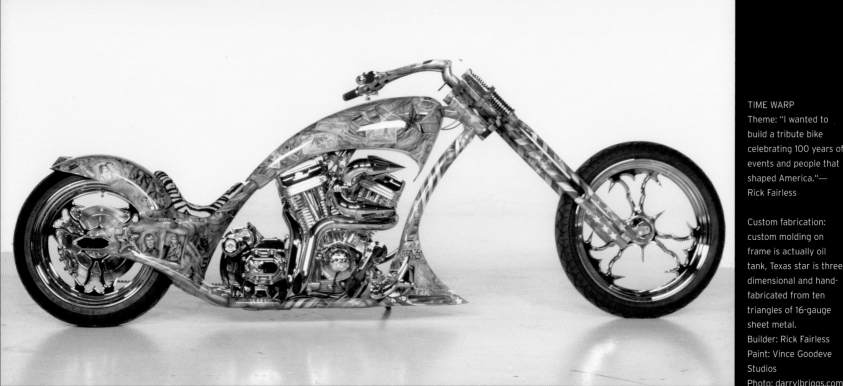

TIME WARP
Theme: "I wanted to build a tribute bike celebrating 100 years of events and people that shaped America."— Rick Fairless

Custom fabrication: custom molding on frame is actually oil tank, Texas star is three-dimensional and hand-fabricated from ten triangles of 16-gauge sheet metal.
Builder: Rick Fairless
Paint: Vince Goodeve Studios
Photo: darrylbriggs.com

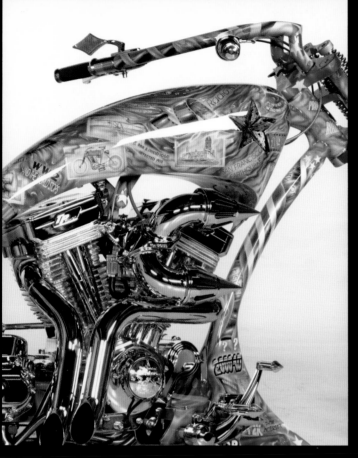

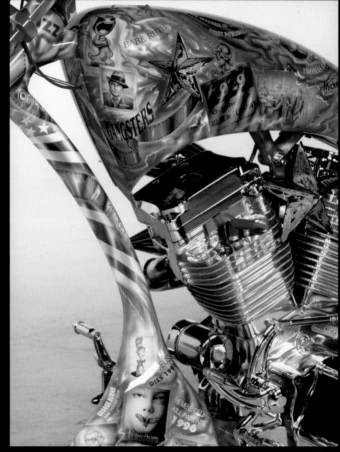

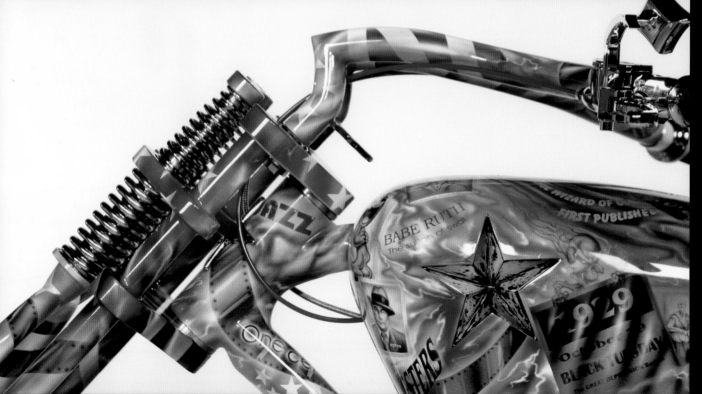

Engine: TP 121 cu. in. (1983cc),
full polish
Air Breather: dual breather
by D&M "The Boss"

Fuel tank has inverted Texas star
made by cutting out the star
pattern and welding in an
inverted version of the ones
found on the fenders and
side panels.

Time Warp is more than 9 ft.
(274 cm) long, with a Springer
front end and 47 degrees of rake.
Regulator and headlights are
hidden in the front air dam.

Handlebars are hand-fabricated
to Rick Fairless's specifications.
"Bike is a joy to ride and turns
heads wherever I go. I love the
Springer front end, 'cause I'm
old-school and that's the way
we build 'em."—Rick Fairless

PSYCHEDELIC CHOPPER

"The Psychedelic chopper was one of my early builds and I recently sold it to my big-shot brother the lawyer. He keeps it in the lobby of his high-dollar office building. I didn't want to part with it but he had to have it"—Ric Fairless
The Psychedelic Chopper is painted with a '60s theme by Vince Goodeve studios. Vince is an airbrush artist from Ontario, Canada. Paint scenes include all things '60s: JFK's portrait, as well as Marilyn Monroe, Rat Fink, Helter Skelter, The Beatles, Woodstock, Charles Manson ... the list goes on.

Year: 2001
Fabrication: Rick Fairless's Strokers Dallas
Frame: Daytec
Rake: 46 degrees
Stretch: 8 in. (20 cm) up/3 in. (7.5 cm) backbone
Forks: 12 in. (30 cm) Over/Rolling Thunder
Engine: TP Engineering 121 cu. in. (1983cc)
Transmission: Baker
Carburetor: S&S Super G
Wheels: RC Components
Rear Tire: 250
Paint: Vince Goodeve
Theme: '60s
Color: All of them
Custom fabrication: custom molding on frame
is actually oil tank. Texas star is three-dimensional
and hand-fabricated from 10 triangles of 16-gauge
sheet metal.
Owner: Randy Fairless
Photo: darrylbriggs.com

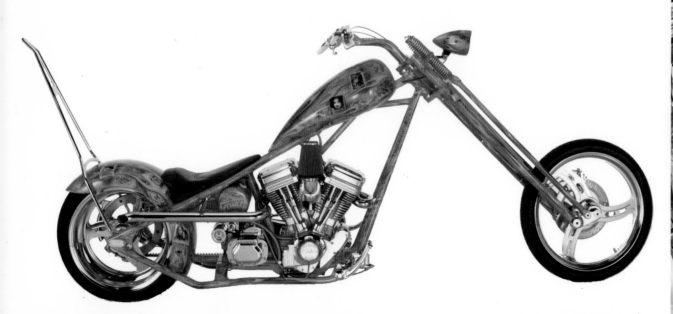

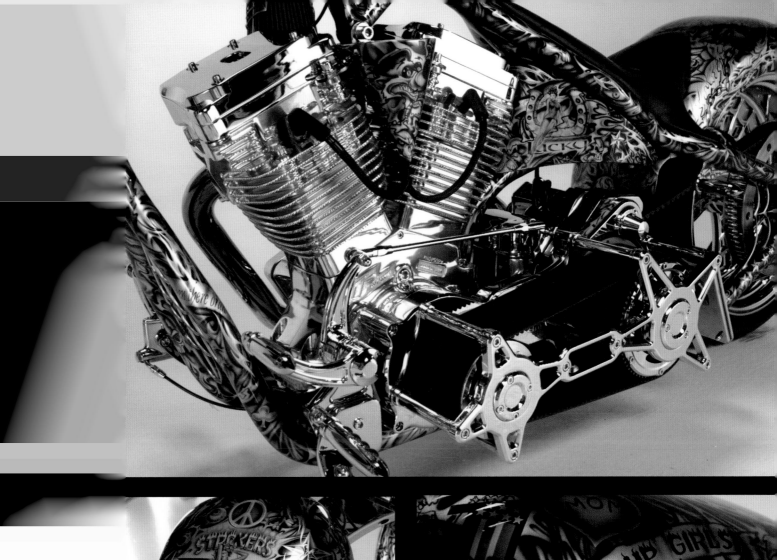

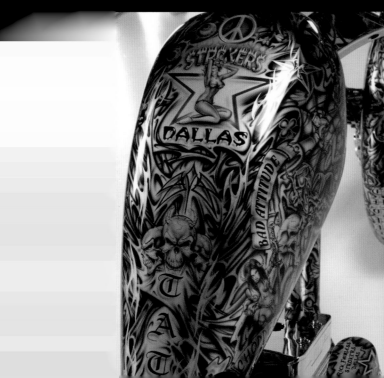

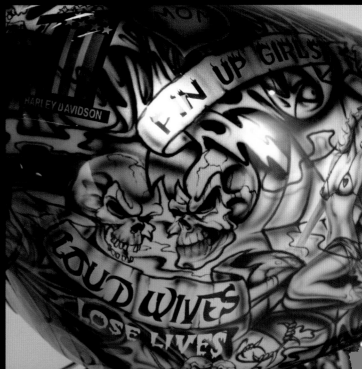

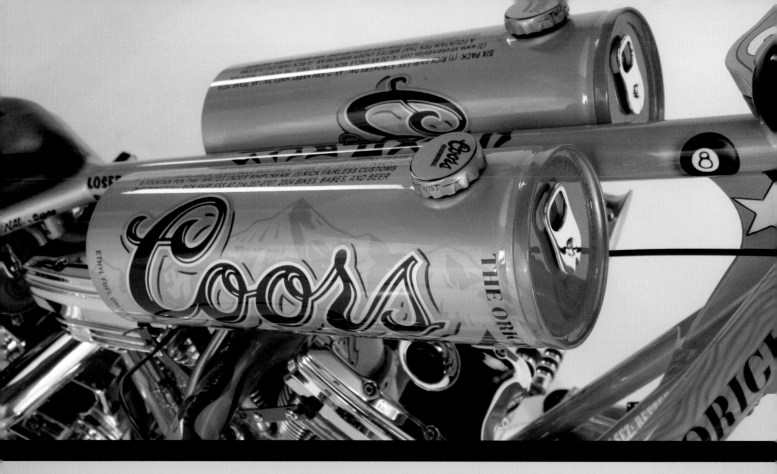
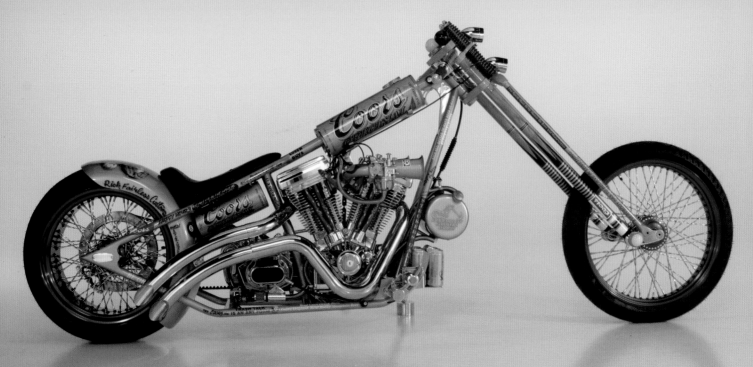

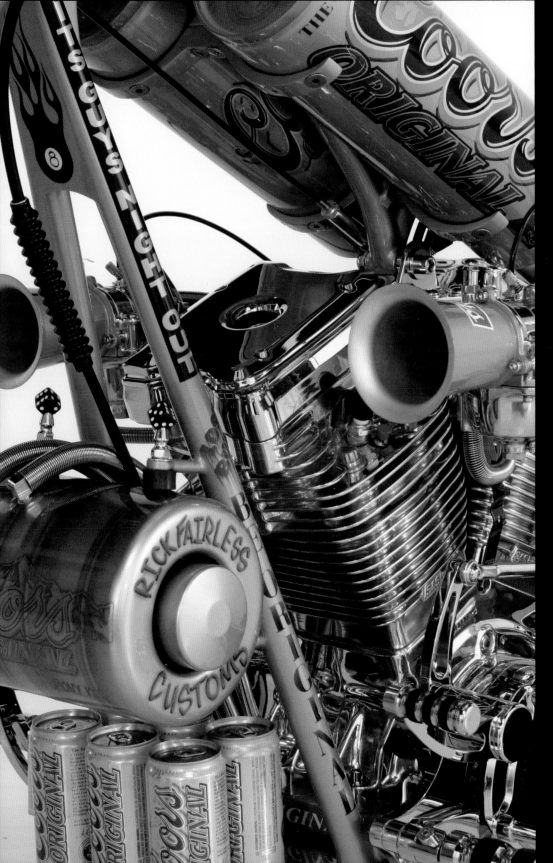

COORS BIKE PROFILE
Model: 2004 rigid chopper
Build time: 60 days
Fabrication: Strokers Dallas
Assembly: Strokers Dallas
Frame: 3 in. (7.5 cm) up, 2 in. (5 cm) back
Front end: Rolling Thunder—Springer
Rake: 43 degrees
Engine: S&S 113 cu. in. (1852cc)
Primary: Hi-Tech
Transmission: Terry Components
Carburetor: Terry Components—dual S&S
Ignition: Crane Hi-4
Exhaust: Sampson
Wheels: Black Bike
Paint: Other Side Customs—Gary Queen
Photo: darrylbriggs.com

Gas tanks are made from 5 in. (13 cm) aluminum tubing fabricated to look like beer cans. Tabs are made from aluminum plate and bottom of can made from recycled derby cover to replicate the reverse dome of the bottom of a can. Beer caps are made from aluminum plate die-ground to emulate a real beer cap.

Oil supply tank is painted to replicate a pony keg. Oil filter screws into oil reservoir. Carburetor mounts are actually bottle openers. Air breather intakes are painted to look like cool cupholders.

Cans under seat are in fact the battery/ electronics box. Springer forks are painted to imitate pool cues. Actual pool balls are cut in half and mounted in various locations. Wheels, valve guide covers, carburetor mounts, and Springer springs are candy powder coat over chrome.

Ron Finch has been building custom motorcycles since 1965, when he opened Finch's Custom Styled Cycles. For forty years, his professional career has been devoted to designing, building, and painting customs in his own unique style.

Finch has a distinctive gift for metal fabrication and engineering. In his desire to accentuate the magnificence of the motor, he has been known to relocate the gas tank to the rear fender, the saddlebags, or even the floorboards. Many of his creations include smooth sculpting of the sheet metal and intricate rodwork.

Ron continues expressing his art with his world-renowned mastery of paint. His custom motorcycles have been featured in hundreds of magazines, in several art museums, and in shows throughout the US and abroad.

The focus of Ron Finch has always come from the perspective of "art in motion." His ability to fuse together artistic design, brilliant paint, and functionality establishes him as one of the premier builders of our time.

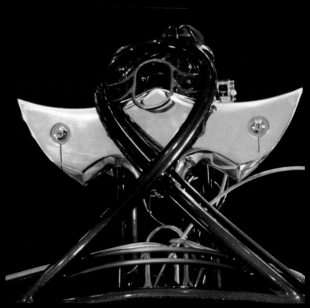

Left Double-Cross handlebars

Below left Double-Cross exhaust

Below Aorta heart air cleaner with many steel arteries
Aorta photo: Ruth Finch

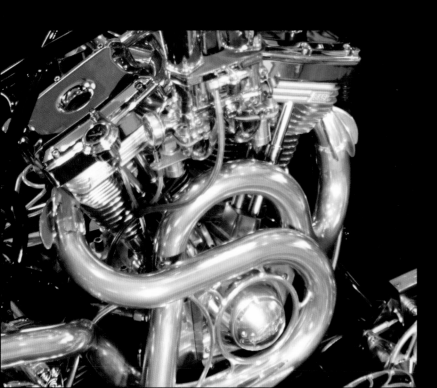

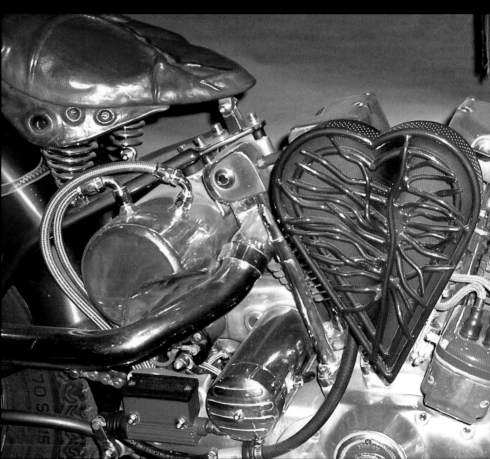

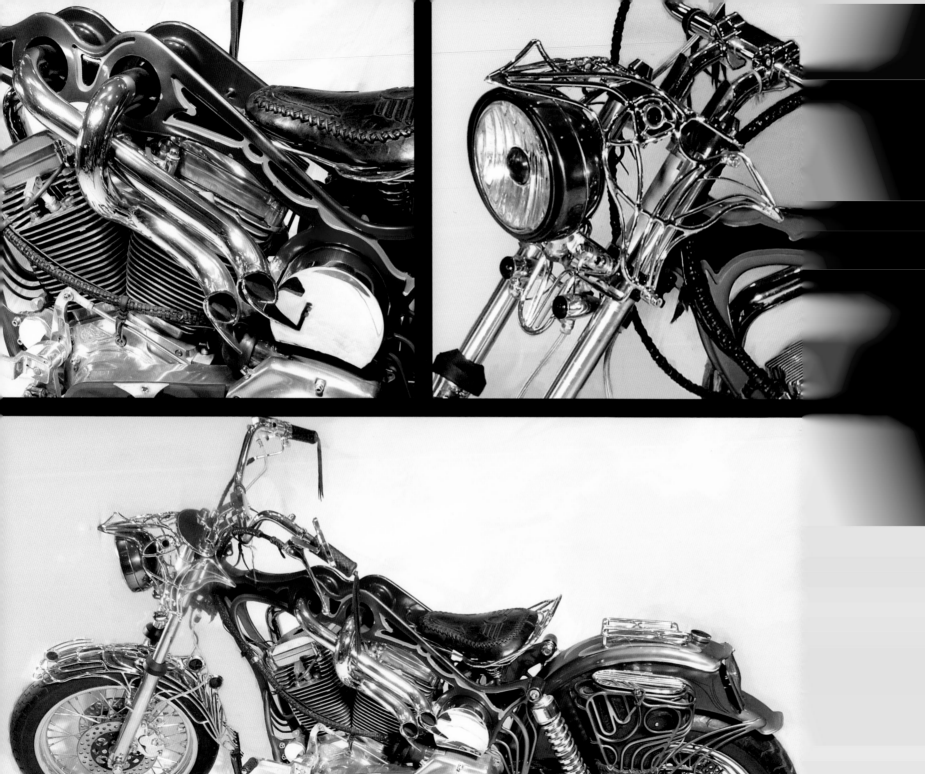

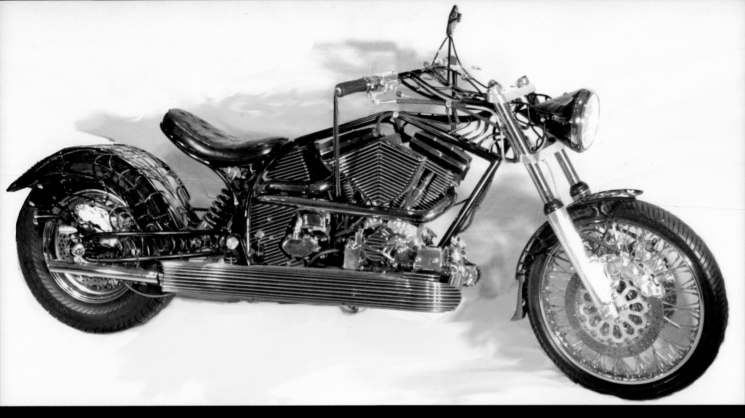

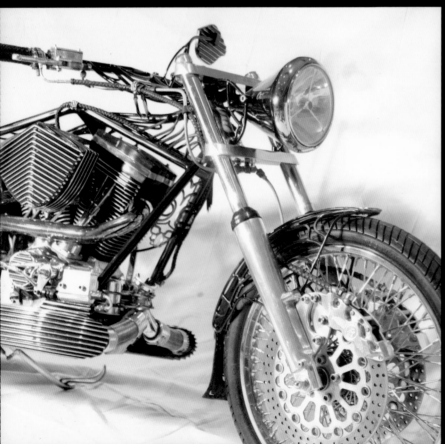

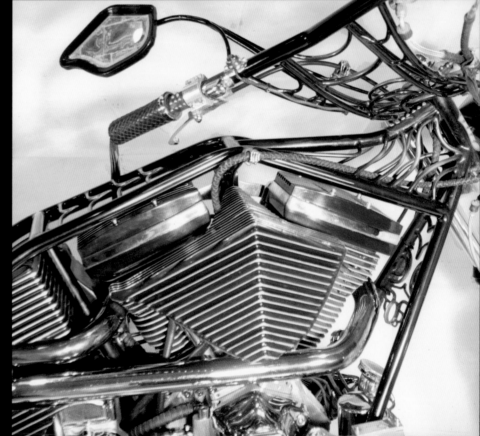

OUTSPOKEN
Industrial-style machine with a 96 cu. in. (1573cc) motor. Extruded aluminum floorboards are used for the gas tanks and exhaust guards.
Builder: Ron Finch

Martin Bouchard, known as "Fitto," lives in Montreal. He has
been working with airbrush for fifteen years. He studied art
in college and took welding lessons, and went on to airbrush
other people's things. In the early 1990s, after only two weeks
of experience, Fitto was hired at a rock shop, where he
painted leather jackets, including jackets for band members
of Iron Maiden and Metallica.

After this he devoted himself to creating paint jobs for
custom bikes. Fitto's painting has always been hardcore
compared to the fashions espoused by most painters. All of
his work is created freehand. His work has been featured at
shows and in magazines and has won the VQ Award. Fitto has
inspired a number of other artists.

Bike: Concept Design Cycles. Molding: Yves Showpaint. Paint: Yves Showpaint.
Airbrush: Fitto

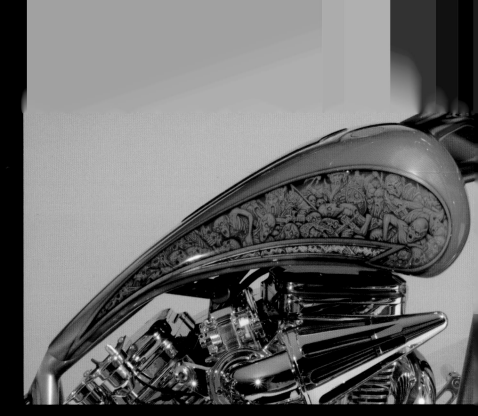

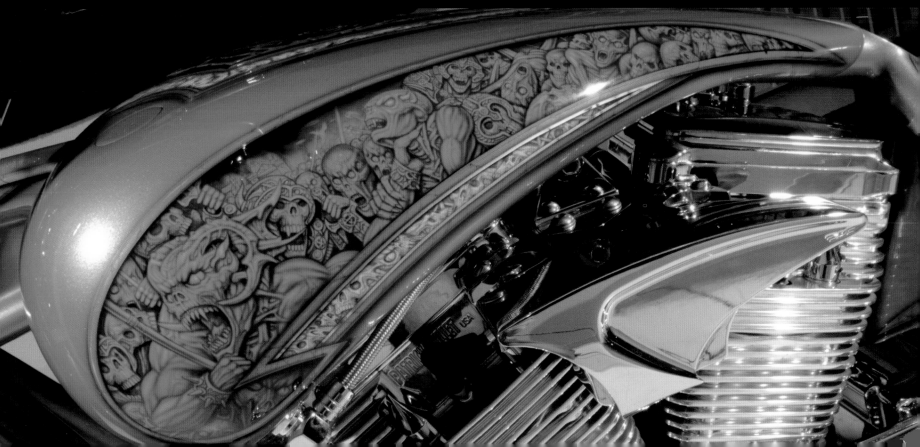

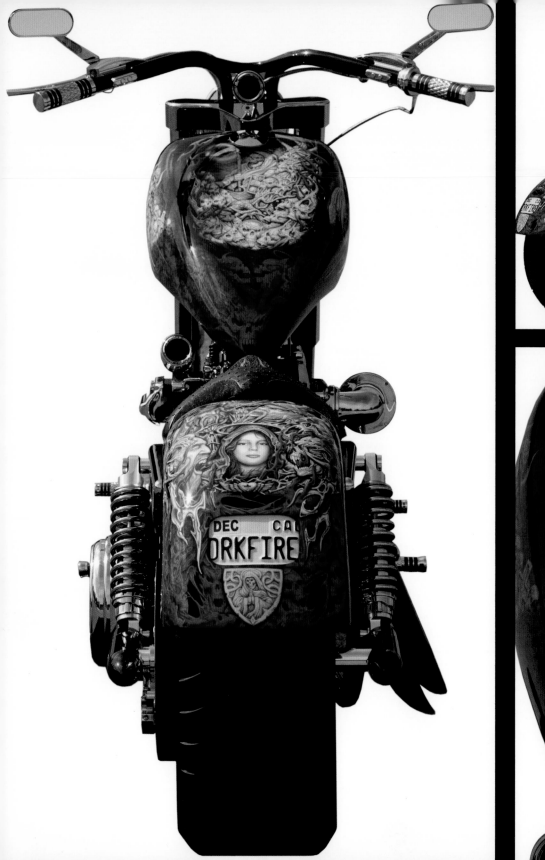
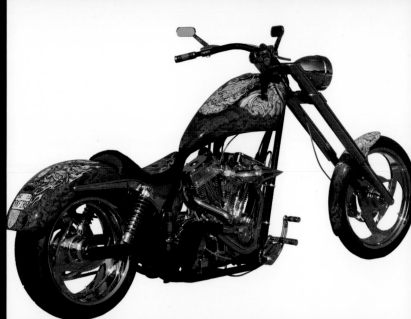
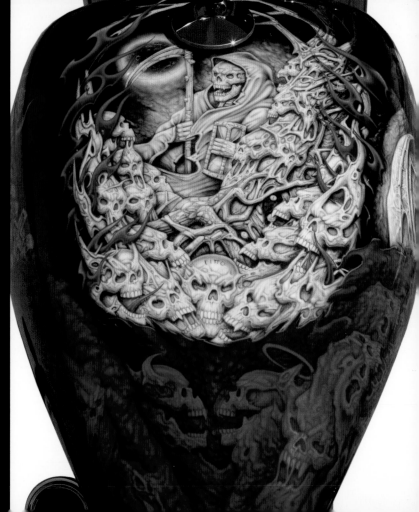

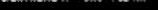

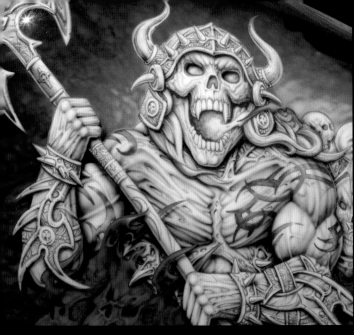

ARLEN NESS 2004 Y2K
Builder: Arlen Ness and Tim Stanton
Metal fabrication: Arlen Ness. Embedded rear tail light and turn signals in rear fender. Custom tank
Rake: 42 degrees
Engine: S&S 124 cu. in. (2032cc)
Rear tire: 250 Avon
Paint: Fitto
Theme: Seven hand-painted murals telling the story of a struggle between good and evil
Owner: Patrick Reichenberger, Half Moon Bay, California
For questions contact: Patrick Reichenberger at patrick_reichenberger@yahoo.com
Photo: Charlie Couch and Jim Fryhling

See also photographs on next page

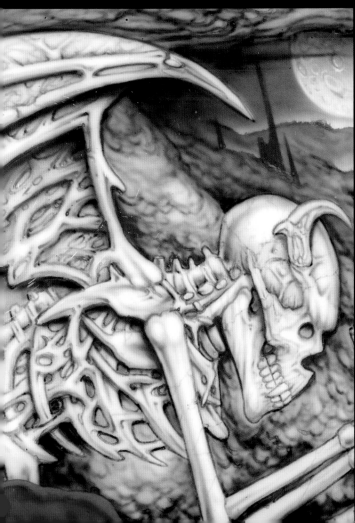

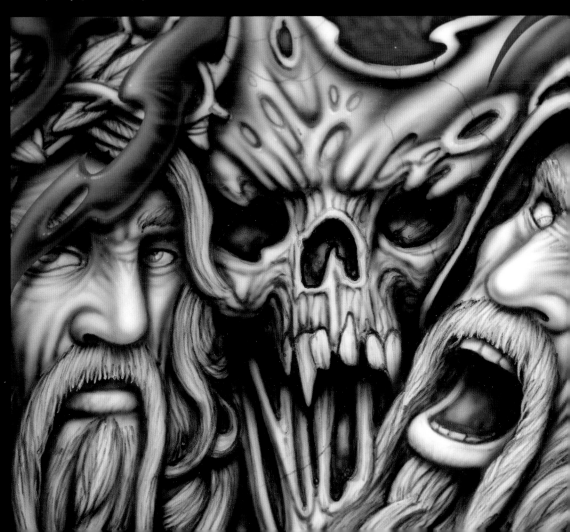

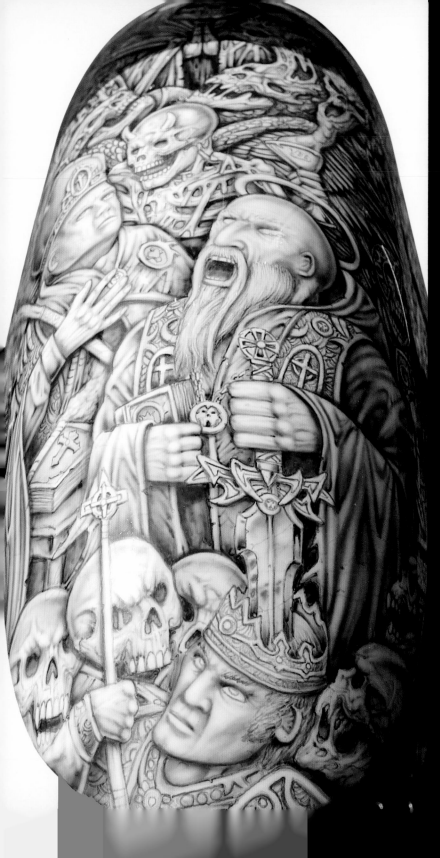

A customer in California asked me to make him something depicting good and evil. He asked only that my painting be morbid and strange and to use blue as the main color.

CONSPIRACY

So I attack the front fender, drawing something I see in my head. It's an hysteric monk, illuminated not by God but rather by madness, who drives a sword into his king's head. Then higher, one sees the Pope in fright holding a medallion shaped as a $ sign with his Bible emanating a fog of demon angels. We see him semi-conscious listening to a demon's advice whispered to him in his ear on how to appease his thirst for dominance and control over humanity. The demon holds in his left hand a cup of blood as an offering to seal the agreement with the head of the Church.

THE COMING OF A PROPHECY

On the right-hand-side tank, the same winged demon brings back the evil cup to a decomposed virgin dressed in a cloth.

THE WARRIOR'S FURY AT THE GATES OF HELL

On the left tank one sees a death warrior contrasting with the blue storm surrounding it.

FALLEN ANGEL

On this part, which is the oil tank, I didn't take a photograph of the finished product, which was a demon in water up to his waist looking at his reflection which instead of being his own is one of a fallen angel in decomposition praying.

DEAD RODENTS

On the back wing, one sees the angelic face of a young woman, surrounded by dark spirits starving for purity. Emerging from dark abysses, they try to impregnate themselves with her light.

FATALITY

On the tank, death with a sand glass symbolizing time, at its left a tree that symbolizes life. The tree is made from the skulls of tormented souls from the roots to the top. The harvester of lives stands surrounded by a beautiful garden of skulls to remind us that we will all be ripe for the picking when our time comes.

COVERING MOST OF THE BIKE

I drew angels and demons whose faces spin in a tornado of blue heads mixing up in a cloudy fog of basic ocean tones that submerge the borders of each black-and-white trim on the motorbike. I slipped the blue flame tips between the faces on the back fender to get a better harmony of the masses.

The customer, Patrick Reichenberger, is very satisfied; he told me that it was even better than he ever imagined it would be.

Seat: Alligator Bob
Seat tattoo: hand-sewn stingray, full quill ostrich, blue stingray accents, kangaroo-skin hand-lacing

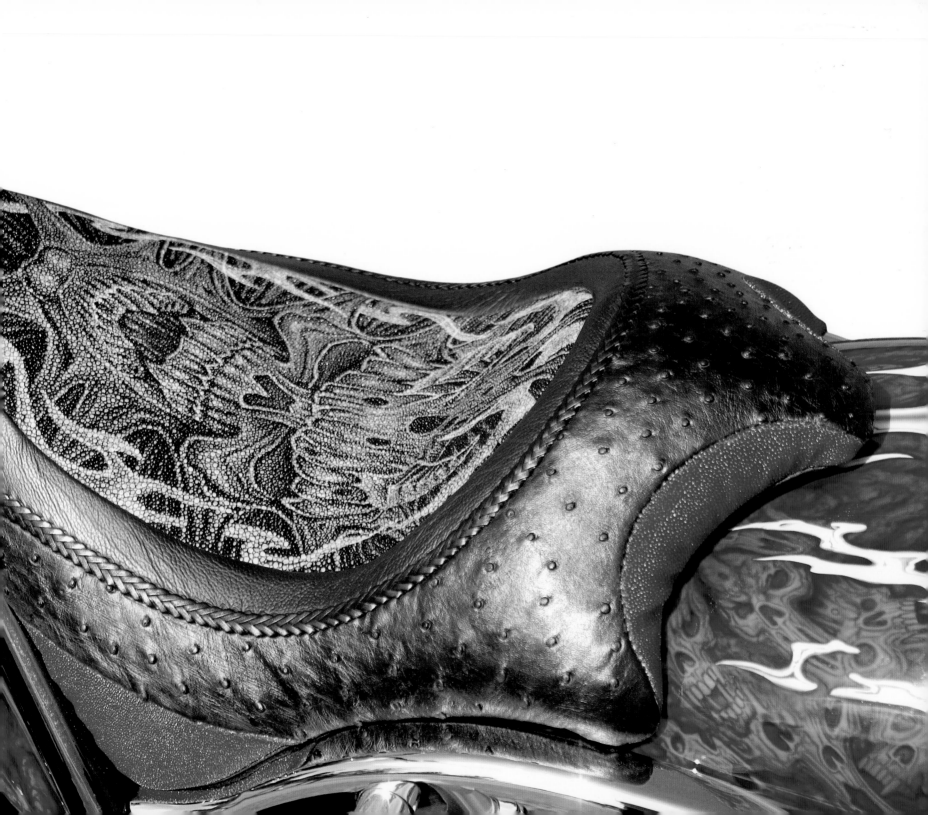

FOUR HORSEMEN

Four Horsemen Motor Company was started in June of 2002 by Steve Raymond and Robin Casper. Steve has been building and working on motorcycles for more than thirty years, and Robin for nearly twenty. Steve and Robin aim to give people what they want, rather than building identical motorcycles. All of their machines are custom, and their paint jobs are never duplicated. For not much more than the cost of a stock motorcycle an individual can be riding a one-off custom bike.

All photos: Robin Casper

Fabrication: Four Horsemen Motor Company
Frame: 8 up 5 out rigid
Motor: 100 cu.in. (1640cc)
Transmission: 6-speed
Wheels: Weld Racing wheels with 250 rear tire
Paint: Jay'z Custom Paint
Owner: Pat Launder

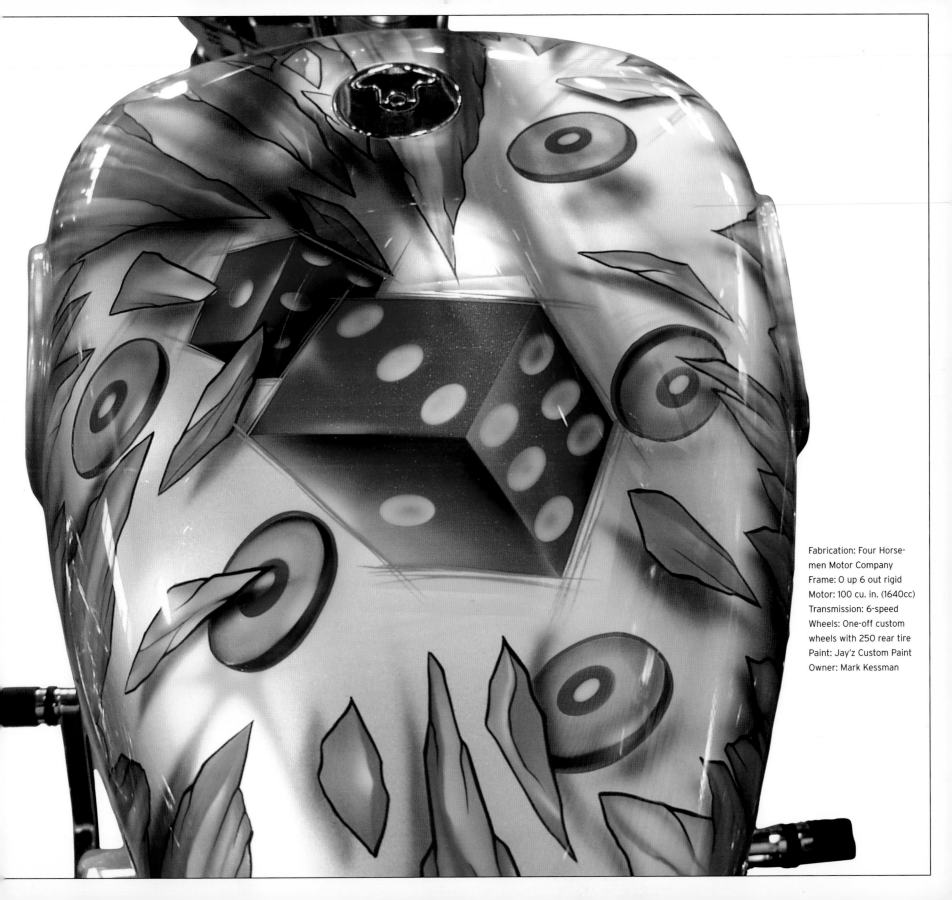

Fabrication: Four Horse-
men Motor Company
Frame: 0 up 6 out rigid
Motor: 100 cu. in. (1640cc)
Transmission: 6-speed
Wheels: One-off custom
wheels with 250 rear tire
Paint: Jay'z Custom Paint
Owner: Mark Kessman

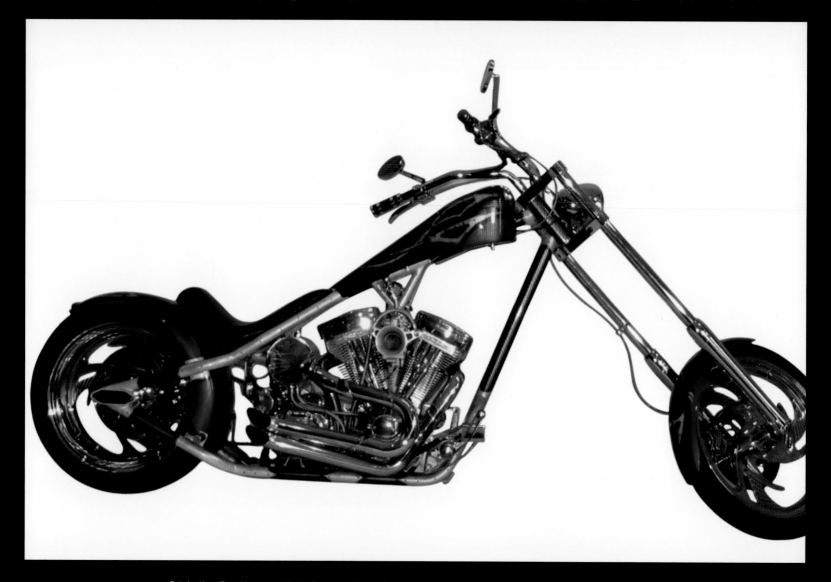

Fabrication: Four Horsemen Motor Company. Frame: 8 up 5 out rigid. Motor: 100 cu. in. (1640cc). Transmission: 6-speed.
Wheels: Carriage Works Riptide wheels with 250 rear tire. Paint: Jay'z Custom Paint. Owner: Mike Holder

Fabrication: Four Horsemen Motor Company. Frame: 4 up 6 out rigid. Motor: 125 cu. in. (2050cc) Patrick Racing motor. Transmission: 6-speed. Belt drive: BDL Top Fuel open belt drive. Wheels: RC Components Wicked wheel with drive-side brake, with 250 rear tire. Paint: Jay'z Custom Paint. Owner Steve DelBorrell

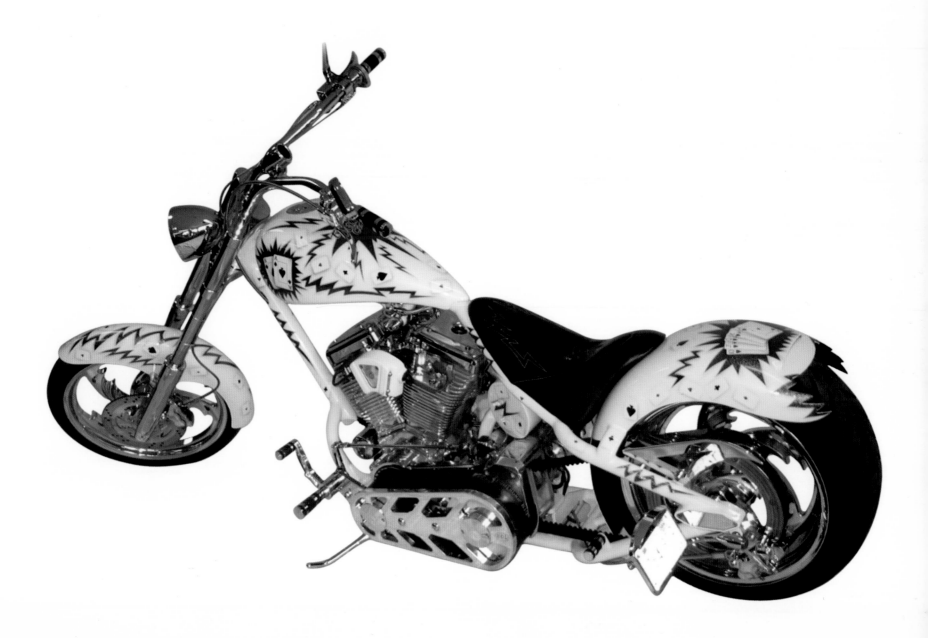

VINCE GOODEVE

Vince was born with a pencil in his hand—very uncomfortable for his loving mother. From the age of five he was drawing with his father and learning the trade in his grandfather's sign shop. Loving hot rods and motorcycles since he was a kid, it was a natural progression to end up (for now) with steel canvases as his mainstay. But it was a long and bumpy road of body shops, art schools, and a million odd jobs for Vince to reach the point of doing custom paint and airbrush work full time in the mid-1990s. "The best part about learning the trade on my own," says Vince, "is not depending on anyone for any part of the projects. Lock me in a room with the sheet metal and frame as well as my tools and materials and I'll emerge with the finished project that I can guarantee from the ground up."

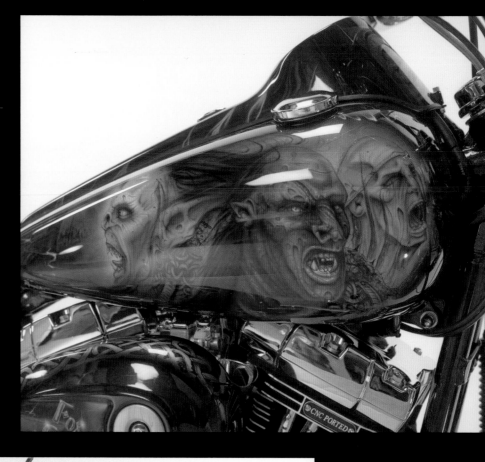

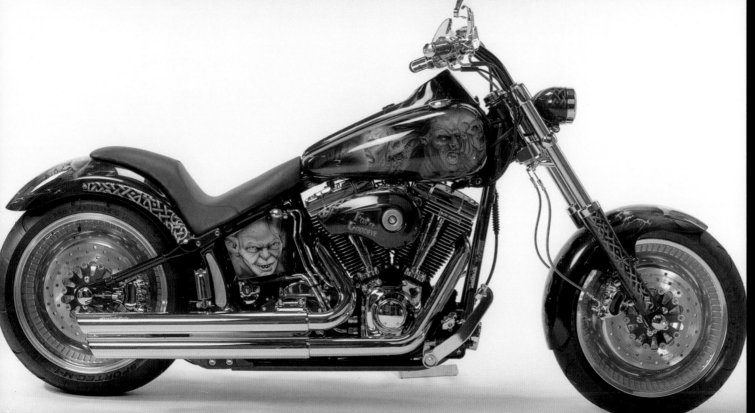

LORD OF THE DEUCES
This project is probably the first of many with the Fox Harley-Davidson/Dan Metzger team. They approached me with a highly modified 2003 H-D Deuce, 103 cubic inch, 110 hp Monster. They installed Screamin' Eagle performance parts to achieve this, and then just threw a big slab of rubber on the front and back.

Year: 2003
Model: Deuce
Engine: 103 cu. in. (1688cc), 110 hp
Wheels: Type modified HD, 17 in. front and rear
Tires: rear 200/50-17, front 150/60-17
Builder: Dan Metzger/Fox Harley Davidson
Paint: Vince Goodeve
Color: Vince's Custom Blends, PPG Global Line
Owner: Randy Fox
Photo: Charles Van den Ouden

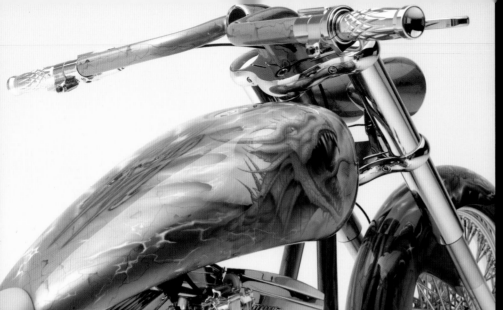

9 DRAGONS

Theme: Yin and Yang, nine dragons, which means good luck (four evil and five good). The graphic on the top portions of the bike represents a stylized number nine in Chinese calligraphy. The dragons also symbolize human emotion, anger, joy, nobility, wisdom, and so on. The bats on the swingarm also represent good luck opposed to bad luck.

Motor: Merch 131 cu. in. (2147cc)
Frame: Rolling Thunder—Softail,
Rake: 36-degrees, 4 in. (10 cm) out, 2 in. (5 cm) up
Wheels: Hallcraft
Fenders: Fat Katz—Full Blanks, cut by RNR Custom Cycle Ltd
Tank: Fat Katz
Builder: RNR Custom Cycle Ltd
Paint and molding: Vince Goodeve
Colors: Vince's Custom Blends, PPG Global Line
Owner: Jerry Norskog
Photo: Ashley Ranson

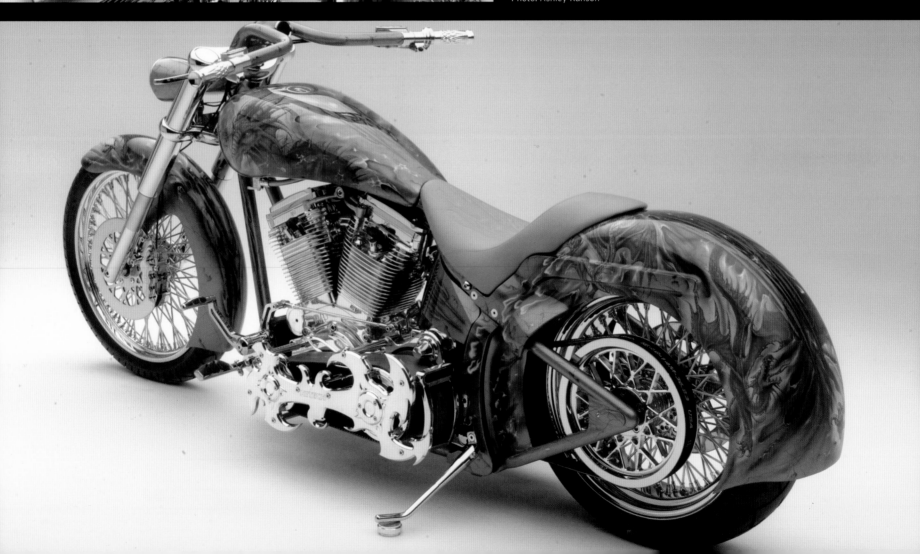

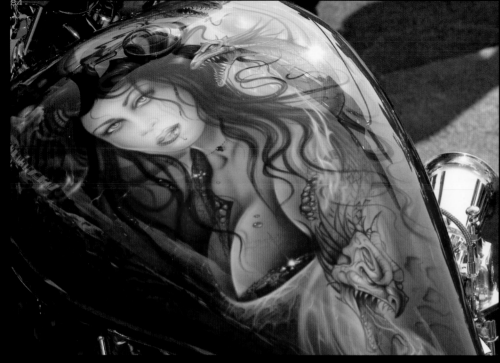

MEDUSA

Medusa theme with a series of evil reptilian images in opposition to human beauty and courage. The deep coppers and the sepia tones give the bike a very ancient and majestic feel. The dragon-scale texture on the bike and the ancient ruins carved into it by Goodeve serve to amplify its mystery.

Year: 2003
Model: special construction
Frame: Diamond Chassis/Metal Rebel Customs
Engine: 124 cu. in. (2032cc)
Wheels: front 21 in., rear 18 in.
Tires: Metzeler
Builder: Jimmy Bullard/Kerry Love/Metal Rebel Customs
Paint: Vince Goodeve
Colors: Vince's Custom Blends, PPG Global Line
Owner: Kerry Love
Photo: Ryan Photography

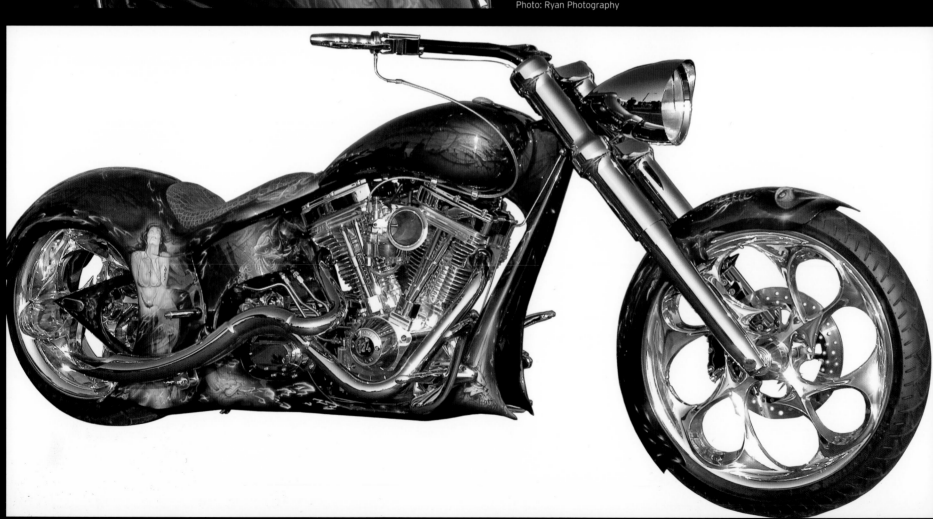

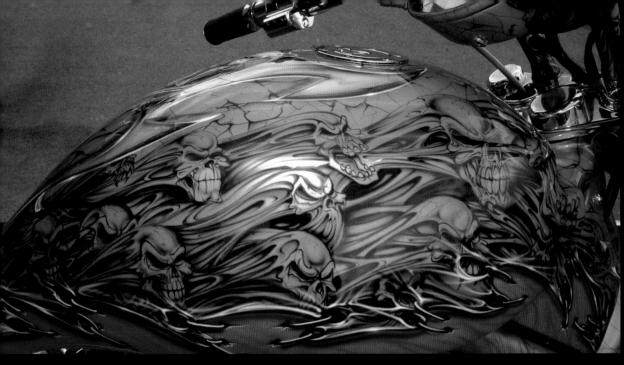

V-ROD SEA OF SKULLS
Year: 2002
Model: VRSCA
Frame: Stock HD
Engine: Stock HD
Wheels: PM
Molding and paint: Vince Goodeve
Colors: Vince's Custom Blends, PPG Global Line
Owner: Kenny Price/Samson Exhaust

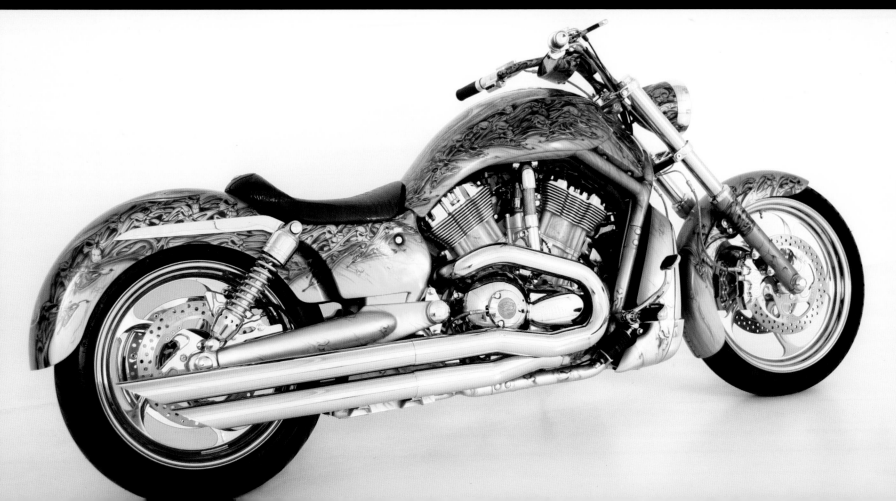

About five years ago, Dany and Thomas Habermann met Bianca Hennig at a custom bike show. In 2002 they collaborated for the first time on the Skull project. One year later this was followed by the Sin project. Both Skull and Sin were very successful at the Daytona bike week and at other bike events. Thomas Habermann is one of the top men of the German custom bike scene. He creates breathtaking sculptures from sheet metal and lead. Those sculptured shapes are emphasized by Bianca's airbrush work. Dany, executive manager at Habermann-Performance, and Bianca have the same preference for skulls and bones, as evidenced by some of their combined efforts.

2002 chassis and metalwork: Habermann-Performance
Engine: HD-twin-cam, 103 cu. in. (1690 cc)
Chromed design and custom paint: Bianca Hennig
Photo: Habermann-Performance

CALIGO BIKE Fork: SJP Netherland Fat Glide 18 in. (46 cm) over handlebar by Habermann-Performance. Handlebar controls: OMP Italy. Photo: Habermann-Performance

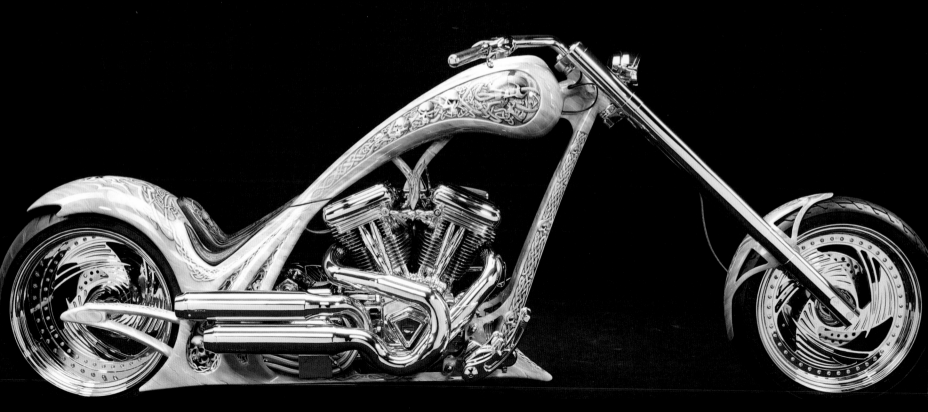

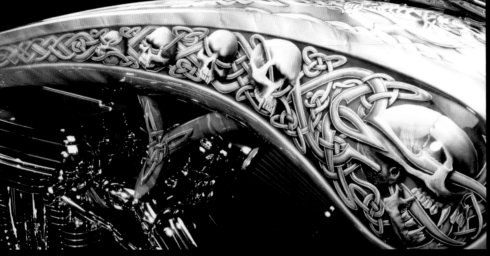

2002 hand-crafted gas tank with Celtic artwork, specially created by Bianca Hennig. The clean, sleek, and smooth lines are typical Habermann-Performance style.
Owner: Thomas Habermann
Photo: Habermann-Performance

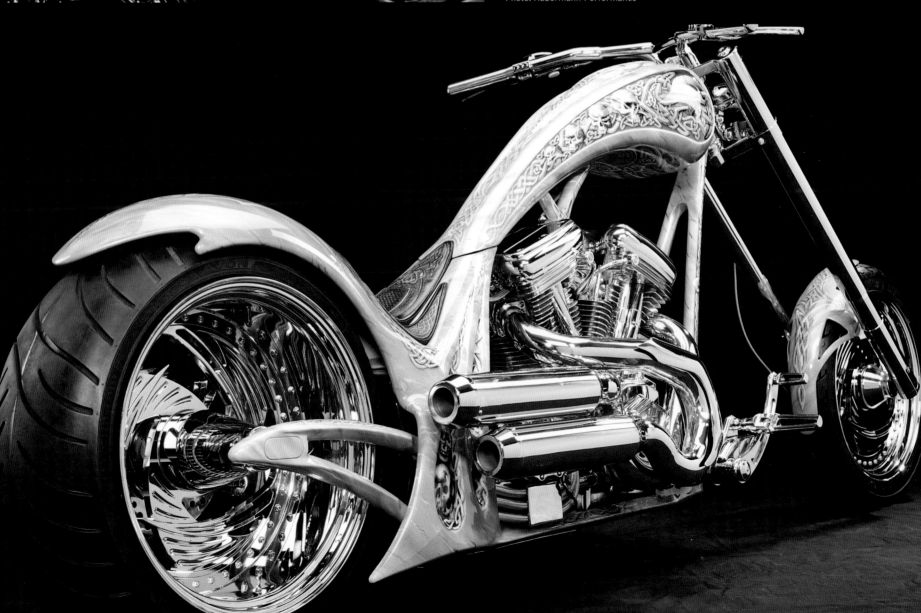

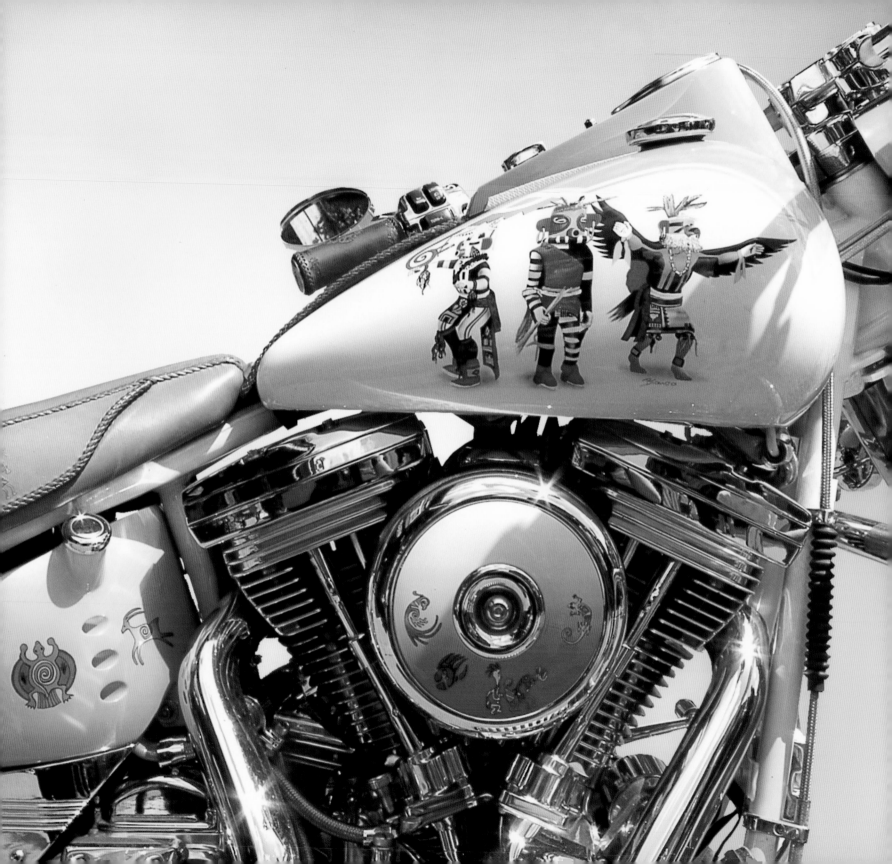

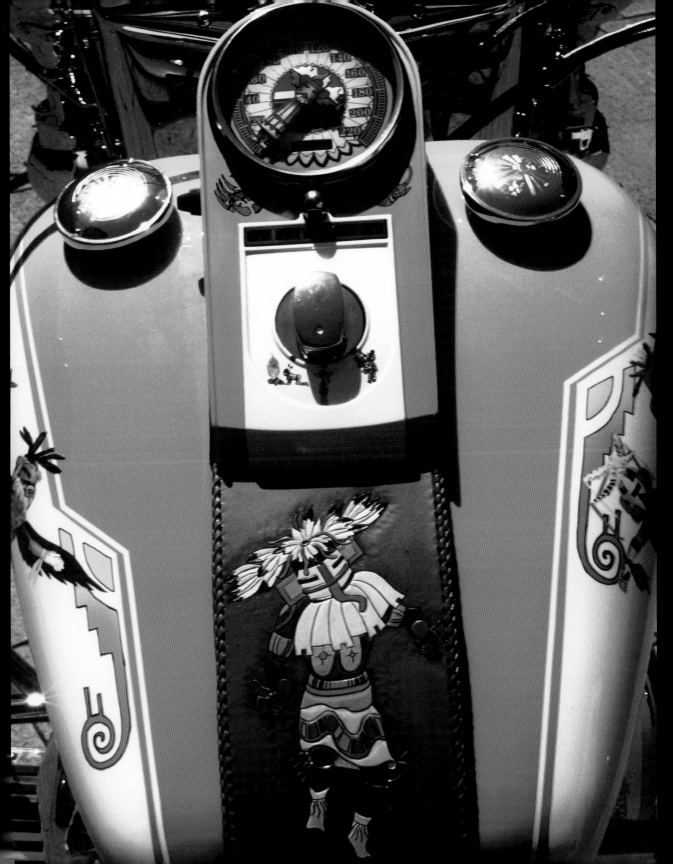

Opposite page 1999 HERITAGE SOFTAIL
Design and Native Indian artwork created
and painted by Bianca Hennig
Owner: Peter "Acoma" Hölzl

Left 1999 HERITAGE SOFTAIL
Stock tank
Leatherwork: Acoma design
Custom paint: Bianca Hennig
Owner: Peter "Acoma" Hölzl

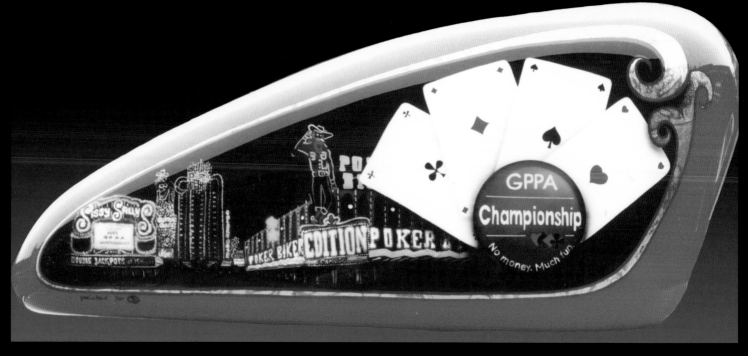

Right
1999 Sportster tank
Design, custom paint and
gold leaf: Bianca Hennig

Below right
1967 Sportster tank,
antique Greek vase
Design, idea and custom
paint: Bianca Hennig

Below
1996 customized Suzuki
Intruder tank
Design and artwork:
Bianca Hennig

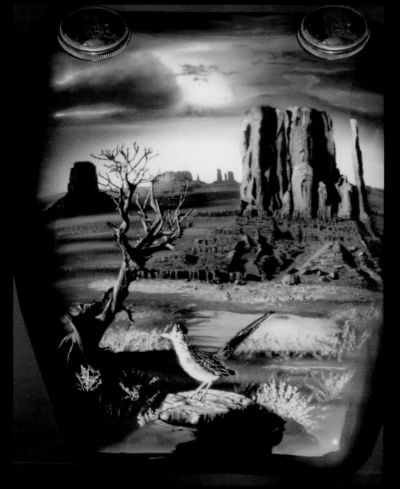

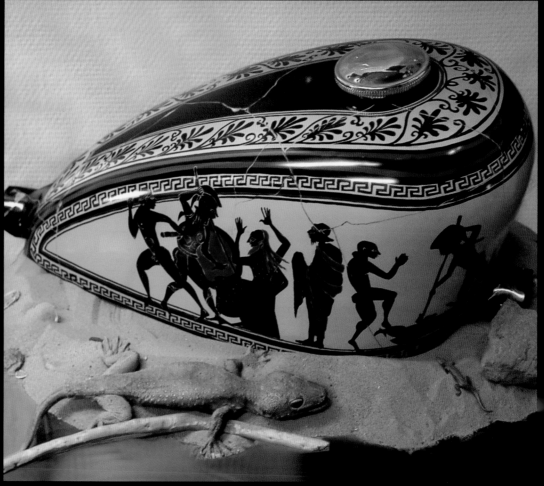

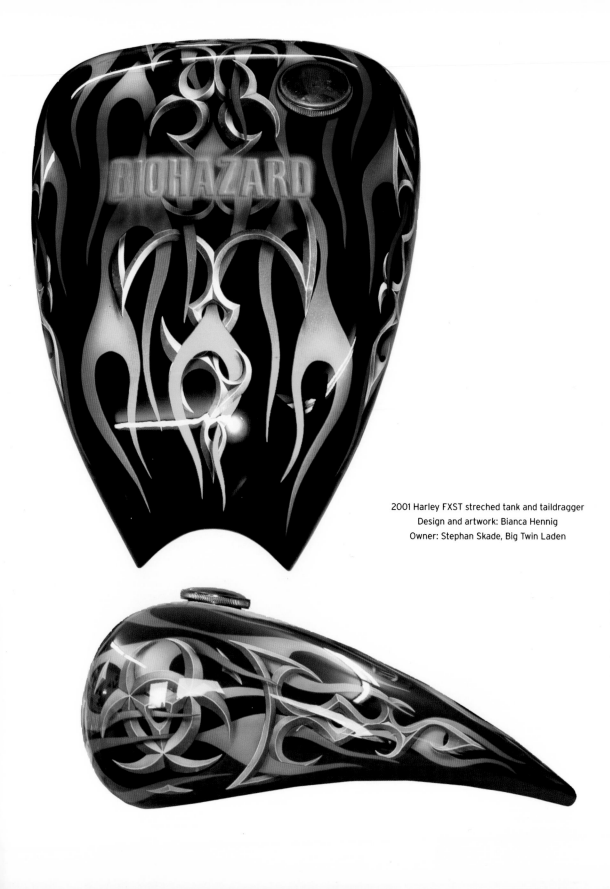

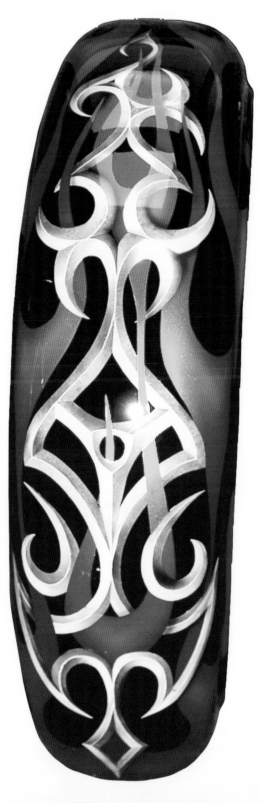

2001 Harley FXST streched tank and taildragger
Design and artwork: Bianca Hennig
Owner: Stephan Skade, Big Twin Laden

CYRIL HUZE

Cyril Huze has a simple and powerful motto: "I will never design and build a bad motorcycle just because somebody could buy it."

Raised in Paris, and working for years in the advertising industry, Cyril had a passion for everything American. He was a part of the first generation of Europeans to be enthralled by American culture: rock 'n' roll, hot rods ... and Harleys.

After moving to the US in the late 1980s, Cyril started customizing his own and his friends' motorcycles, more as a hobby than as a profession. Soon his motorcycles were featured all over the world.

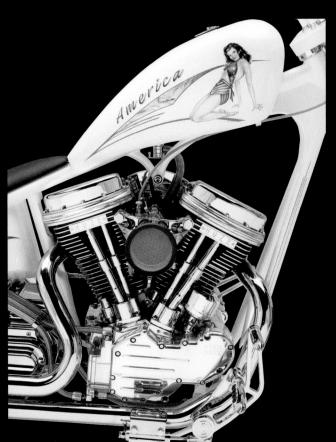

All photos: C.H.C.

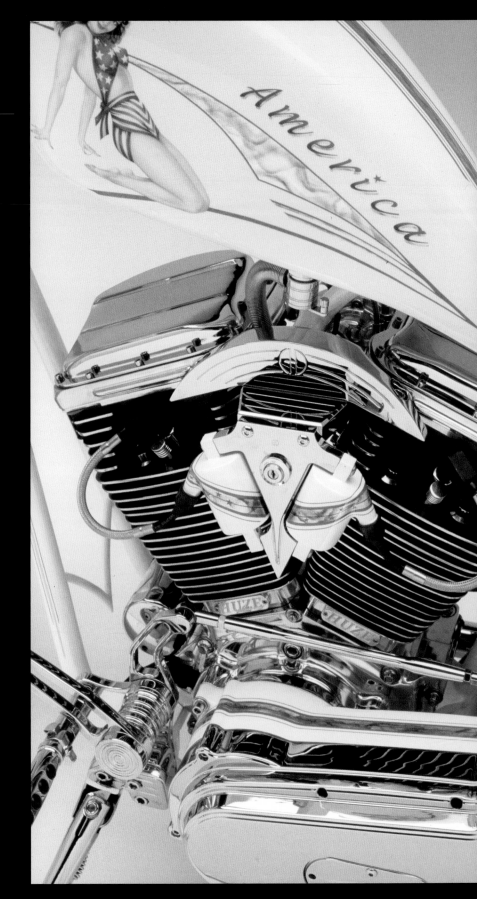

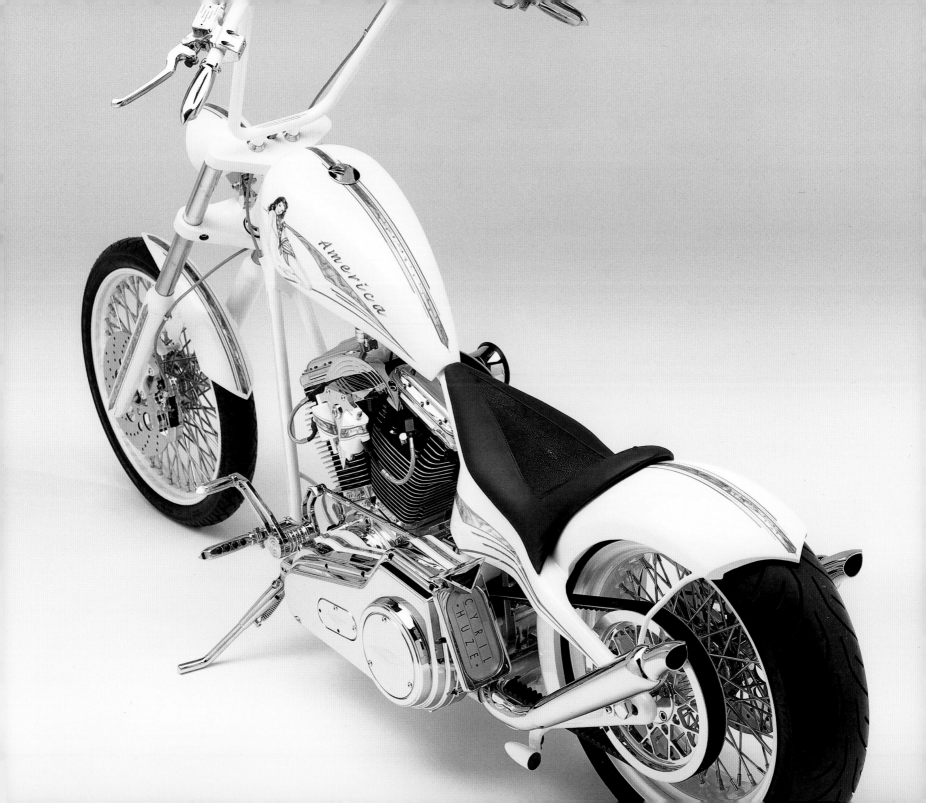

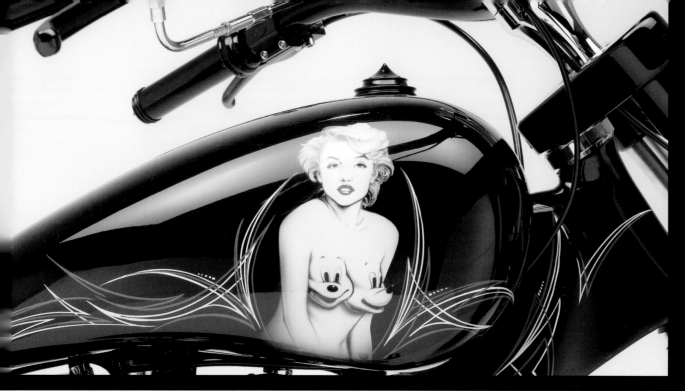

SEXEE

Take a genuine Harley Shovelhead. Strip it, cut it, grind it, and redesign it the way the factory should have done it in the first place. Throw away the ugly and unnecessary parts, then design, reshape, and weld a new body. Of course, keep the beautiful engine. But rebuild it, juice it up, and give it the polishing and black lacquer beauty treatment it deserves. Now she is looking as sharp as she runs. Here's an HD to which Cyril added awesome one-off custom parts, a lot of black anodizing, a touch of bloody red, and a paint job mixing '70s pinstriping with a dose of biker humor. With just a facelift and some heavy body liposuction an old star just got back its irresistible sex appeal.

Design: Cyril Huze
Builder: Cyril Huze
Artwork and pinstriping: Chris Cruz
Owner: Cyril Huze

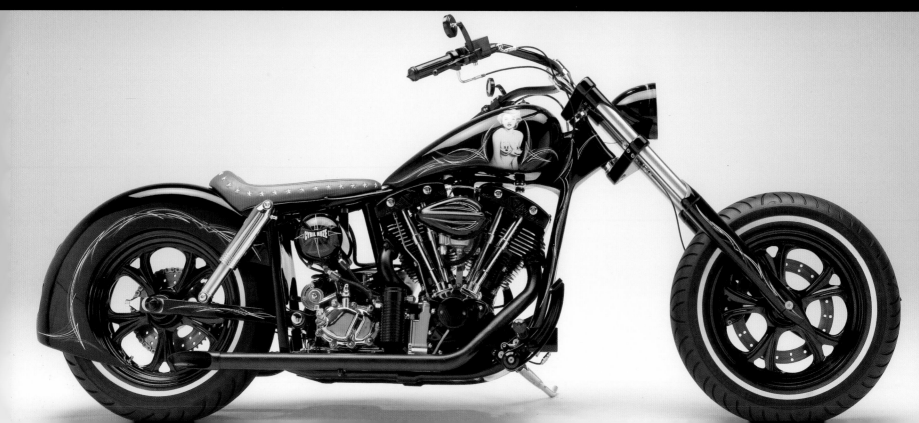

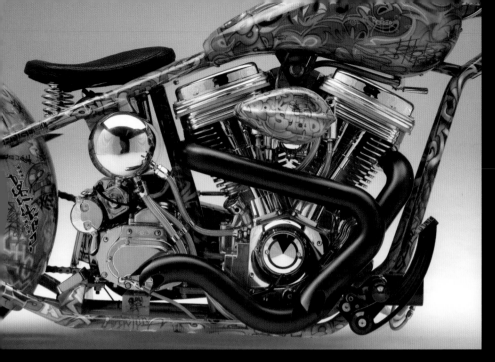

GRAFFITI STREET ART BOBBER

Graffiti is still the only art form where the lifespan of a work can be as brief as hours. As with other non-conventional art forms, some people have a negative point of view on graffiti based on limited or erroneous information. Same with custom motorcycles. Both are innovative and truly original art forms because they allow people to express ideas and share in each other's feelings via the artwork. They are created by artists doing their art for the sake of doing their art. And nobody can seriously challenge the historical relevance of any form of art, be it tagging walls or customizing bikes. This Graffiti Bobber was built to be reminiscent of the late '60s, when aerosol culture was exploding in New York City and when at the same time bikers began to turn bikes into their own pieces of art. Graffiti is Cyril showing his respect to street art, on walls and on wheels.

Design: Cyril Huze
Fabrication: Cyril Huze Customs (Rick Taylor)
Paint inspiration: Cyril in NYC. Paint and graffiti: Chris Cruz
Special paint: Yo, from the Bronx
Owner: Paul Gren

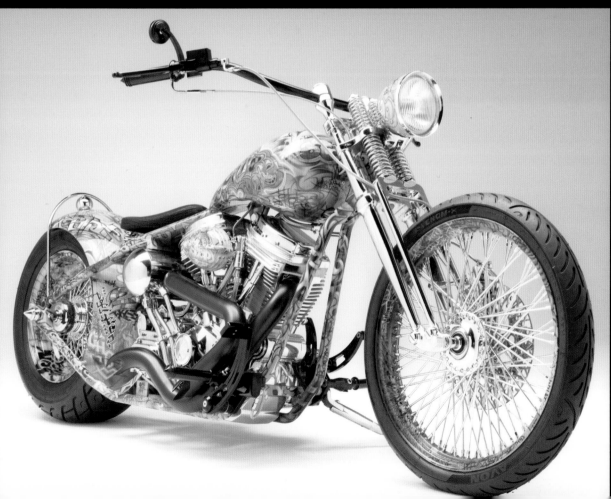

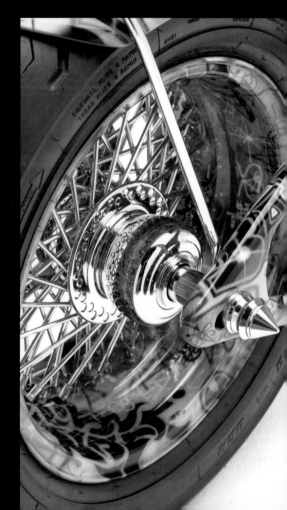

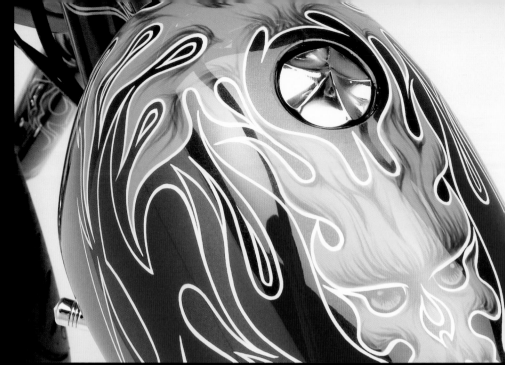

RIPTIDE

A low-slung chopper with dangerous lines and a stream of custom one-off parts, Riptide was built by Cyril with this obsession in mind: how fast could one flow above the asphalt? This is one to blow you away each time you twist the throttle. With a nasty chop job hidden under an elegant dress code, Riptide demonstrates once again how cool is our chopper world. Chop till you drop!

Design: Cyril Huze
Artwork: Chris Cruz

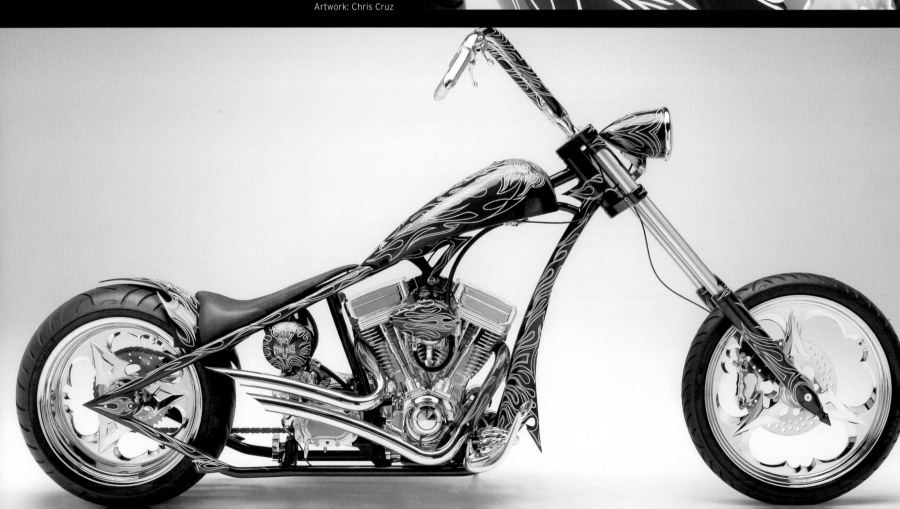

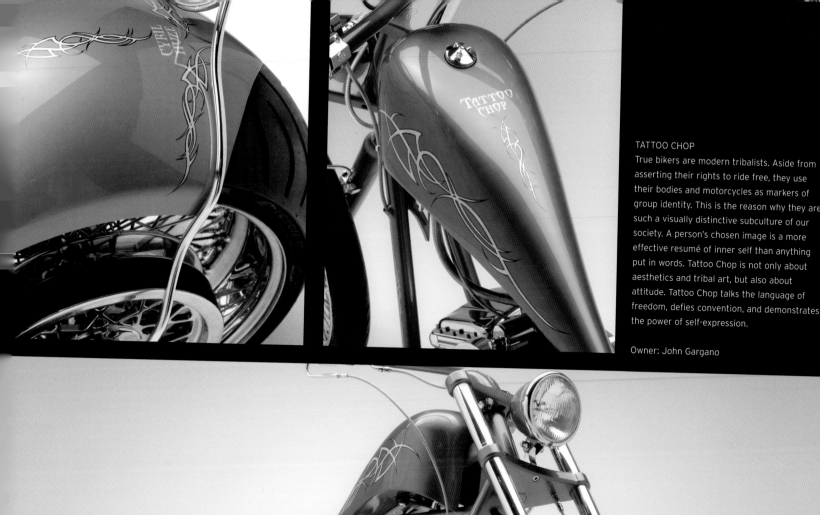

TATTOO CHOP

True bikers are modern tribalists. Aside from asserting their rights to ride free, they use their bodies and motorcycles as markers of group identity. This is the reason why they are such a visually distinctive subculture of our society. A person's chosen image is a more effective resumé of inner self than anything put in words. Tattoo Chop is not only about aesthetics and tribal art, but also about attitude. Tattoo Chop talks the language of freedom, defies convention, and demonstrates the power of self-expression.

Owner: John Gargano

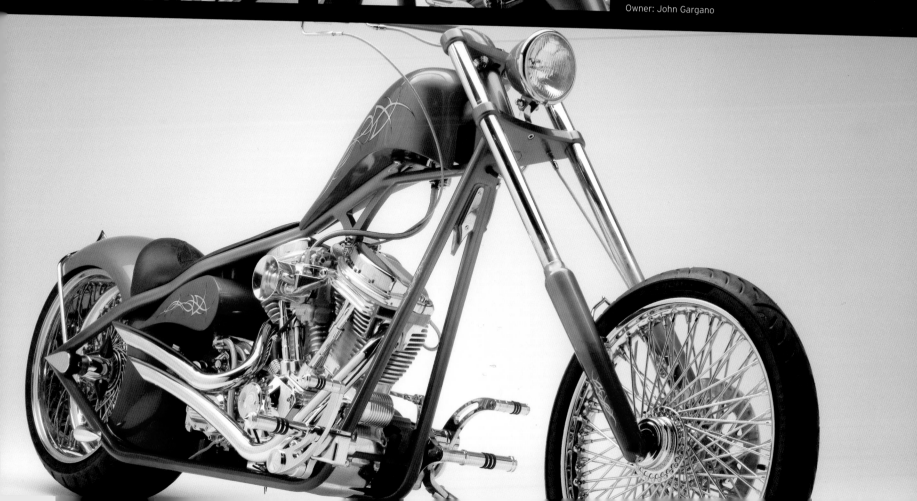

INFINITI CUSTOMS

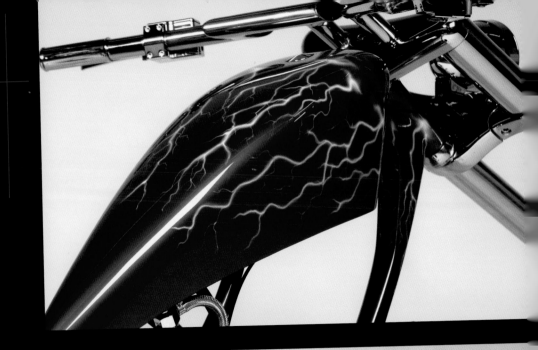

Dean Bauer started off doing fabrication and design when he was sixteen years old, and owned his own hot-rod shop by the age of eighteen. An art major in school, he later took a job working in animation on the *The Simpsons*. After ten years, however, he has come back to the thing he loves most: shaping metal, and painting and building one-of-a-kind custom bikes.

LIGHTNING CHOPPER
Fabrication: Infinity Paint; work done by Zeak
Photo: Robert Kazandjian Kazphoto.com

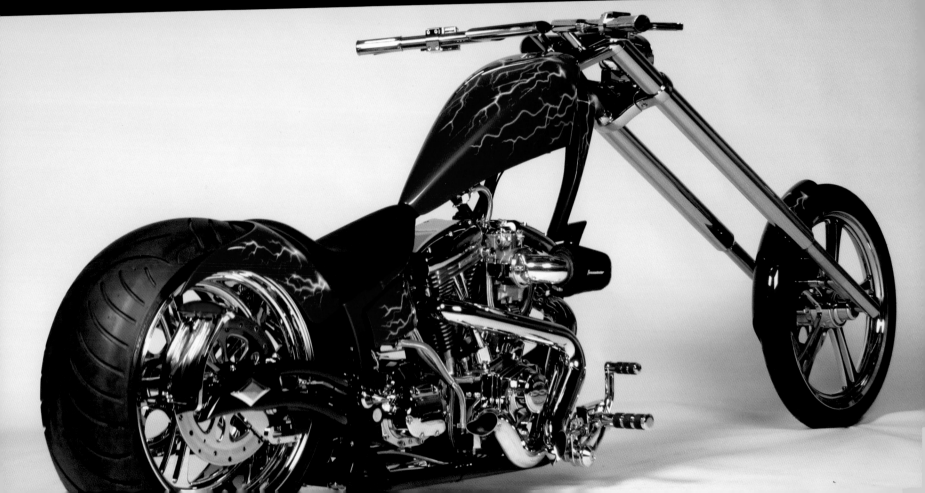

JAY'Z CUSTOM PAINT

Jason Avery, owner of Jay'z Custom Paint, and Richie Lucente, aka "Richie Rich," have been working together for some years. Richie has been painting and airbrushing for twenty-five years. He has spent most of his time in New York City studying art and doing T-shirts. Jason started airbrushing relatively recently. After attending New England Tech in Rhode Island for a year, he worked in countless auto body shops and has built his own hot rods from scratch. Jason started painting bikes with the Four Horsemen Motorcycle shop in Connecticut.

Below 2005 Harley custom orange flame rear fender, based in House of Kolor Tangelo Pearl with an overlay of orange Kandy and airbrush art. PPG Paint also used. Paint: Richie Lucente

Right 2000 Harley Sportster tank, based in PPG black then airbrushed using mostly white and Kandy colors. PPG white base coat, PPG black base coat and Sem Kandy paints were used. Paint: Jason Avery

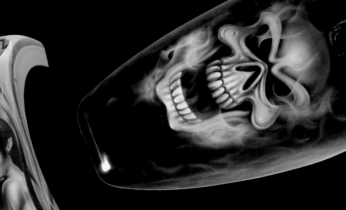

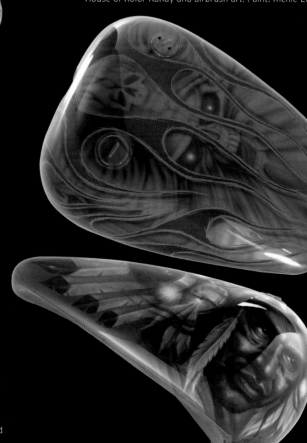

Left 2002 Harley Fatboy tank painted with a silver PPG base coat and multiple freehand airbrush effects using Kandy. Paint: Jason Avery

Below 2003 HERITAGE SOFTAIL Painted using PPG green base coat and House of Kolor Kandy and airbrush art. Paint: Richie Lucente

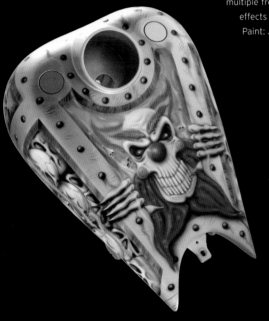

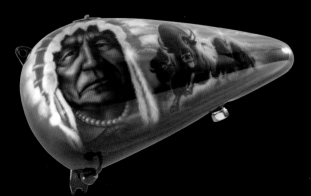

Above
2002 Harley Fatboy rear fender painted using PPG silver base coat and a bunch of freehand airbrush effects.
Color: PPG and Sem Paint.
Paint: Jason Avery
Left
1994 Harley Softail tank painted with a Cameleon pearl base and artwork done with Kandy colors. PPG base coat and House of Kolor. Paint: Richie Lucente
Right
1994 Harley Softail tank painted with black pearl base and various colors using airbrush art. Color: House of Kolor.
Paint: Richie Lucente

DOUG KEIM

Doug Keim, based in Fort Pleasant, New Jersey, is one of America's leading custom bike builders. He's made his mark with a unique mastery of the fusion of motorcycle art and design. His passion began at age seven with an unforgettable joyride on a Hodaka. Since then, Doug's desire to craft high-end freedom machines and share his experience with others has catapulted him into a fast-paced world of freewheeling notoriety. His bikes are easily identifiable for their blend of function and form. On the surface, they are eye-popping paint jobs interwoven with detailed metal of art. But behind the fanfare, they're meticulously designed to ride and fit the style of each glorified owner. With such names as "Thor" and "Battle Axe," his bikes have won hundreds of awards and have had features and covers in major magazines, including *Hot Bike*, *Easyriders*, *Street Chopper*, *American Iron*, and *V-Twin*. At his shop, Creative Cycles, Keim also creates a visionary line of parts, from wheels and pipes to frames and more. His originals are sold by powerhouse distributors, such as Custom Chrome and Paul Yaffe Catalogs. Doug will soon join other high-profile builders on the 2005 Seminole Hard Rock Hotel & Casino Tour.

2004 DOUG KEIM
BATTLE AXE
Motor: TP 124 cu. in.
(2032cc)
Color: Orange
House of Kolor
Paint: Dragon Studio
Photo: Dino Petrocelli

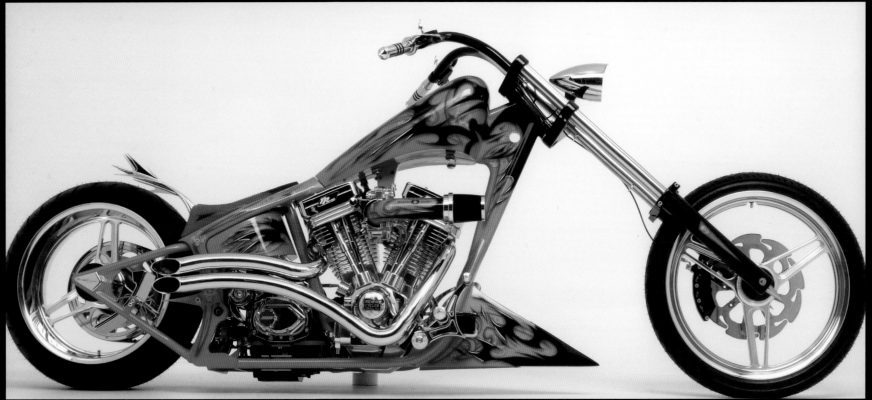

Fred Kodlin has been in business for twenty-four years, designing parts, making custom bikes, painting, and manufacturing parts all under one roof. He builds about eighty custom bikes a year plus another ten or twelve high-end customs.

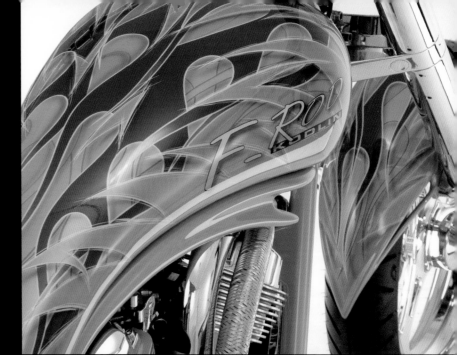

F-ROD
2003 V-rod
Frame: Kodlin
Handlebar: Kodlin
Front fork: Kodlin
Exhaust: Kodlin
Shock absorber: specially made by Ohlins
Wheels: custom chrome
Fenders/rear fenders: Kodlin
Paint: Marcus Pfeil
Owner/builder: Fred Kodlin
Photo: Oerendt Studios

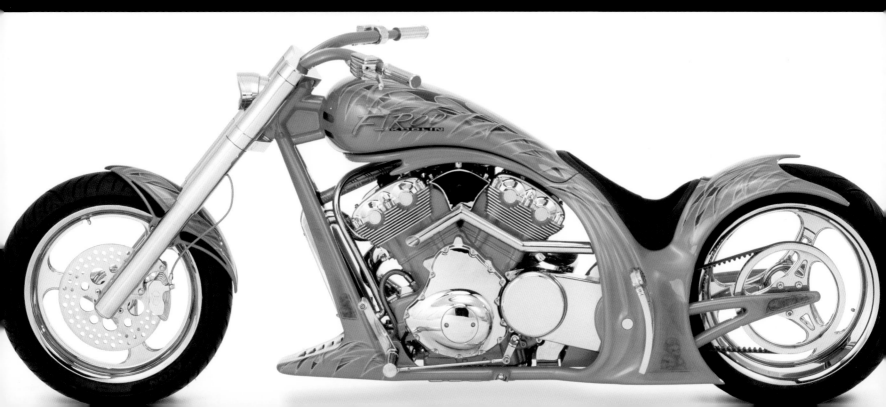

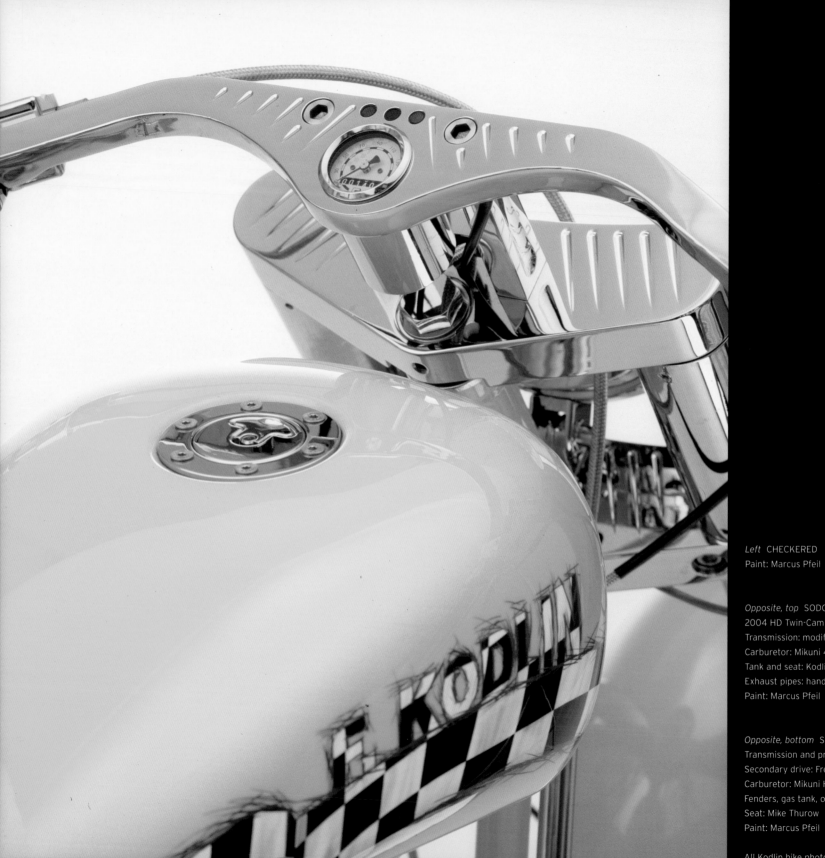

Left CHECKERED
Paint: Marcus Pfeil

Opposite, top SODOM
2004 HD Twin-Cam
Transmission: modified 2004 RevTech 6-sp
Carburetor: Mikuni 42mm
Tank and seat: Kodlin
Exhaust pipes: hand-made by Kodlin
Paint: Marcus Pfeil

Opposite, bottom SHINE
Transmission and primary drive: H-D
Secondary drive: Fred Kodlin Special
Carburetor: Mikuni HSRTR 42mm
Fenders, gas tank, oil tank: Kodlin
Seat: Mike Thurow
Paint: Marcus Pfeil

All Kodlin bike photos: Oerendt Studios

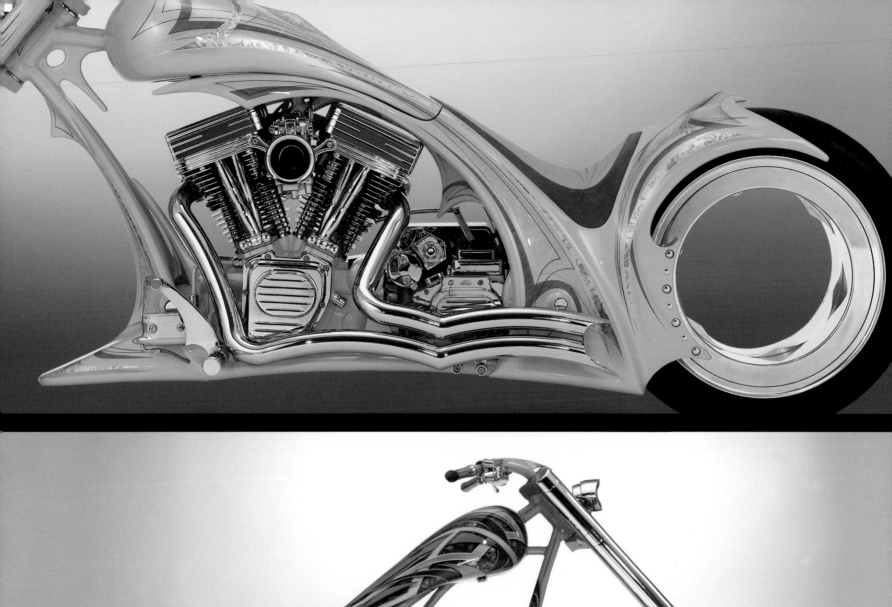
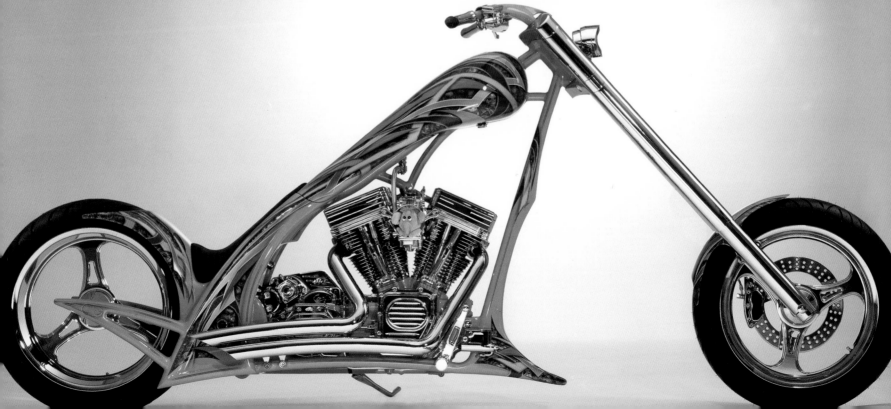

MIKE LAVALLEE

Internationally acclaimed airbrush master Mike Lavallee has been custom painting for more than two decades. His work has been featured in numerous publications and on such television shows as the Discovery Channel's *Monster Garage* and TLC's wildly popular series *Overhaulin & Rides*.

Mike is the owner of the renowned Killer Paint Custom Airbrush Studio located in Snohomish, Washington. Killer Paint has a crew of highly skilled painters, designers, and office staff who help Mike keep the paint flowing to clients from all over the world. They specialize in top of the line, show-quality paint on everything from motorcycles and hot rods to offshore boats and even helicopters!

Mike is the creator of the "True-Fire" effect, which has set the custom paint world alight.

SHE DEVIL A collaboration between Mike Lavallee, who designed the concept and look of the bike as well as painting it, and Puget Sound Choppers, who executed its flawless build and fabrication. The She Devil bike is Puget Sound Choppers' first attempt at building a custom motorcycle.

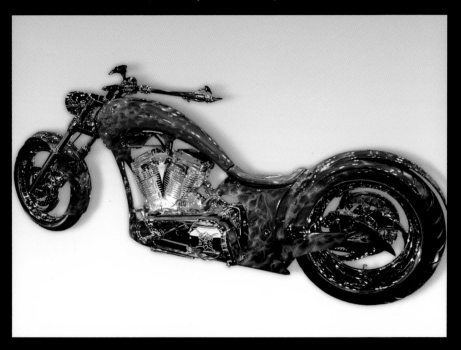

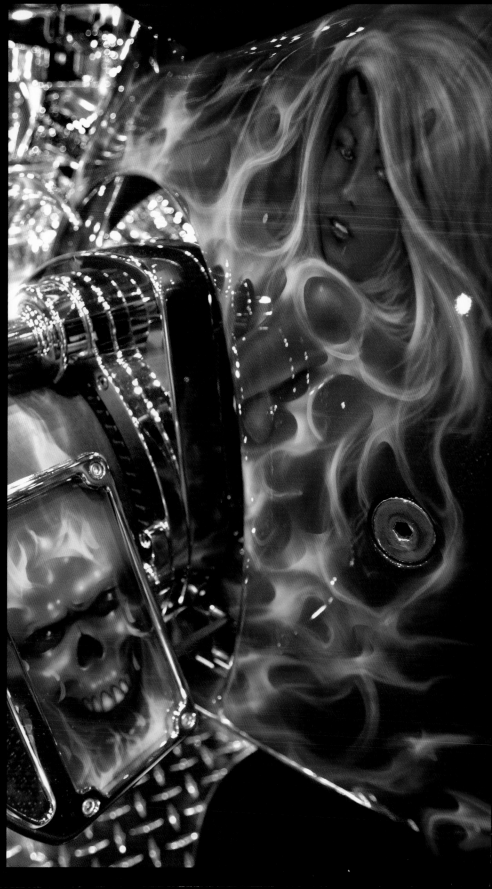

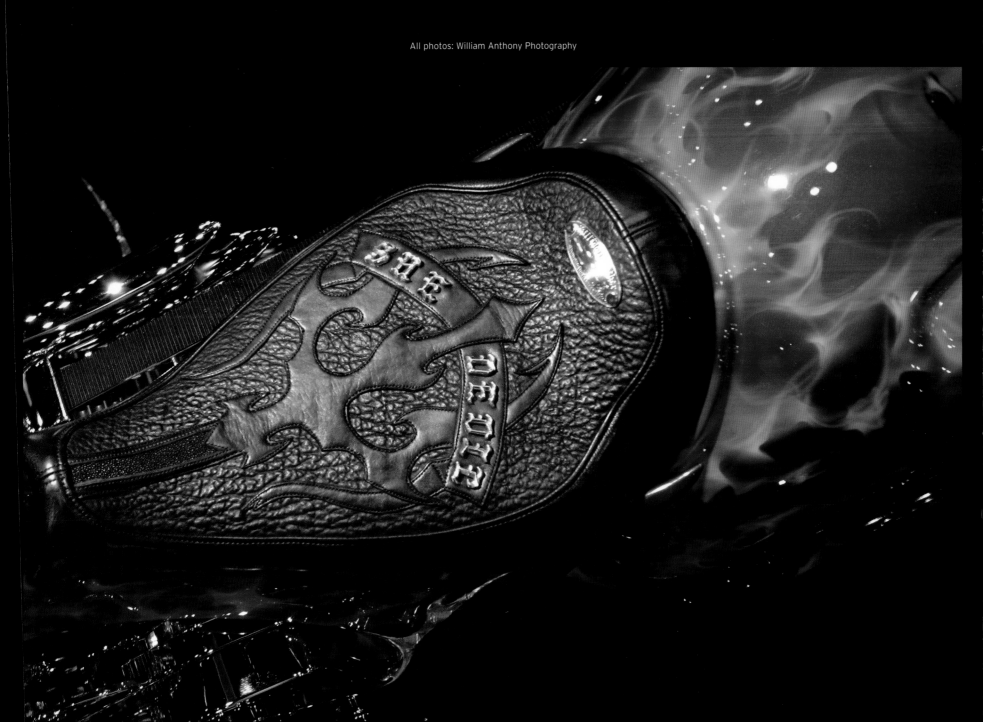

All photos: William Anthony Photography

MIKE LEARN

Mike Learn has been airbrushing for twenty-six years and is one of the premier airbrush artists in the American motorcycle industry. In the spring of 2004, *V-Twin* magazine awarded Mike the prestigious Painter of the Year honor, and featured the shop in several publications. Mike preserves the art of true custom painting by creating unique and individual pieces of art for each client he works with.

Mike has painted bikes for Jim Nasi, Kendall Johnson, Jesse Rooke, BBW, Echelon Motorcycles, Tony Cenzi, and Death Valley Choppers, to name but a few. Mike also provides airbrush instruction via web site, seminars, and DVDs.

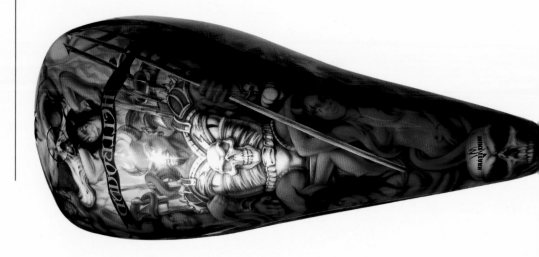

2003 KENDALL JOHNSON SPECIAL CONSTRUCTION
Paint: X-Otic candies over silver metallic base
Airbrush: Mike Learn
Owner: Justin Humphries

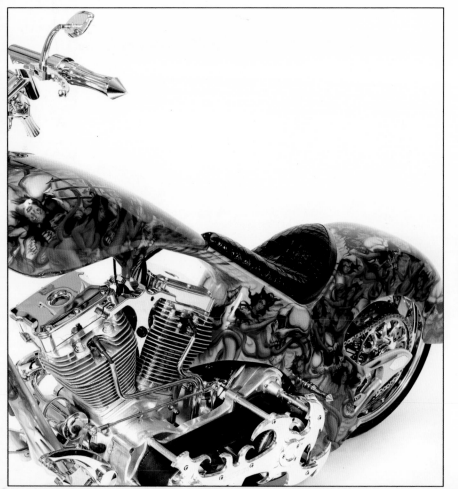

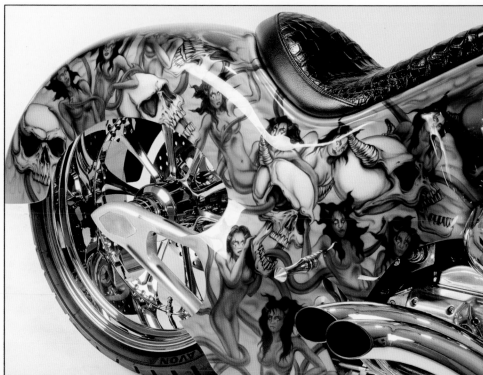

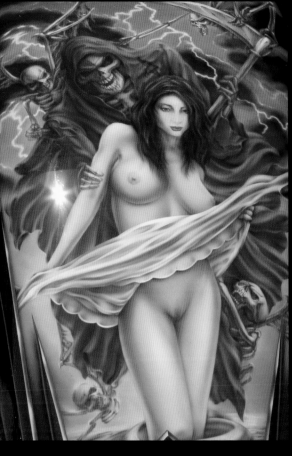

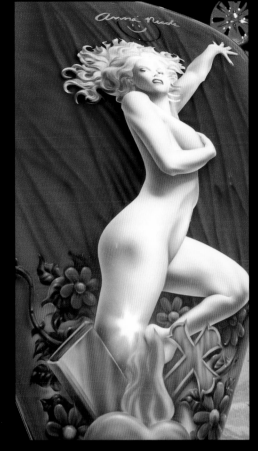

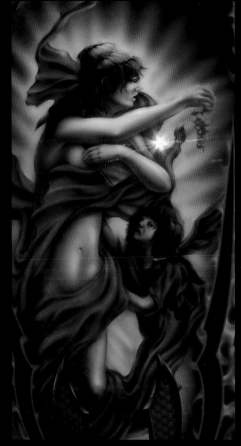

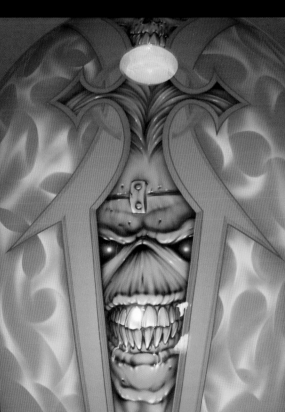

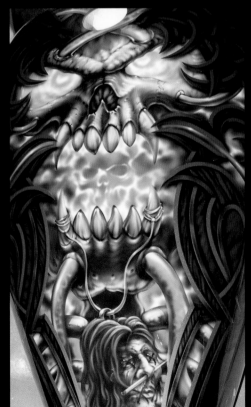

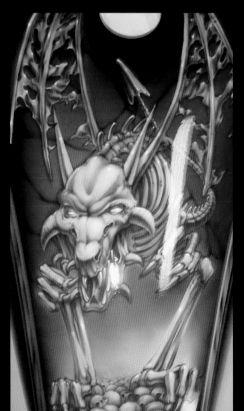

Paint: Mike Learn Tank Art

Top, left to right
Builder: Pokerville
Ironworks
Owner: John Williams
Builder: Big Boar Customs
Owner: Anna Nicole Smith
Builder: Jim Nasi Customs
Owner: Jim Voege

Bottom, left to right
Builder: Custom &
Performance
Cycles, New Jersey
Owner: Alan Sharpe
Builder: Custom &
Performance
Cycles, New Jersey
Owner: Jersey Joe
Builder: Custom &
Performance
Cycles, New Jersey
Owner: Richard Baird

LOTTEN BOYZ CUSTOMZ

Brothers James and Eric Lotten founded Lotten Boyz Customz
in 2004. Located in a small town near the northern coast of
California, the Lotten brothers combine more than twenty-five
years of automotive refinishing talents along with a newfound
passion for custom cycles to put forth some outstanding work.
James contributes his meticulous building and fabrication skills
to lay the groundwork for Eric's flawless paint applications,
which show a propensity for incredibly realistic flames. Though
he is a relative newcomer to the custom motorcycle scene, Eric's
realistic fire has grabbed the attention of some of the best
motorcycle artists in the world.

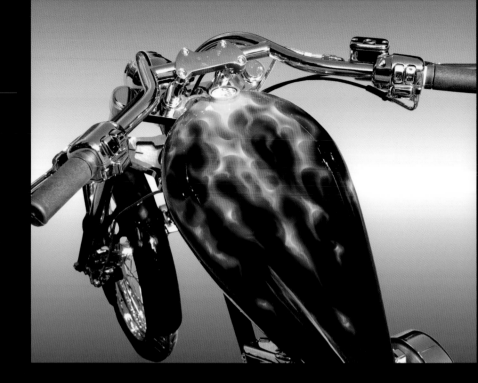

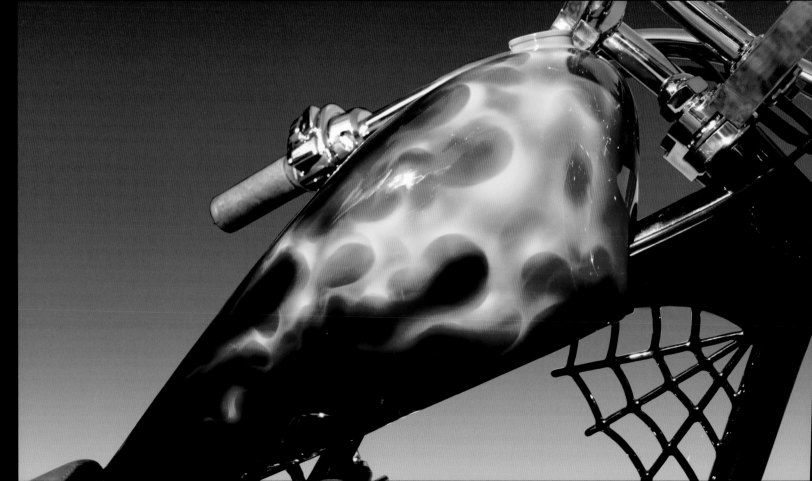

Jesse James "Villain"
tank freehand
airbrushed in layers
using House of Kolor
paint over a PPG
black base.
Builder: James Lotten
Paint: Eric Lotten
Owner: Lotten Boyz
Customz
Photo: Gary Richards

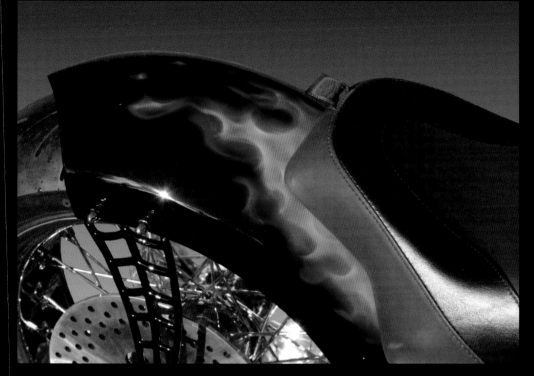

Left Chopped and restyled Jesse James rear fender supported by custom hand-made spider-web brackets and skinned with Eric Lotten's realistic flame technique over a black base.
Builder/fabrication: James Lotten
Paint: Eric Lotten
Owner: Lotten Boyz Customz
Photo: Gary Richards

Below 2004 Hard-Core II rigid. 7 in. (18 cm) raked billet triple trees, 100 cu. in. (1640cc) motor, chopped rear fender with custom fabricated spider-web supports, Jesse James "Villain" tank, custom spider-web frame gussett, Chica "V" handlebars, Santee® "Y Bent" exhaust pipes.
Builder/fabrication: James Lotten
Paint: Eric Lotten
Owner: Lotten Boyz Customz
Photo: Gary Richards

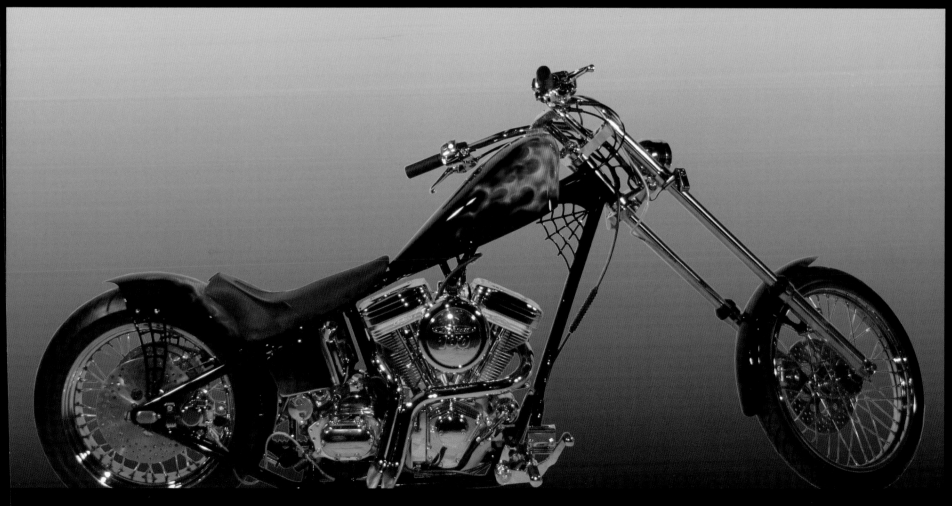

LUCKY CHARM CHOPPERS

Lucky Charm Choppers, located in Norristown, Pennsylvania, is a full service custom and fabrication shop focused on building rideable, old-school customs with a twist. They like to blend heavy metal fabrication with heavy metal flake to build bikes that are as much fine art as they are roadworthy machines. Their bikes have been seen in major publications and have taken awards at some major shows around the country. Owners Don and Duncan believe that the paint makes or breaks the bike: the gas tank, being the focal point of most motorcycles, needs to draw you to it with a passion. The ability to visualize the end product is nearly as much of an art form as the laying down of the paint.

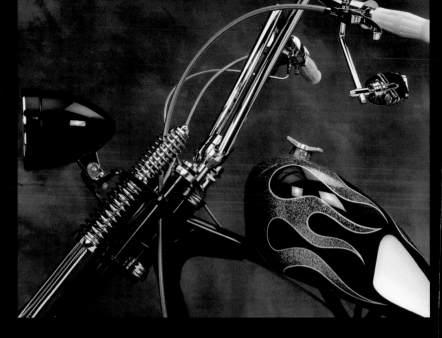

2004 93 in. (236 cm) Shovelhead chopper. Frame: 6 in. (15 cm) stretch Diamond/LCC frame, 5-speed kick-only, and stainless oil tank by LCC. Builder: Lucky Charm Choppers. Paint: gold rainbow flake flames over black with ivory inset panels by Pat Patterson at Leadsled Custom. Owner: Dan Spencer

Tank by Lucky Charm Choppers, recessed side panels, drop tunnel, spinner gas cap. Paint: gold rainbow flake flames by Pat Patterson at Leadsled Customs. Owner: Dan Spencer

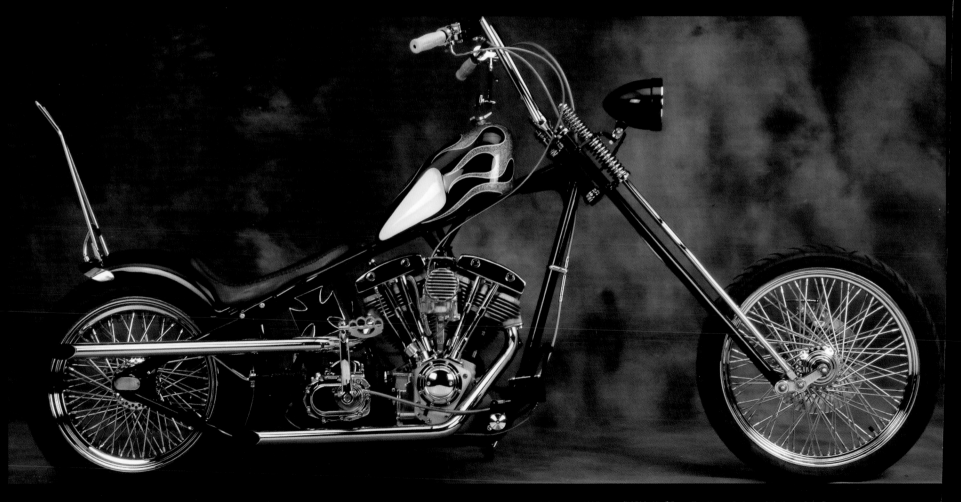

MGS CUSTOM BIKES

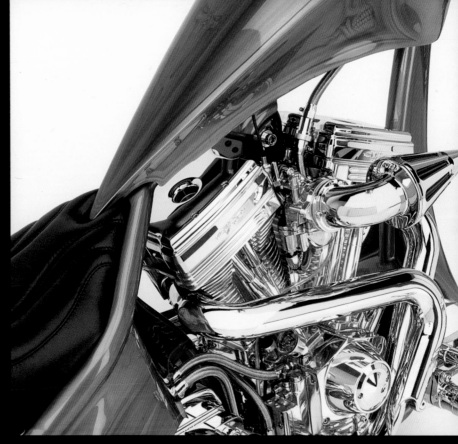

Mike Stafford was born and raised in the Antelope Valley, California. Forty-six years on, he's still a resident and also a small-business owner there. Ten years ago Mike decided he wanted to start riding again. Once an avid motocross rider, he wanted this time to ride on the street, and, of course, he wanted a Harley-Davidson-style bike.

Mike began buying parts, and what he couldn't afford to buy, he built. He wasn't satisfied with the off-the-shelf look of many parts, so he took to the garage with what few tools he had and hammered out some custom parts. Eventually this new hobby became his livelihood.

Building business relationships that turn into friendships is all part of Mike's successful venture. A perfect example of this is the combination of Little Designs' artwork on MGS bikes. In the years to come, look for MGS Custom Bikes and Little Designs as a major force in the custom bike world.

Above EXTREME NIGHTMARE 9 Paint: Little Designs. Color: tangerine candy, PPG. Graphics: Dave Little, Little Designs. Airbrush: Chris DeRubeis, Little Designs. Photo: John Wykoff

Below STREET RODDER 5 MGS Custom Bikes Softail pro-street. Motor: H&L 131 cu. in. (2147cc). Tires: 280 mm. Paint: Little Designs. Color: special mix blue, PPG. Graphics: Silver pearl. Hand-laid flames: Dave Little, Little Designs. Pinstripe: Bob Coslett, Little Designs. Photo: John Wykoff

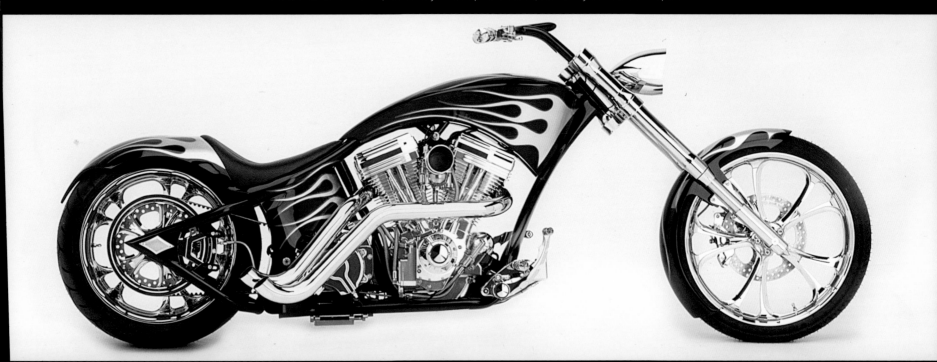

NEW YORK CITY CHOPPERS

In 2003 New York City Choppers adopted a bike style created in the late 1940s and early 1950s that, since becoming identified with New York City, has become known as the NYC Bobber. The style has had a major impact on the motorcycle industry, and is currently being imitated all over the world. Living in NYC offers us the opportunity to evolve continually and create the art and style that is the foundation of the industry. We are at the forefront of defining the look of a New York City motorcycle.

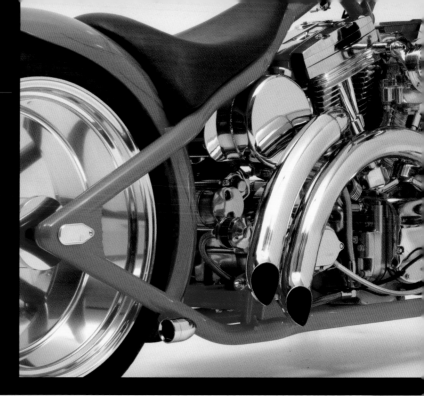

Frame: New York City Choppers. Engine: 108 cu. in. (1770cc) with fully polished billet top end producing 118 hp.
Transmission: 6-speed transmission. Rear wheel: solid billet with 250 tire. Rear fender: Fat Katz.
Tank: Independent Gas Tank Co. Exhaust pipes: Jesse James. Paint: Visual Impact of Long Island.
Color: tangelo pearl by House of Kolor with lime-green flames. Owner: Vincent Savino.
Featured in *Easyrider*'s top 100. Photo: Dino Petrocelli

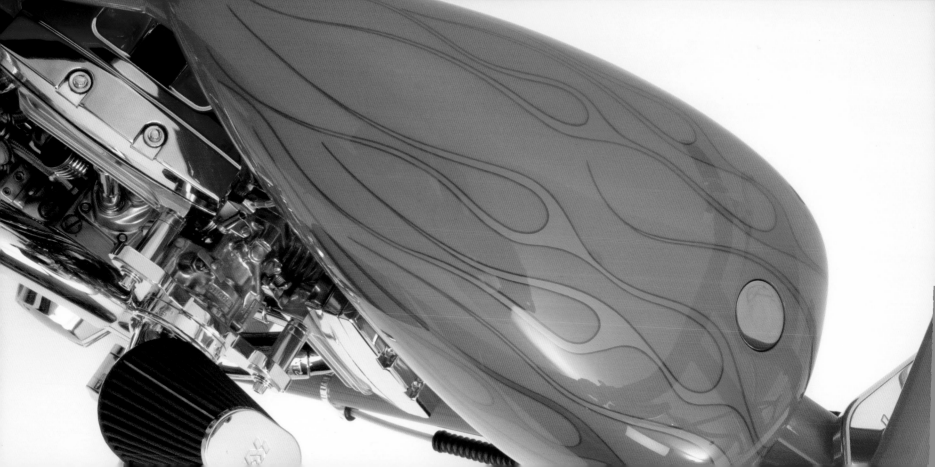

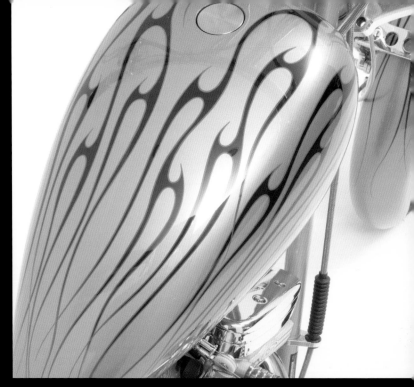

Rake: frame rake is 46 degrees, 8 up and 3 back. Ten over front end with 5 degrees of rake in the tree for an overall rake of 51 degrees.
Length: 9 ft. 6 in. (290 cm).
Engine: 100 cu. in. (1640cc).
Transmission: 6-speed.
Wheels: 80-spoke Hallkraft Wier wheels. The front is a 21 x 3 and the rear is from the old school, 15 x 7 with a 230 tire, all by Metzler.
Tank: Independent Gas Tank Co.
Paint: Visual Impact of Long Island, PPG with House of Kolor flames. Color-keyed headlight and HD-style front legs.
Owner: Joe Joseph
Photo: Dino Petrocelli

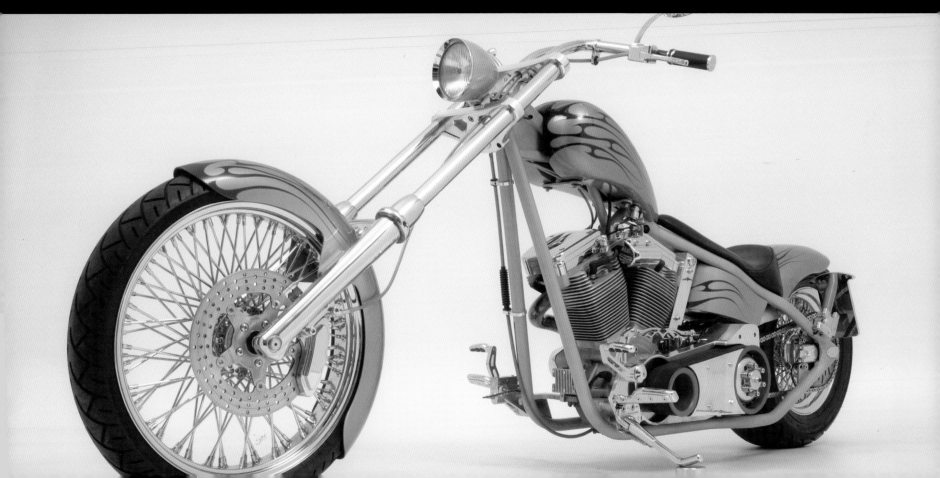

Jonathan Pantaleon has been airbrushing for more than a decade, and specializes in photo-realistic and custom graphic designs for the motorcycle and automotive industries. His attention to detail is famous and is something that helps to make his designs unique. Pantaleon is considered one of the top muralists in the country by many. Based in Rochelle Park, New Jersey, he divides his time between day-to-day obligations to his clients and his responsibilities as an airbrush instructor in various disciplines nationwide for *Airbrush Action* magazine.

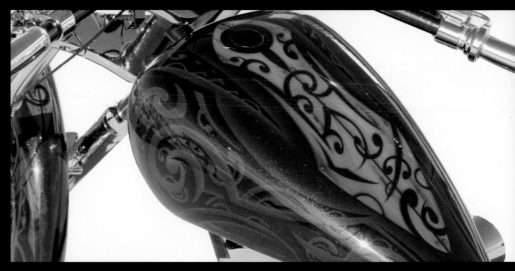

KANALOA Builder: Matt Kraft. Owner: Dennis McGuire, Florida. Photo: Matt Kraft

CELTIC BIKE Owner: Randy Dedrickson, North Carolina

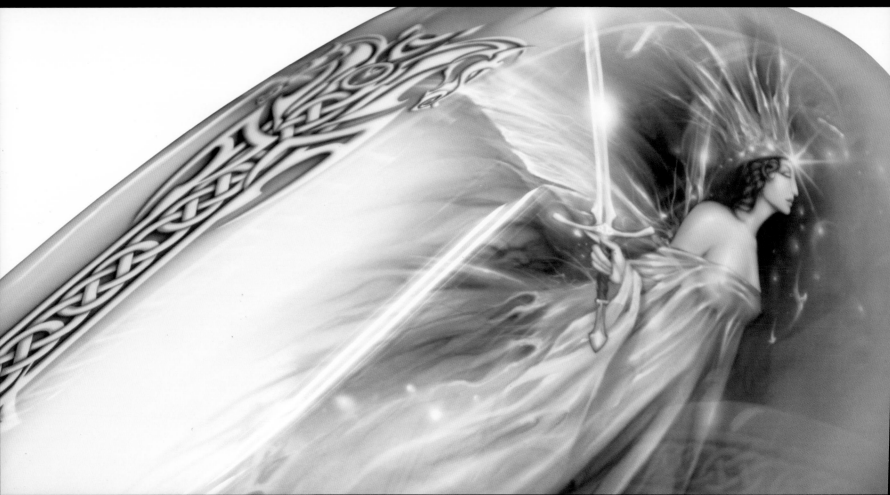

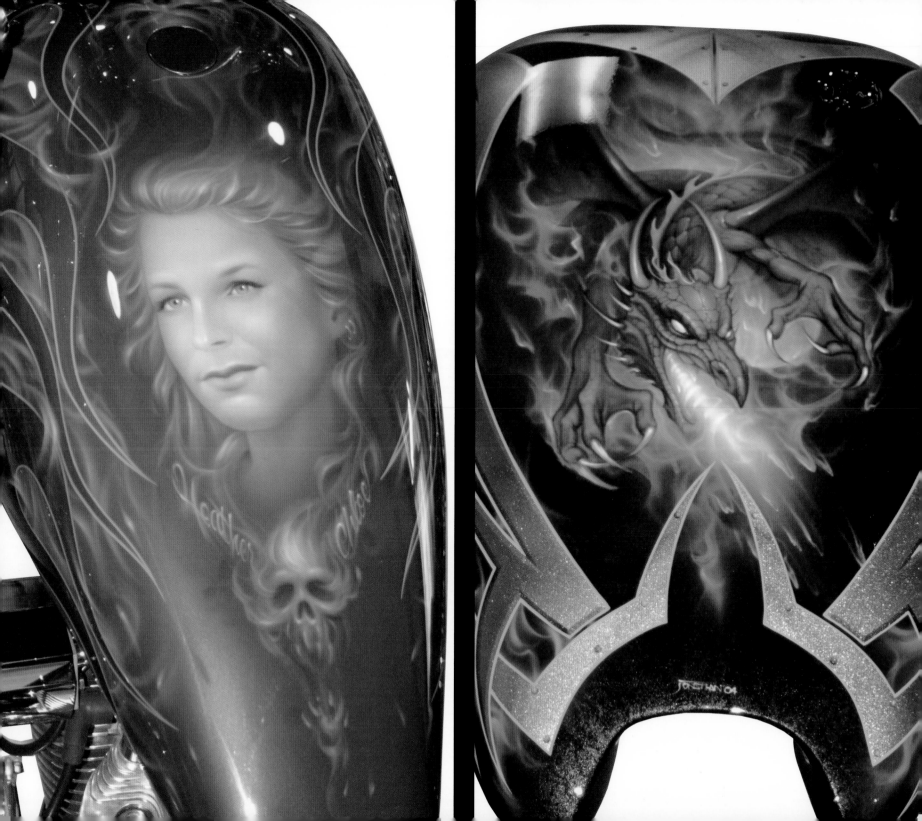

MUNEWARI Builder: Matt Kraft. Owner: Dennis McGuire, Florida. Photo: Matt Kraft

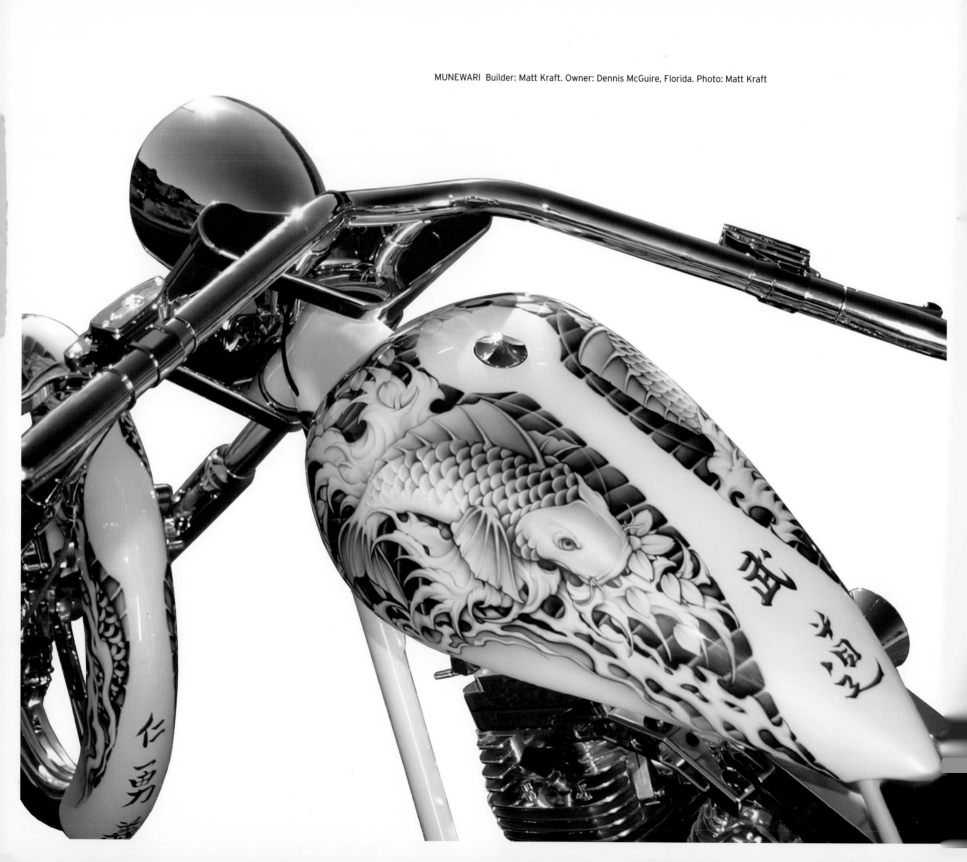

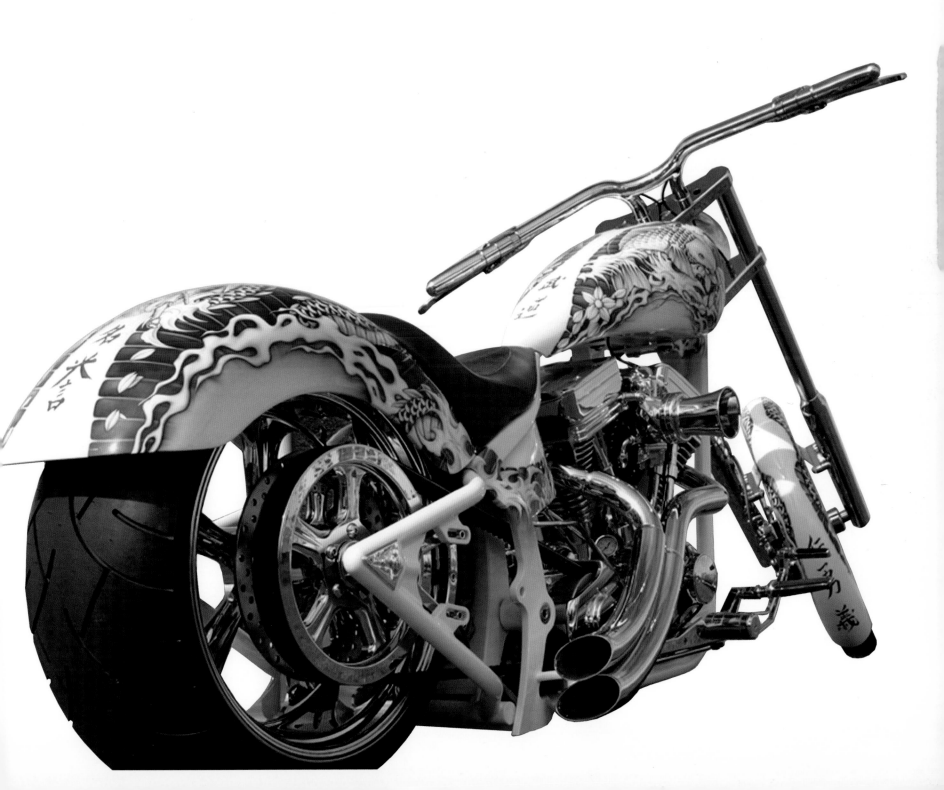

PASTRANA UNLIMITED

Born and raised in Queens, New York, self-taught artist Alan Pastrana began drawing with his father's work supplies at the age of four. From a young age his father would take him to The Metropolitan Museum of Art, where he was influenced by such artists as Van Gogh, Raphael, Peter Paul Rubens, and John Singer Sargent.

After high school Alan attended the Fashion Institute of Technology in New York City, where he studied illustration and learned how to perfect his skills through life drawing and oil painting. At F.I.T. Alan took airbrushing classes under the famous medical illustrator Radu Vero, whose influence is visible in the airbrushing techniques that Alan uses today. Alan has been airbrushing for more than fifteen years and is the head artist at, and owner of, Pastrana Unlimited Airbrush Studios in New Britain, Connecticut.

Pastrana Unlimited has been rapidly expanding and as a result Alan has recently hired Honorio Reynolds to work alongside him. Alan outsources all bodywork and clear finishing to John Kaplan of Custom F/X: John's excellent work is an essential factor in the success of Pastrana Unlimited.

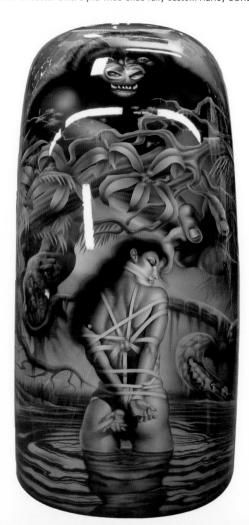

Rear fender of Jester bike. Dyna Wide Glide fully custom Harley-Davidson

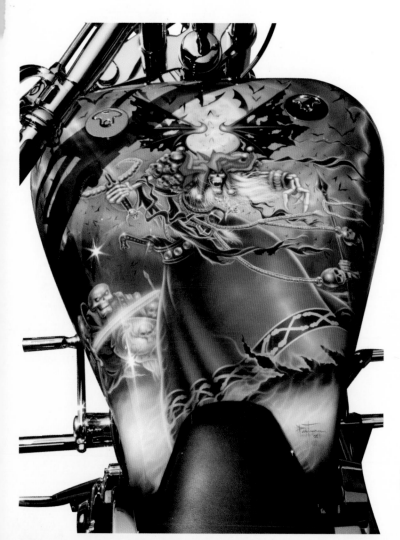

Jester tank on a Dyna Wide Glide fully custom Harley-Davidson

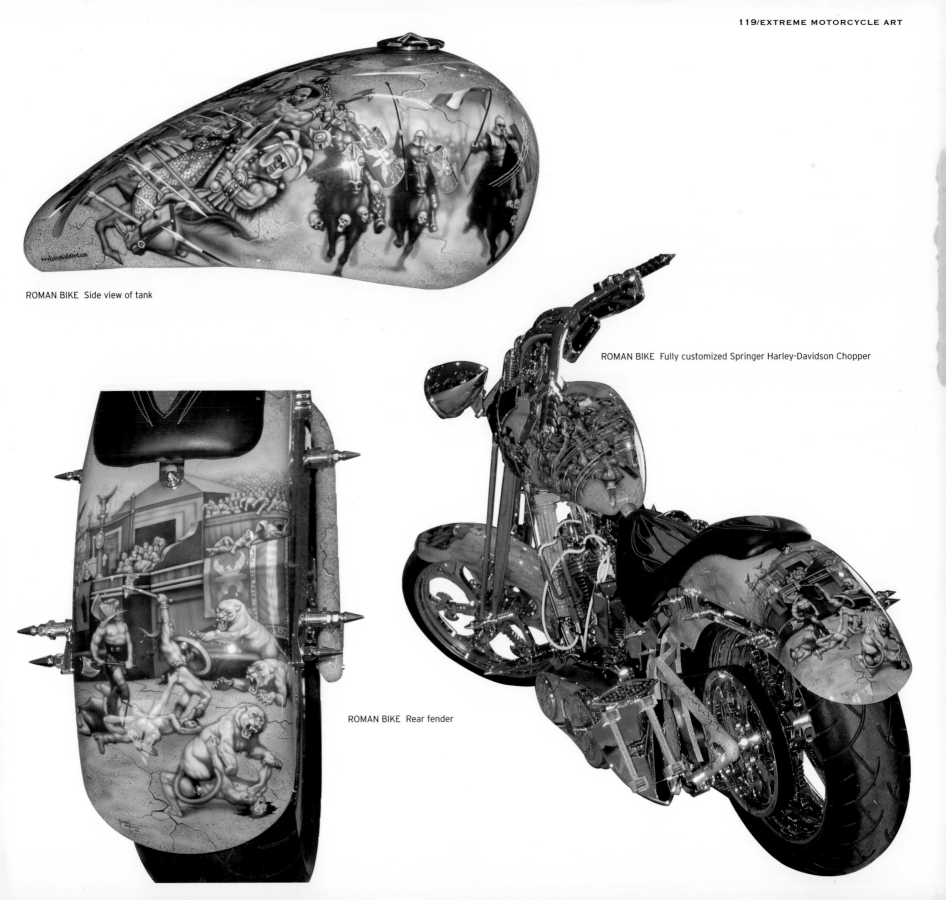

ROMAN BIKE Side view of tank

ROMAN BIKE Fully customized Springer Harley-Davidson Chopper

ROMAN BIKE Rear fender

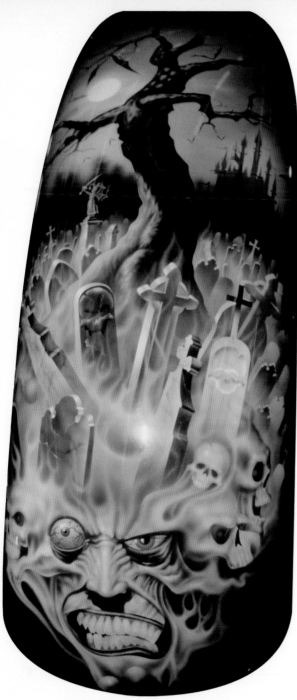

Rear fender with skulls and alien

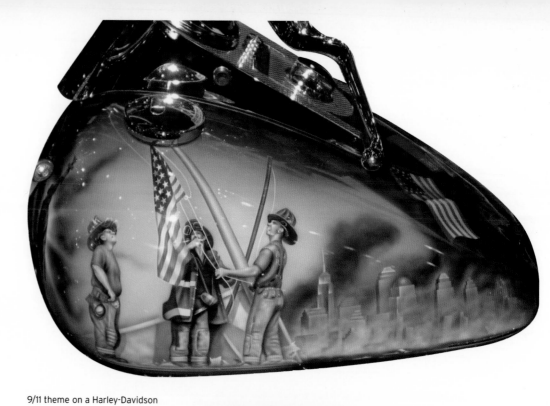

9/11 theme on a Harley-Davidson
Road King tank

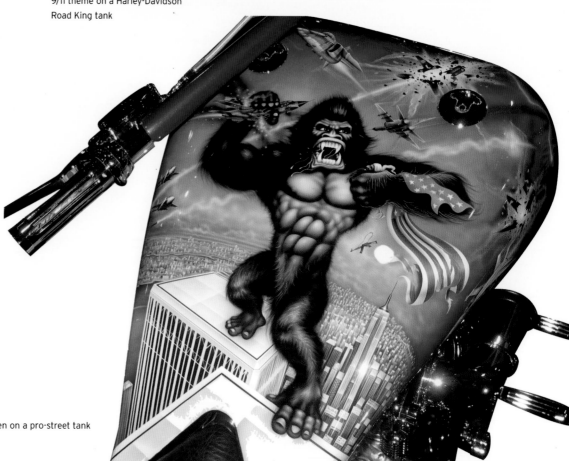

King Kong holding Osama bin Laden on a pro-street tank

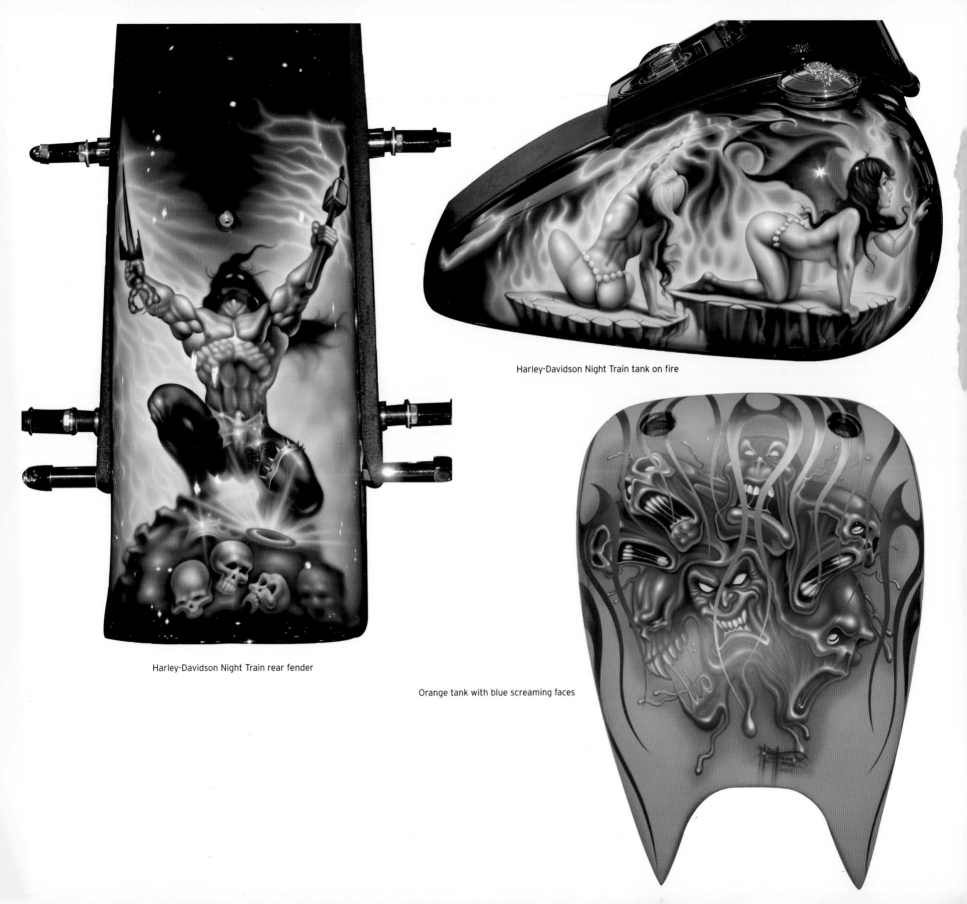

Harley-Davidson Night Train tank on fire

Harley-Davidson Night Train rear fender

Orange tank with blue screaming faces

PETER PENZ

Peter Penz Original Custombikes, established in 1996 and based in Altheim, Austria, has manufactured hundreds of frameworks on which exclusive motorcycles are developed. In 2001 the Penz Flash Style framework became the "Custom Part of the Year." Since then his bikes have been present in Europe, the USA, and Asia.

Peter's motorcycles are based on first-class frames made of seamless precision stainless steel. Every frame is individually manufactured for the ergonomics of its driver. Excellent manufacturing builds a wonderful base for an outstanding bike. Riding along the narrow twisting Austrian country roads, often as high as 6500 feet (2000 metres) above sea level, the power and glory of these bikes are experienced to the full.

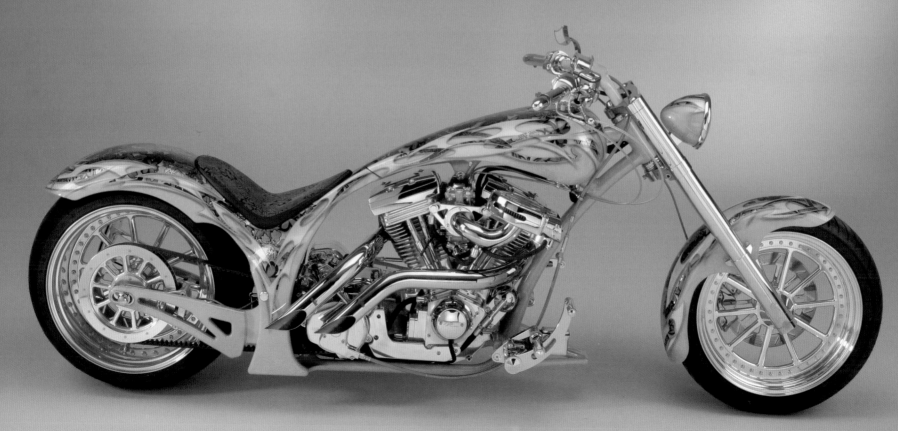

Opposite PENZ FLASHSTYLE SOFTAIL, MODIFIED MILWAUKEE FLOWER 2003
Primary Transmission: Primo Belt 3.5 in. (9 cm). Carburetor: Mikuni 45. Pipes/mufflers: LA Choppers
Paint: Marcus Pfeil. Owner: Peter Penz Original Custombikes

Below MARILYN 2003 Paint: Marcus Pfeil. Color: 24 carat gold leaf House Of Kolor, Kandy Pink, and Perlmut Light Blue
All Penz photos: Gerd Scheidel/Studio 1

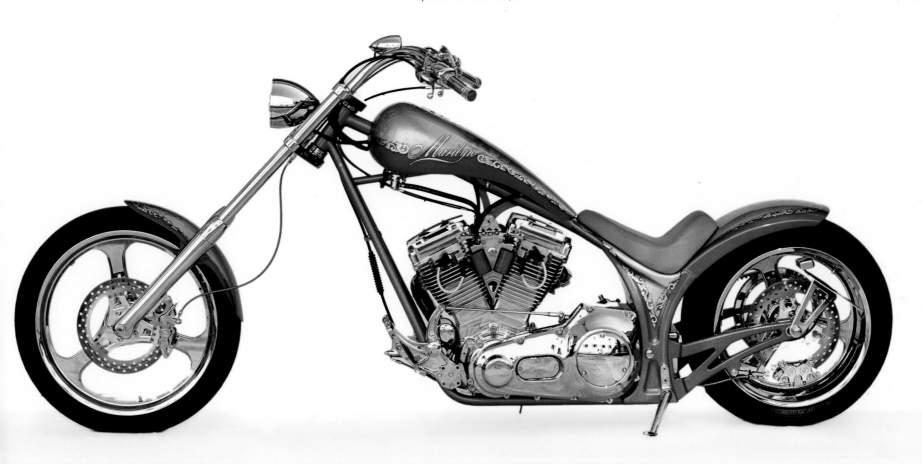

Dave was hooked on motorcycles in 1967 when he bought his first bike. To gain experience he would often do jobs free for his friends and riding companions, and he has now had more than thirty years' experience building and customizing motorcycles. He is a self-taught designer, mechanic, painter, and fabricator. He concentrates on what he does best—one-off, hand-built choppers that are as comfortable and reliable as they are beautiful. In December 2005 Perewitz is due to open a new, high-tech facility in Bridgewater, Massachusetts.

Dave finished filming the *Biker Build-Off II* series for the Discovery Channel in 2003. After the bike was completed, he had to ride it from Pensacola, Florida, to Dallas, Texas, while the cameras were rolling. Bike and rider never missed a beat.

The Discovery Channel *Biker Build-Off* bike. Paint: Perewitz/Cycle Fab. Color: PPG Mario Andretti red

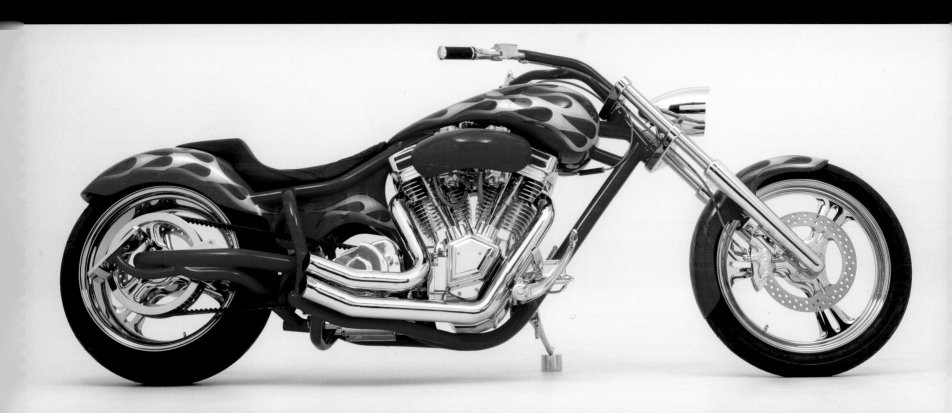

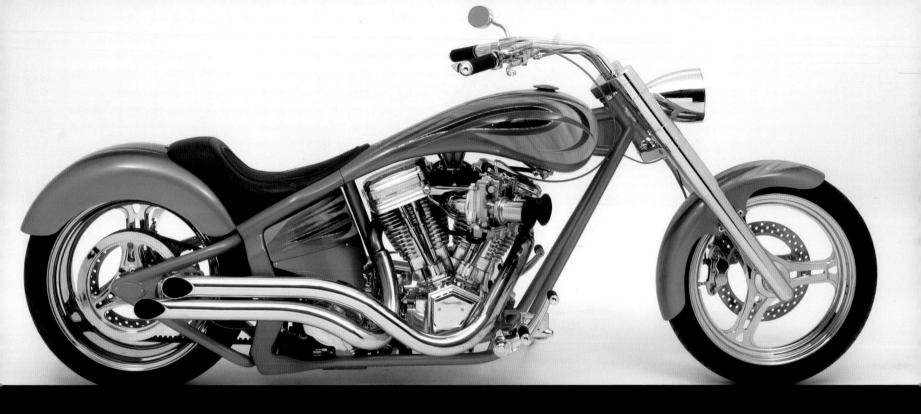

Above 2002 SOFTAIL Motor: TP 113 cu. in. (1852cc). Paint: Jay Chrone, Perewitz/Cycle Fab. Color: PPG Prizmatique green, and many other PPG colors. Photo: Dino Petrocelli

Below GIBSON Cycle Fab bike with matching guitar. Frame: pro-street Eddie Trotta. Motor: TP 121 cu. in. (1983cc). Paint: Perewitz. Color: PPG Perewitz Purple. Photo: Dino Petrocelli

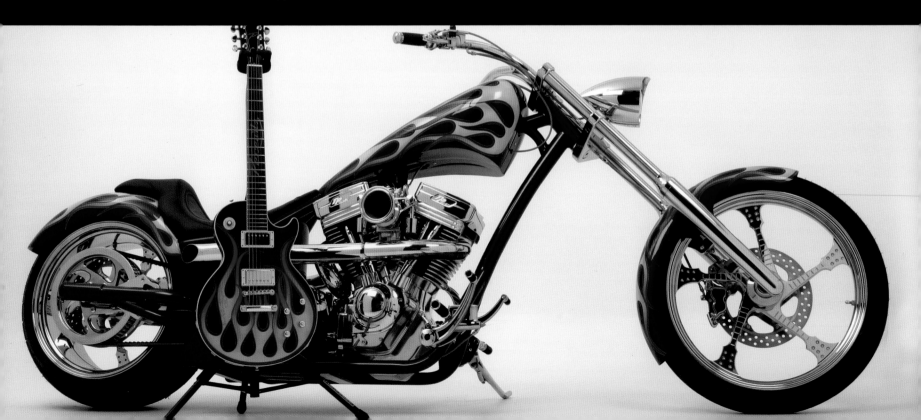

PERRY MICHAEL DESIGNS

Perry Michael, like many kids, started around the age of seven cutting up and piecing together junk bicycles he found in the garbage. From there, and through his brothers' inspiration, he went on to build the fastest cars on Long Island—from a nitrous, narrowed, big block Monza to a supercharged Corvette—always building beyond expectations.

Perry's love for motorcycles didn't take off until his late twenties, when he learned he could create rolling art in such a small space. After owning a few different Harleys he began to hone his metalworking skills. In about 2000 he formed Perry Michael Designs and things started to move along.

Today Perry and his wife Pia have a growing business that includes a shop, a retail store, an online store, and many cool bike projects that are really challenging Perry's artistic imagination.

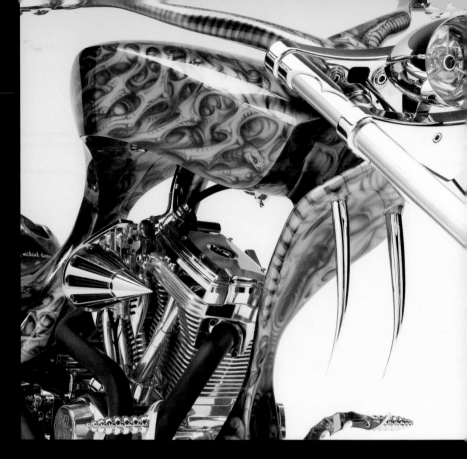

THE DIAMONDBACK Length: 10 ft. 8in. (325 cm). Motor: 125 cu. in. (2050cc) Patrick motor. Transmission: 6-Speed RSD Baker transmission. Rear tire: 300 Avon "Venom". Paint: Mike Calderone. The Diamondback's sheetmetal is all hand-fabricated by Perry Michael Designs. The paint design incorporates more than a dozen rattlesnakes underneath a Kandy gold overlay with hidden pictures in various locations to keep the viewer continually exploring all sides of this creation. Photo: Don Roger

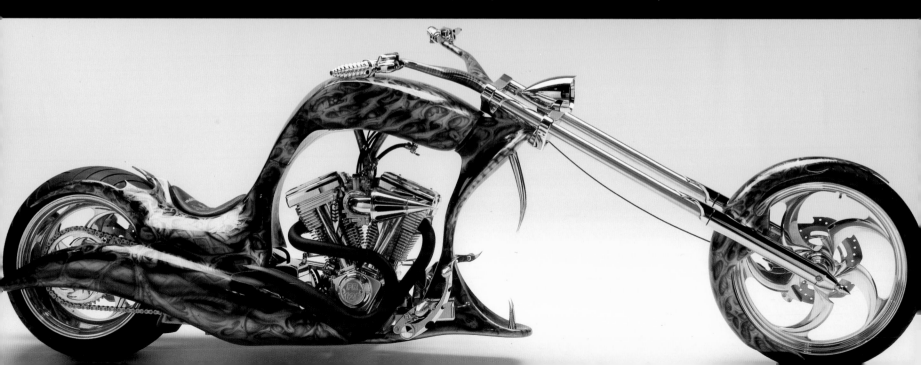

PFEIL-DESIGN

Marcus Pfeil started painting in 1992 with customized scooters (Vespa and Lambretta). Peter Penz of Penz Performance recognized the quality of his work and began to bring him parts from Harleys to finish in the same way as his scooters. After participating in his first bike exhibition, the business is growing and Pfeil-Design is becoming known as a brand name for high-quality, high-capacity, highly creative—and highly priced!—custom paint jobs made in Austria.

Pfeil now has nine employees and in 2004 moved into a new facility of more than 5380 square feet (500 square meters). They paint more than 100 bikes a year for such builders as Custom Chrome, Fred Kodlin, Peter Penz, Habermann, Ducati Austria, and many more.

2004 GHUL by Habermann-Performance. Molding/chassis: Habermann-Performance GmbH, Germany. Engine: twin-cam B 95 cu. in. (1550cc) (big bore). Rake: 40 degrees. Height 8 in. (20 cm), stretch 6 in. (15 cm). Fork: 22 in. (56 cm) over. Rear turn signals in swingarm. 280 tire, 10 x 18 in. rim. Exhaust system: Habermann-Performance. Paint: Pfeil-Design, Austria. Owner: Thomas Habermann

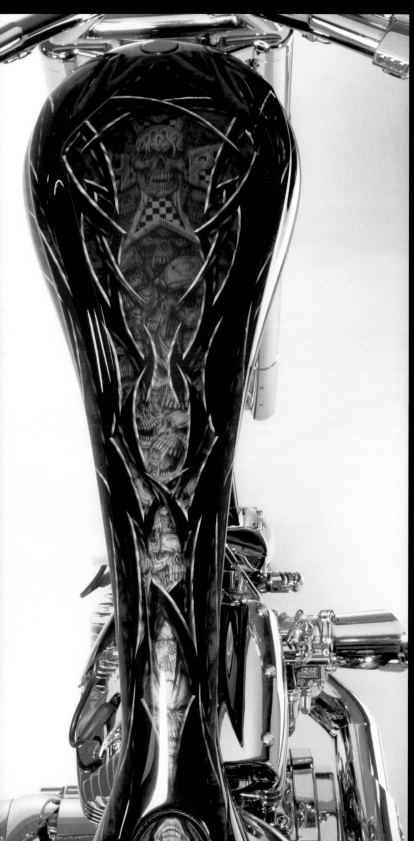

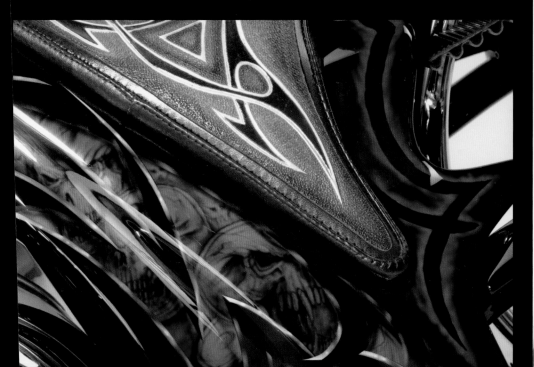

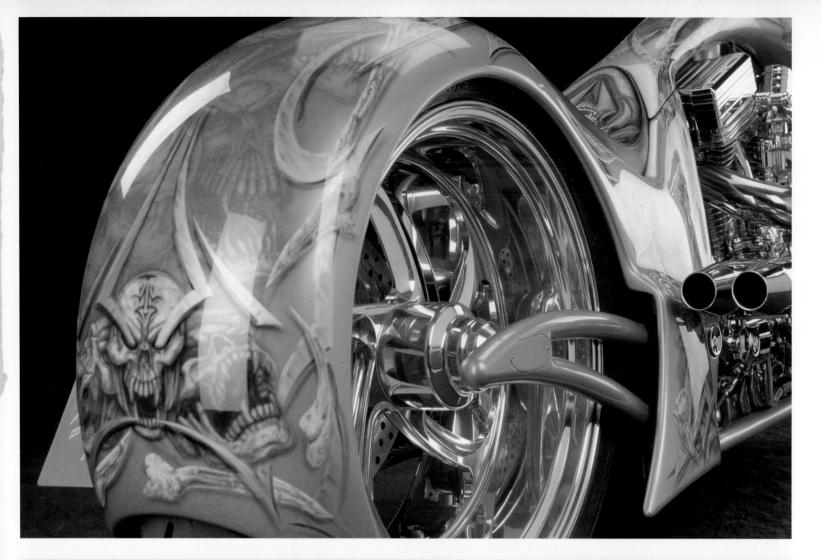

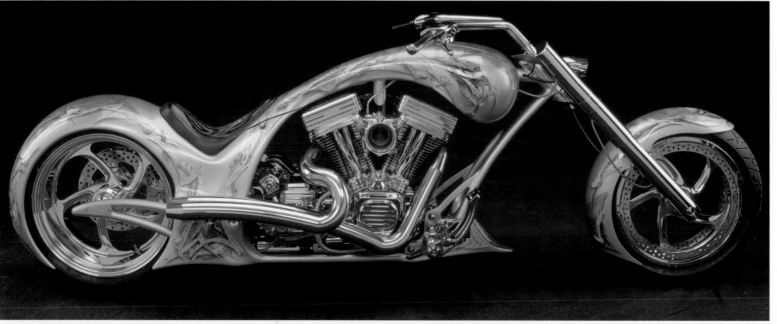

2004 INSOMNIA
by Habermann-Performance

Metal rear fender:
Habermann-Performance
GmbH, Germany
250 tire
Paint: Pfeil-Design, Austria

ROBERT E. PRADKE JR.

Custom Auto Design has been located in Eastford, Connecticut, since opening in 1988. Robert Pradke specializes in custom paint and bodywork. Everything from start to finish goes through his hands. Traditional methods of applying 24k gold and sterling silver leaf are combined with hand-laid pinstriping and lettering. Candies, pearls and flakes have been applied to pretty much anything that paint will stick to.

Robert had a strong hot-rod and custom influence handed down to him by his father, which was reinforced by his friendship and collaboration with Indian Larry. The dedication to quality and detail and the constant striving to increase his abilities have given many top builders in the industry a reason to call upon him for his work.

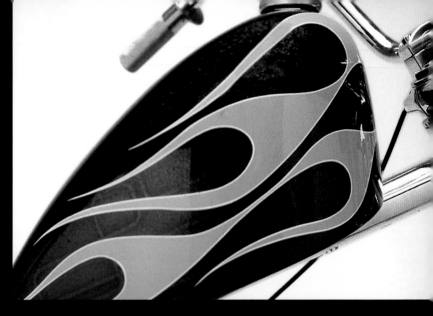

Green flake with endless-line panel shadow with sea-foam green flames and pinstriping.
Builder/Owner: Steven Clark aka "Knucklehead Steve." Photo: Timothy White

CHAIN OF MYSTERY Blue purple flake powder coating, sterling silver, 24k gold and variegated leaf with pinstriping. Builder: Indian Larry. Photo: Timothy White

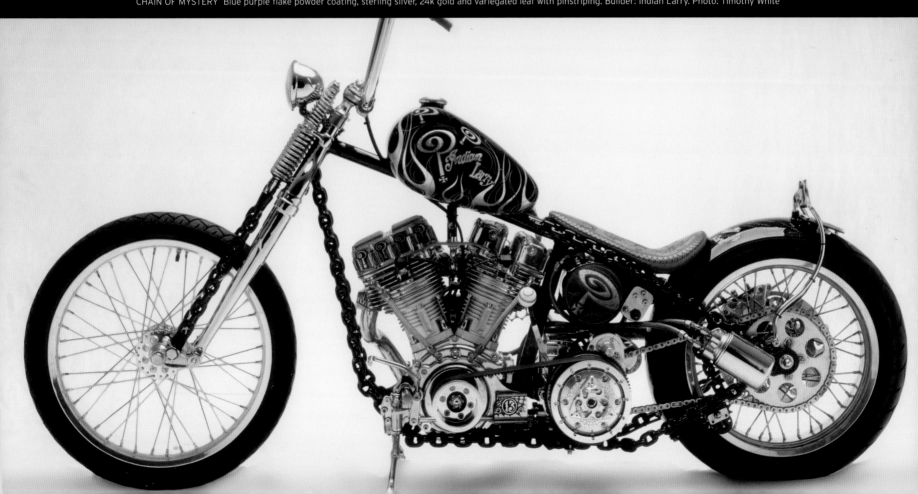

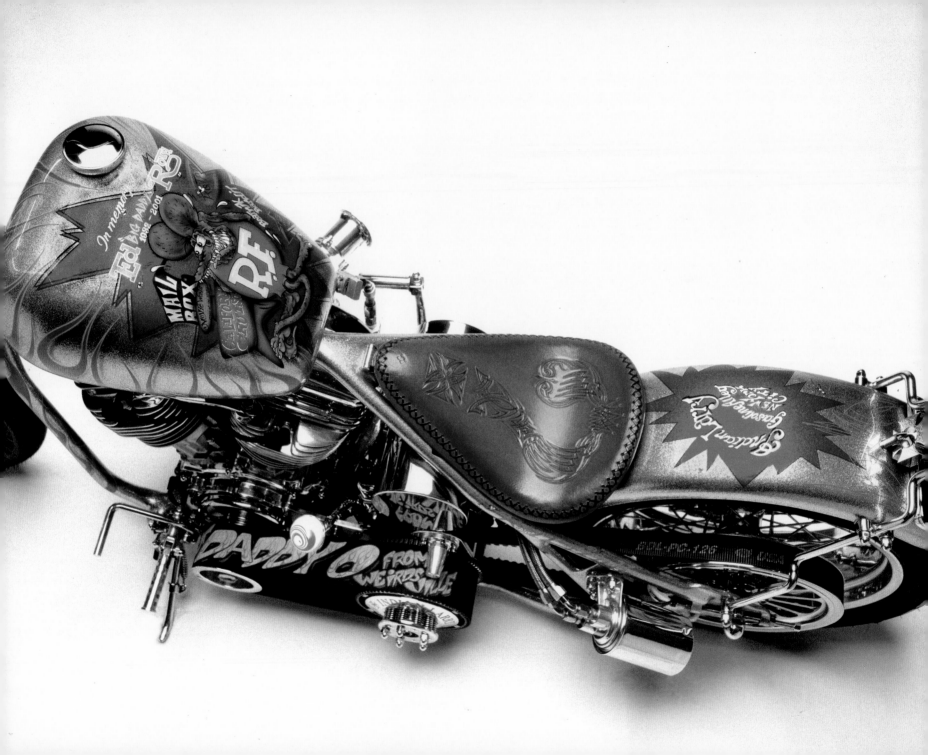

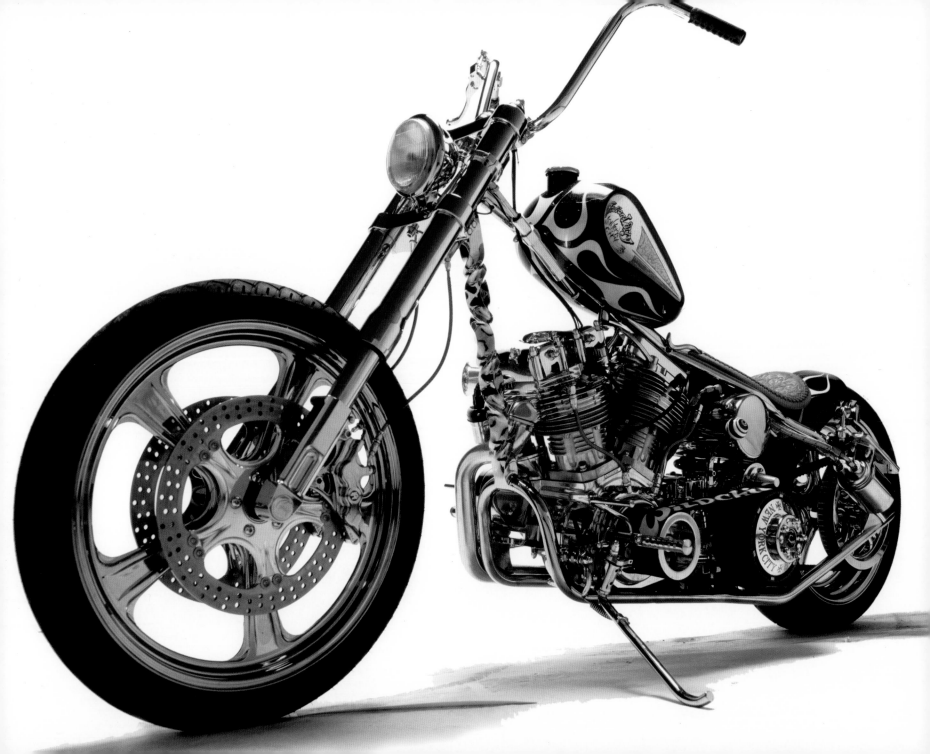

Jesse Rooke is a rising star in the custom motorcycle industry. Inspired by Jesse James in the original Motorcycle Mania, Rooke built his first bike, Dinah, in 2002 and entered the industry with a bang. Dinah won numerous awards, and has been featured on the cover of *Hot Bike* magazine and on several cable network programs.

Jesse's extensive background in motorsports and kart racing has put him well ahead on the learning curve, and now, with eleven bikes under his belt and five more on the table, he is starting to be a significant player in the industry. His focus, drive, and innovative ideas are keeping his competition on their toes and his fans on the edge of their seats.

ROOKE CUSTOMS KALI KRUISER Discovery Channel *Biker Build-Off* bike 2004. Fabrication/assembly: Jesse Rooke. Paint: Airea 5150. Graphics: Shawn at Airea 5150. Photo: Jim Gianatsis/FastDates.com

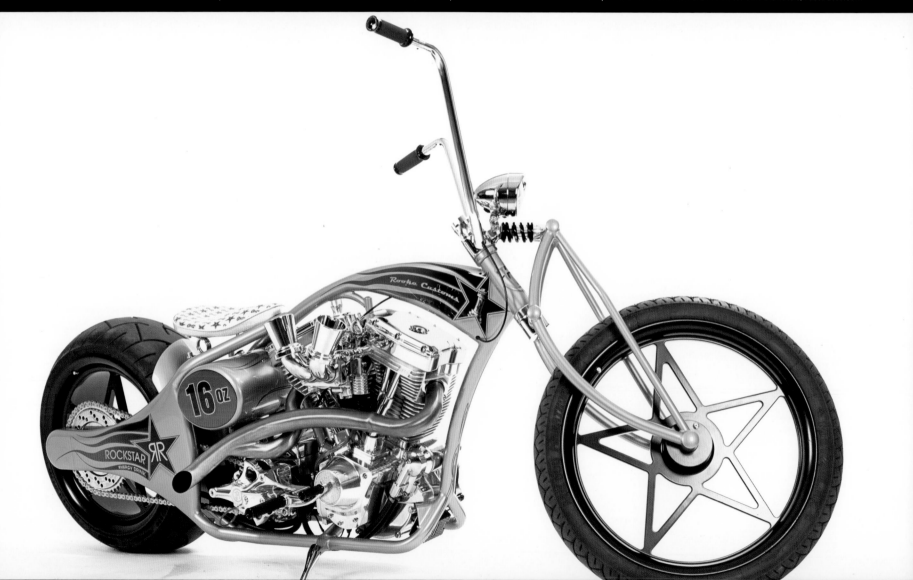

JAVIER SOTO

Javier started out spraying T-shirts in an airbrush shop in Greenwich Village, Manhattan, in 1990. In 1995 he began to pursue his passion for combining automobiles and art, first by taking an auto body class, then attending an Airbrush Action Getaway automotive art class. He then began practicing automotive art on the helmets of friends and family.

Two years later he persuaded an auto body shop owner to lend him some space to do a custom paint job on a Harley-Davidson. The result convinced the shop owner to tap into the custom paint market by forming Paintrix. Javier is now the head artist/painter at Paintrix in South Hackensack, New Jersey. His expertise includes intricate graphics, pinstriping, detailed freehand mural work, and photo-realistic portraiture.

Javier also teaches amateurs at the Airbrush Action Getaways sponsored by *Airbrush Action* magazine. "I still get excited when I see someone that I'm teaching finally get it, even if it's the simplest trick or technique that I'm trying to show. Being able to pass along what I know is one of the most rewarding things about what I do."

A stretched stock Harley tank base painted in House of Kolor Cobalt Blue over Pavo Purple with airbrush work and graphics. Pearls and Kandies were also used to achieve the look of this piece.

A motorcycle tank for a '50s theme bike. This was a job that Javier did for another painter. The tank was painted in PPG urethane basecoats.

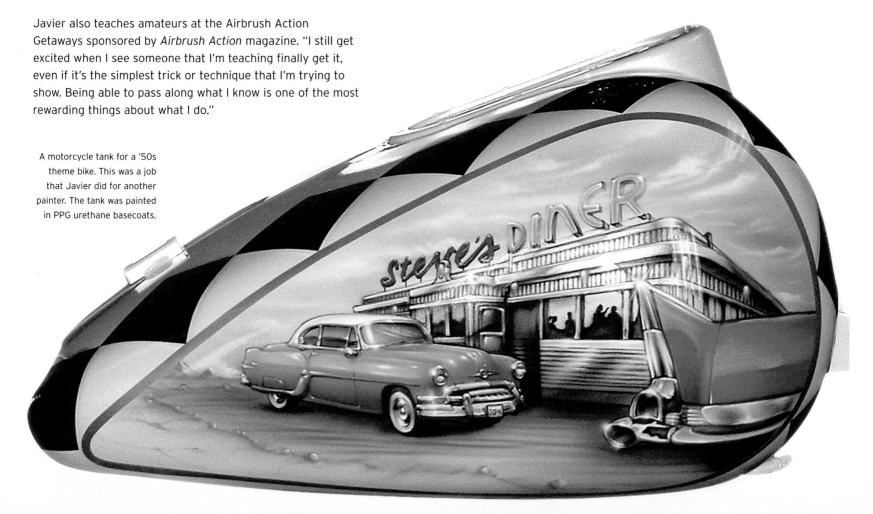

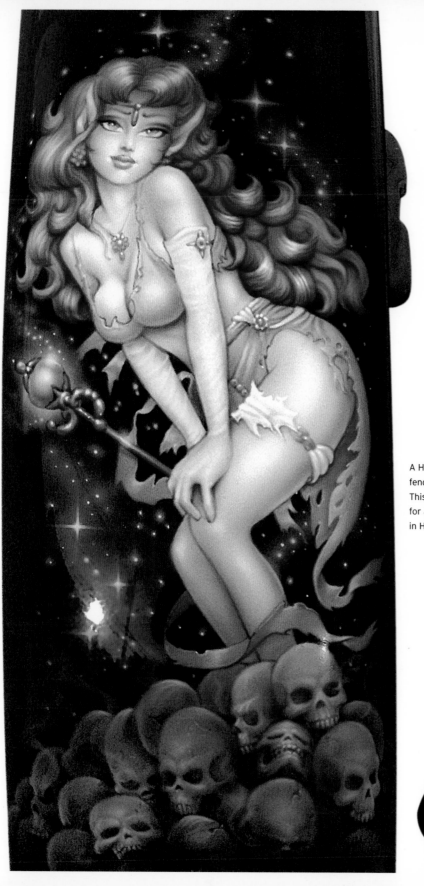

A Harley-Davidson front fender with a fantasy mural. This was a subcontracted job for another painter. Painted in House of Kolor colors.

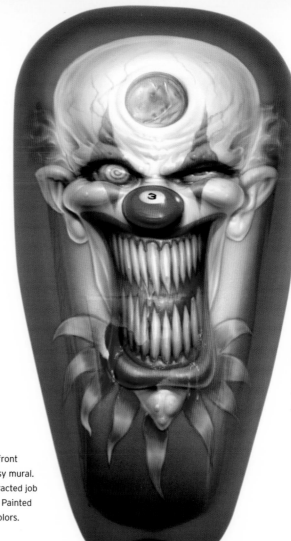

Old stock Harley Davidson Sportster tank painted House of Kolor Kandy Lime over silver, with an airbrushed Krazy Klown.

A stock Harley-Davison split tank. Base coated in PPG black with an airbrushed wizard-themed mural.

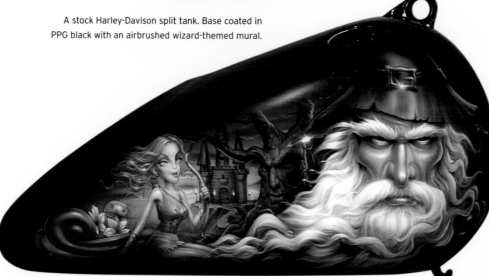

MIKE TERWILLIGER

Mike has been drawing and painting since he was a boy. His passion for motorcycles led him, with his twin brother Tom, to build his first Harley in their garage at age seventeen. Mike painted the tin and from there it didn't take long before every guy in the neighborhood wanted his bike painted too. Mike Terwilliger's custom artwork is world-renowned and highly regarded in the custom cycle world.

Today's bike builders seek extreme quality. Mike works at New York's Visual Impact, completing their award-winning designs. His talent has been commissioned for the best bikes on both sides of the Atlantic. His paint has won him many coveted awards, including *Easyriders* VQ award for painter of the year.

Paint: House of Kolor
All photos: Phil Fazin

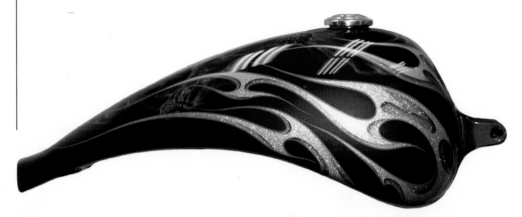

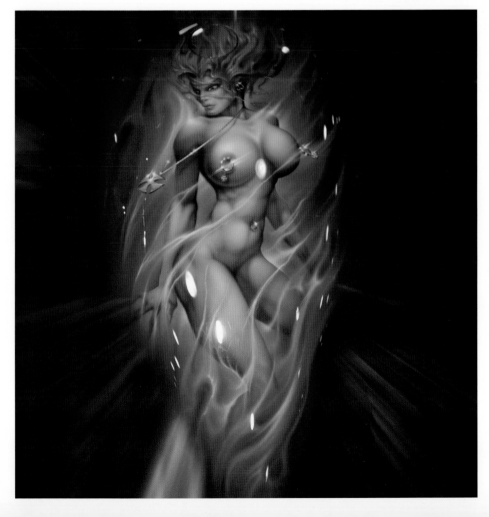

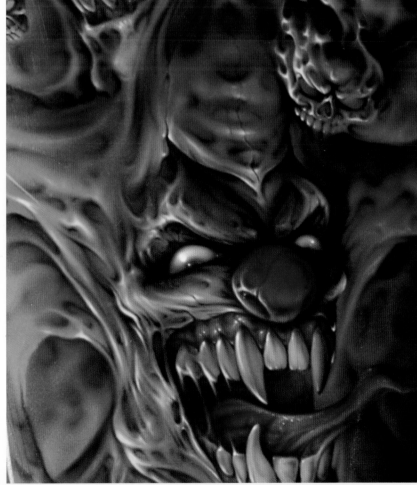

Von Dutch, aka Kenneth Howard, is a Southern California legend in the hot-rod counter-culture. Using bikes and autos as his canvas, his painting, pinstriping, and engraving invoke timeless and distinct themes. Von Dutch Kustom Cycles maintains the roots of the "Kustom Kulture" in its innovative creations of motorcycle accessories, apparel, and attitude. Its motorcycles tap into a yearning for authenticity, and celebrate a distinctive American lifestyle from a time when cool was about true outsiders.

Based outside Los Angeles, Kenneth works with Alex Mardikian, chief designer of Von Dutch Kustom Cycles. The two have received rave reviews, awards, and media attention for their highly stylized and unorthodox bike builds. Their final products nostalgically evoke the '40s-, '50s- and '60s-era hot rods: big, clean, mean, with beautiful flow lines front to back, and performance leaving nothing to be desired.

This page KILLER B Bobber Softail. Paint: Zeak McPeak/Zeakz Customs. Photo: Jay Cwener

Opposite CRUEL WORLD Chopper Softail. Paint: Zeak McPeak/Zeakz Customs. Photo: Jay Cwener

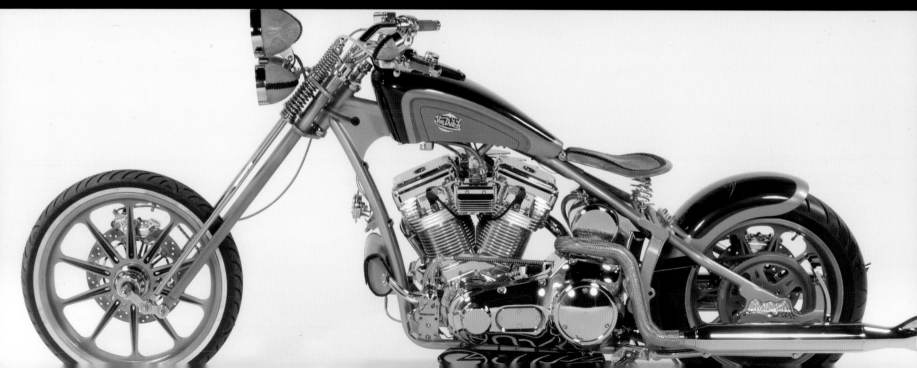

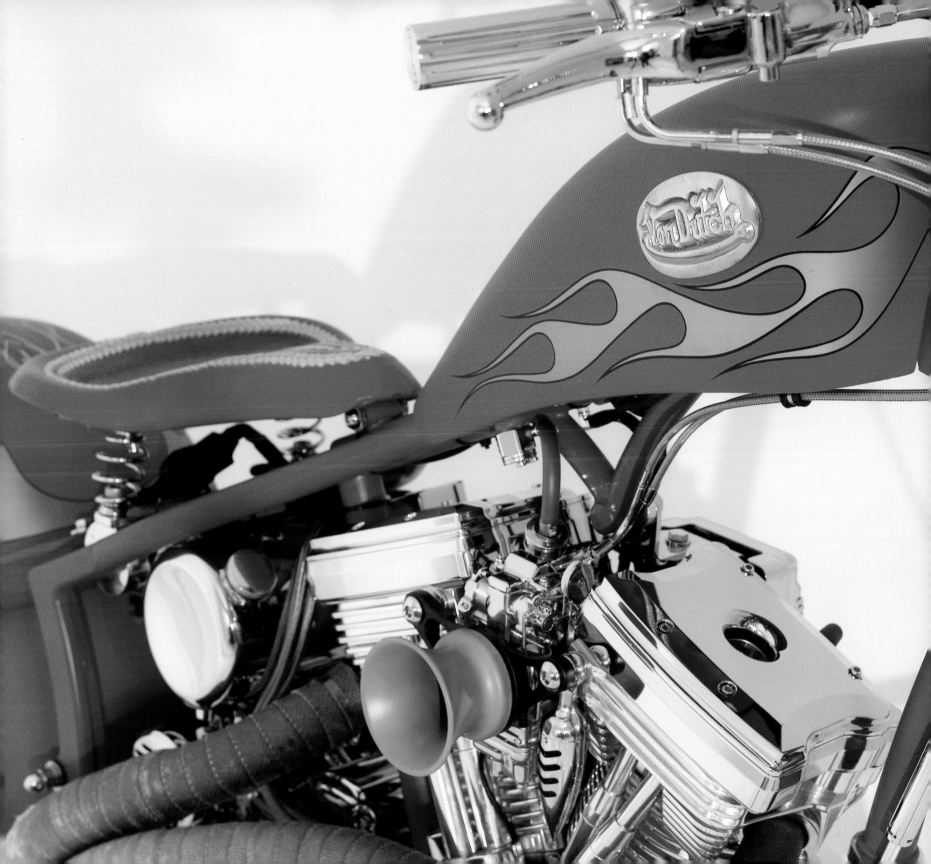

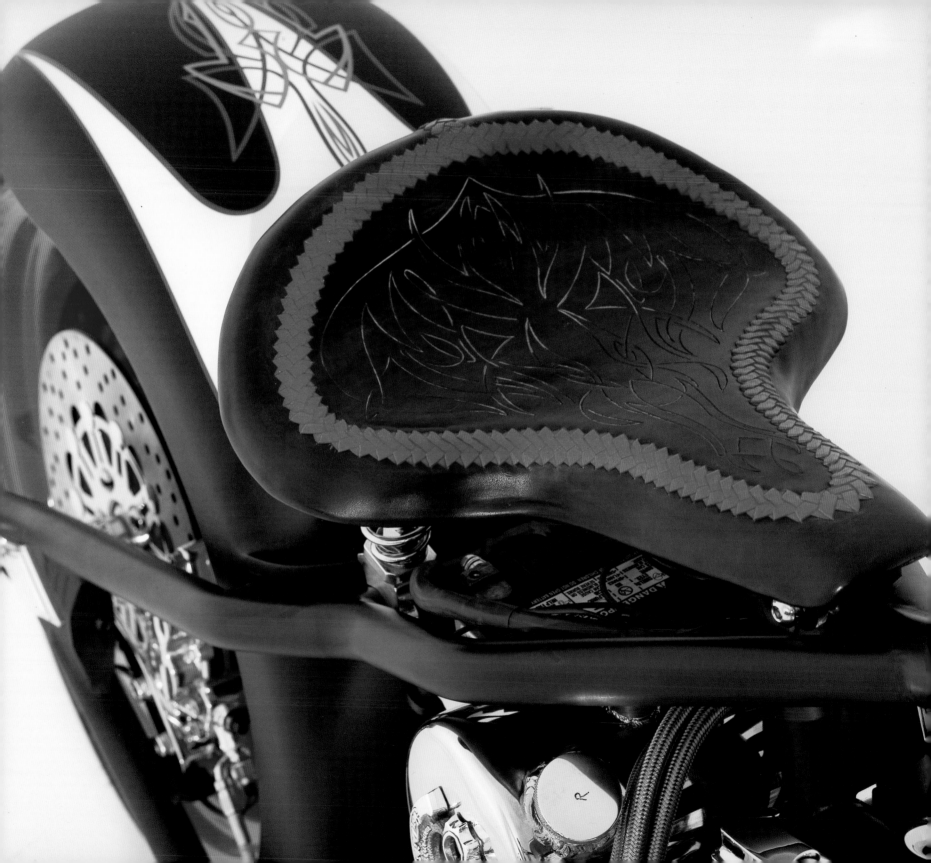

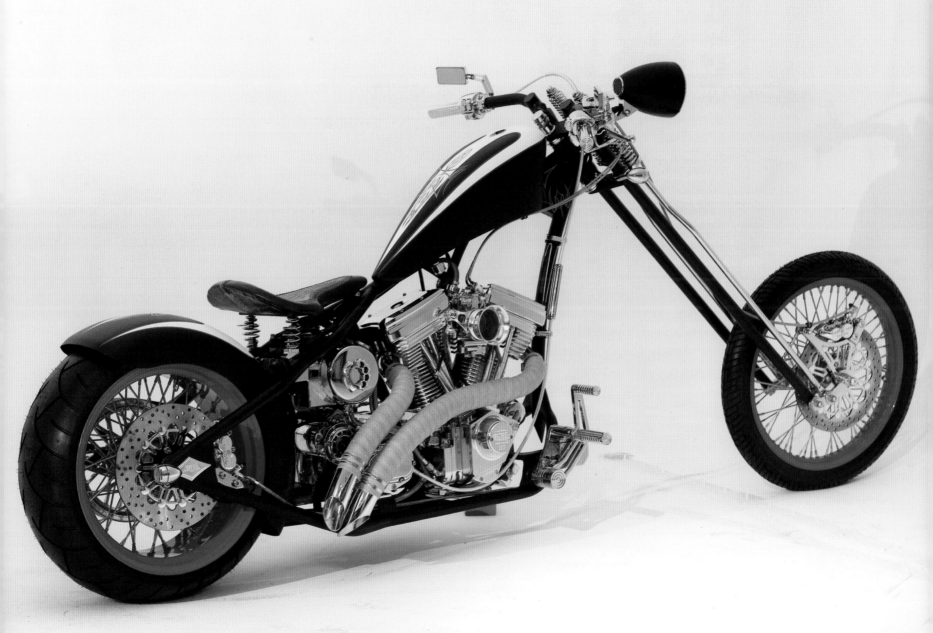

VOODOO CHOPPERS

Voodoo Choppers opened its doors in April 1999, located in a garage behind the owner's house. Eric Gorges had studied metal-shaping as an apprentice with Ron Fournier (Shelby Township, Michigan), and later spent time working with Fay Butler (Wheelwright, Massachusetts). Both of these metal-shaping masters reinforced the concept of pride in your work and the adage of only being as good as your name.

Continually adding equipment to the business, Eric has built up one of the best-equipped shops in the country. Almost every item that comes out of Voodoo Choppers is hand-crafted and one-of-a-kind. All work is commissioned, by people from all across the US and Canada.

Voodoo Choppers continues to strive for excellence in its craftsmanship, standing behind its work with honesty and integrity and creating one-off machines for customers who won't settle for anything less than exceptional.

SUPERSTITION
This bike has a handcrafted oil tank with two Weber side-draft carburetors.
The front motor mount is unique, owing to the two front cylinders and heads.
Seat and suspension display a minimalist approach.
Paint: Ron Finch
Owner: Eric Gorges
Photo: Craig Watters

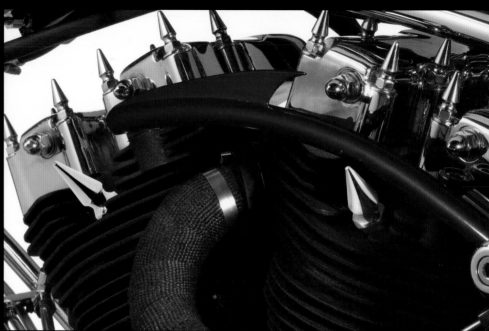

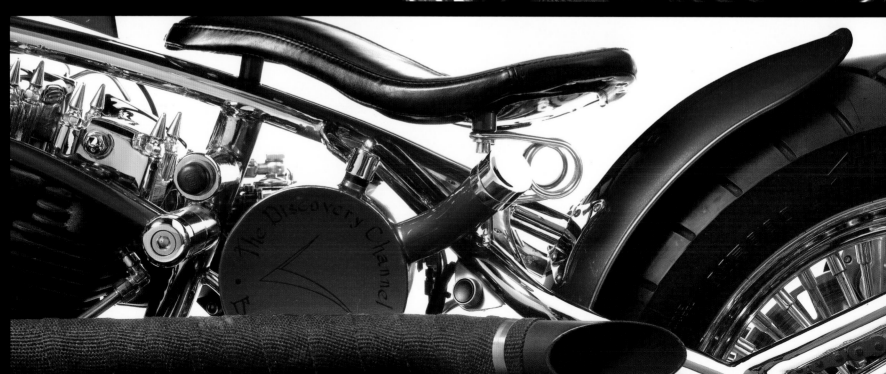

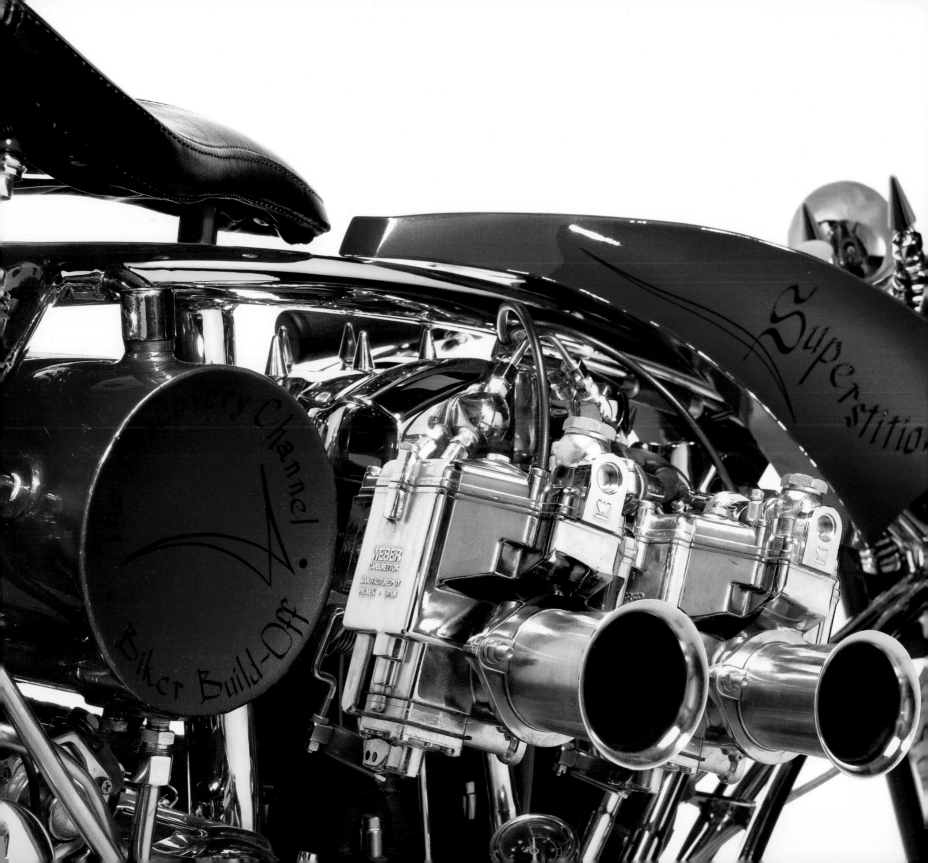

SHAWN WILKEN

Arizonan Shawn Wilken has been painting and drawing since he was very young. Self-taught, with little professional training, Shawn is influenced by a lifetime of experience. More than just painting on motorcycles, his art evokes powerful feelings.

His early work in the textile industry set the stage for a fourteen-year journey of discovery and self-expression through art. Shawn's work now includes custom paint for motorcycles and high-end muscle cars. Designs range from vibrant flames, haunting demons and powerful barbarians, to mystical wildlife and Native American designs. In addition to creating fine art for Phoenix's élite, Shawn also does custom tattoos for clients across the country. His ability to move seamlessly between metal, canvas, and skin is impressive.

Husband, father, artist, and biker, Shawn has always forged his own path. His unique style and keen eye stand tall in a world of mainstream clutter.

Opposite PIRATE
Tank and front/rear fender combo. Pirate design and art airbrushed by Shawn Wilken using an Iwata airbrush and fine paintbrush. AIREA 5150 sprayed the House of Kolor Kandy Gold base coat and clear coat.
Photo: Shawn Wilken

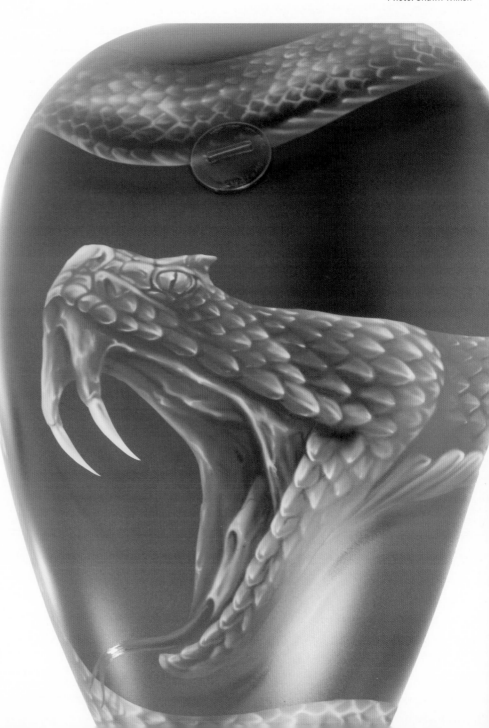

Left SWEET
Tank design and art airbrushed by Shawn Wilken using an Olympus airbrush and fine paintbrush. AIREA 5150 sprayed the House of Kolor Black base color and clear coat.
Photo: Shawn Wilken

Right SNAKE
Tank design and art airbrushed by Shawn Wilken using an Olympus airbrush. AIREA 5150 sprayed the House of Kolor Amber Illusion base color and clear coat.

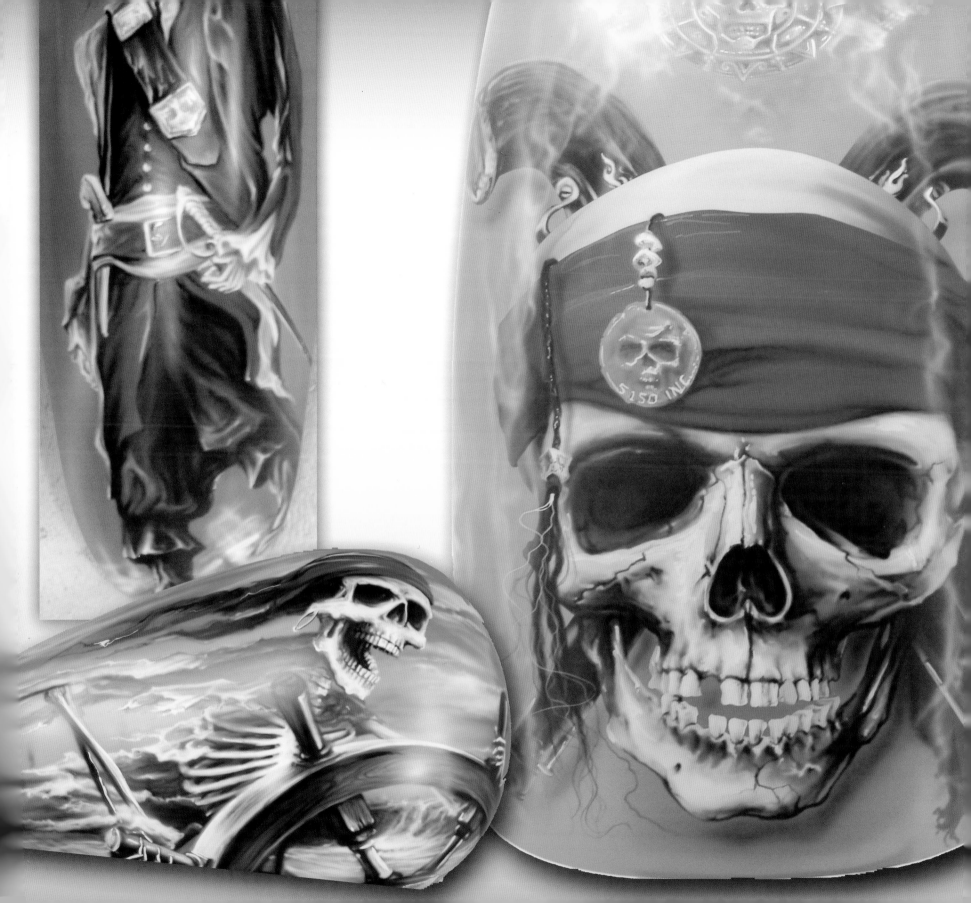

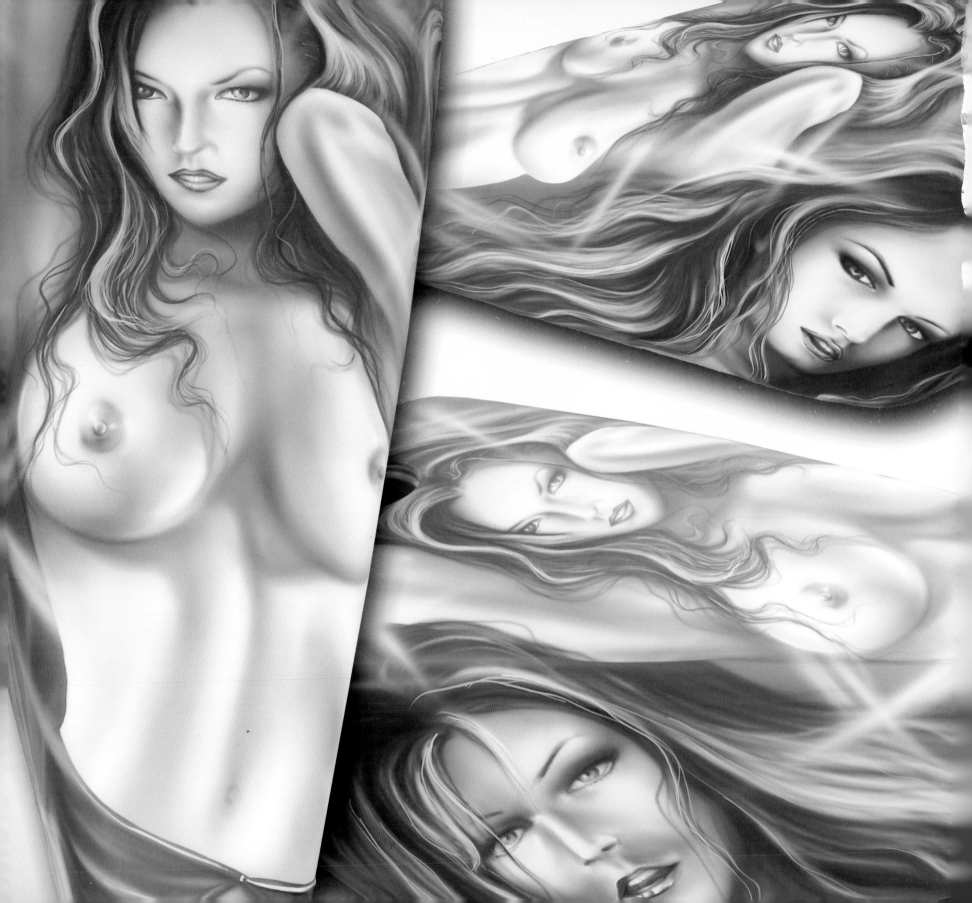

Opposite MUNCH
Tank (triple view). These girls were designed and airbrushed by Shawn Wilken using an Iwata airbrush. AIREA 5150 sprayed the House of Kolor Kandy Gold base and clear coat.
Photo: Shawn Wilken

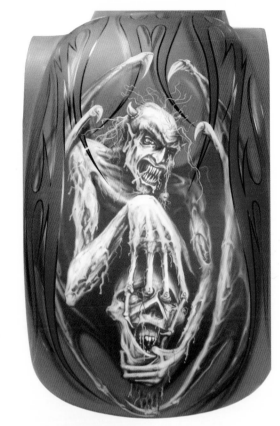

GREEN BIKE SKELETON 8LB, OR "VAIN"
Tank. Designed and airbrushed by Shawn Wilken using an Iwata airbrush. AIREA 5150 sprayed the House of Kolor Green base and clear coat. Photo: Shawn Wilken

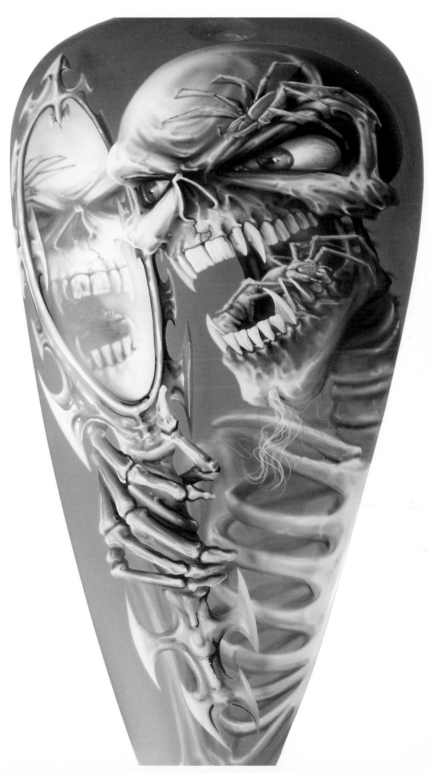

Right STRETCH
Rear fender. Graphic was designed and airbrushed by Shawn Wilken using an Iwata airbrush. AIREA 5150 sprayed the House of Kolor Orange base and clear coat.
Photo: Shawn Wilken

Right INDEPENDENT
Rear fender. This hippy skull was designed and airbrushed by Shawn Wilken using an Iwata airbrush. AIREA 5150 sprayed the House of Kolor True Blue base and clear coat.
Photo: Shawn Wilken

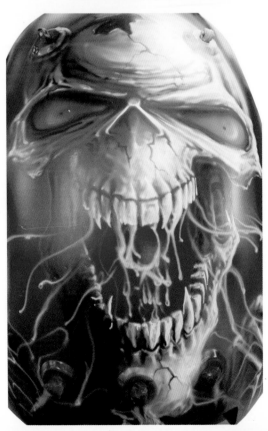

WILLOUGHBY

Matt Willoughby operates his business, Willoughby Paint Design, in New Middletown, Ohio. He's been in the art field since graduating from high school, when he began in a local sign shop and also worked restoring carousel horses.

For some time Matt worked alongside Steve Chaszeyka, where he continued to learn and develop his artistic skills. He has been running his own business for the last eleven years. His work ranges from pinstriping to concept drawings and custom paint jobs on motorcycles. He does some in-house fabrication and molding with the help of Jonathan Fragosa and Troy Willoughby. His work is show quality. Matt likes his artwork to enhance a motorcycle yet not overpower it. He is happy to be doing something he enjoys.

KRIME OF PASSION
Builder: Dave Aulita/Xtreme Cycles of Sarasota LLC
Special construction. Elements of owner's life are tattooed over entire surface of bike, including actual train cars that he owns, and their graffiti, along with key dates and events in his life, expressions, and quotes. New York City theme reflects the fact that he does a lot of his business there and it has helped him arrive where he is.
Paint: House of Kolor blues and silvers, cleared with a hint of specially mixed Kandy blue
Owner: Bill Frank
Photo: Shawn Wilken

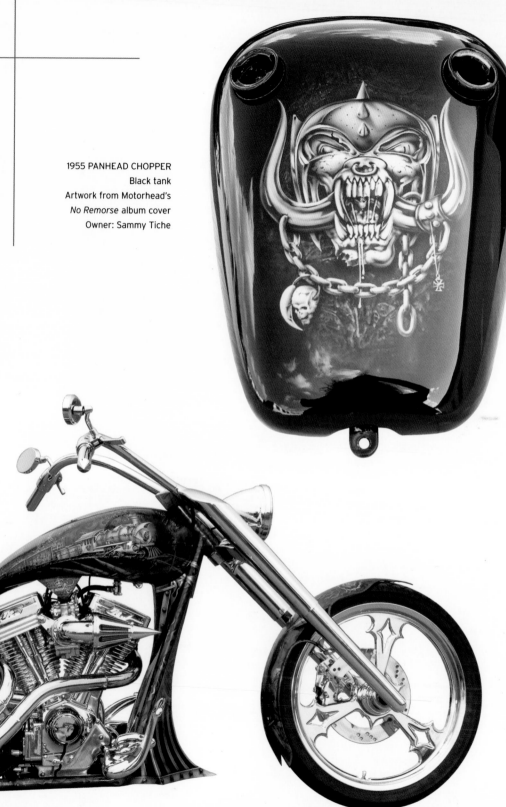

1955 PANHEAD CHOPPER
Black tank
Artwork from Motorhead's
No Remorse album cover
Owner: Sammy Tiche

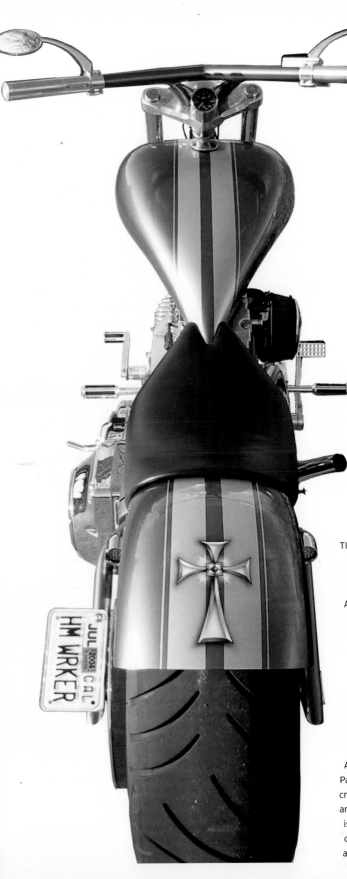

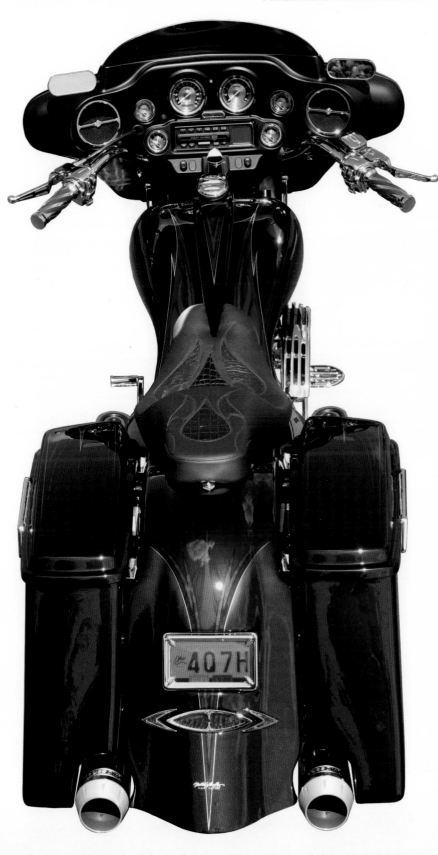

Left
TITANIUM STRIPE AND CROSS
Special construction
Builder: Mike Maldanado,
Heavy Cycle Customs.
Audi titanium and silver with
white diamond ice cross.
Owner: Todd Mudd

Right:
BRANDYWINE BAGGER
1998 Harley-Davidson
owned by Rich Mihalik,
built by Rich Mihalik
and Matthew Willoughby.
Bike has stretched tanks,
Arlen Ness bags and fenders.
Paul Yaffe dash Bodylines were
created in the sides of the bags
and the top of the fairing. Paint
is House of Kolor Brandywine
over multicolored bases, with
alligator and goldleaf accents.

WIZARD

Steve and Carol Chaszeyka operate Wizard Airbrush Graphics, based in New Middletown, Ohio. They can be seen at Daytona, Sturgis, Myrtle Beach, and other major biker rallies. For more than thirty years Steve has been perfecting the skills of airbrushing and pinstriping. He currently writes for *Airbrush Action* magazine, and contributes to *AutoGraphics* and to several other publications in the industry. Carol handles the logistics of running the business.

What makes Wizard different is the range of talents and ideas it offers. Its work has been in countless bike magazines over the years and has received many best paint awards. But the greatest satisfaction Wizard receives is from the small builder or individual who wants help with design ideas and layouts. Wizard has come up with motorcycles from the old-school ways of the '70s, and has helped to define graphics as they are today.

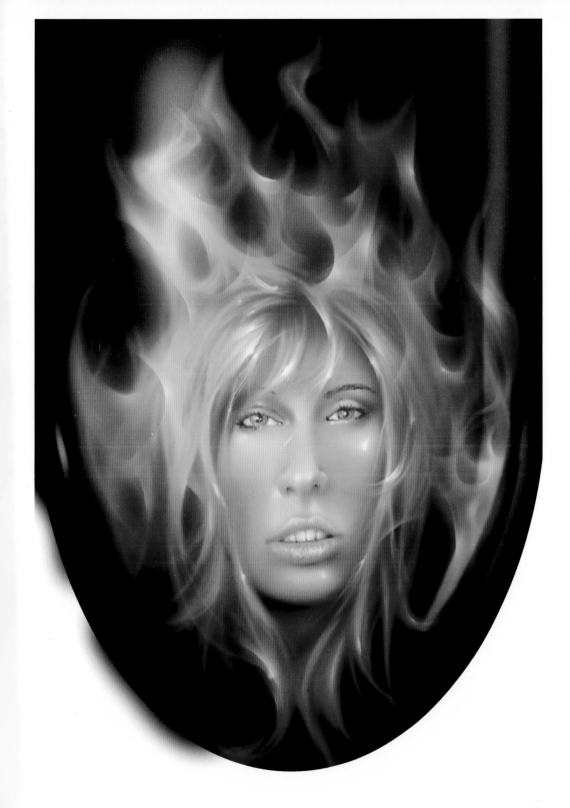
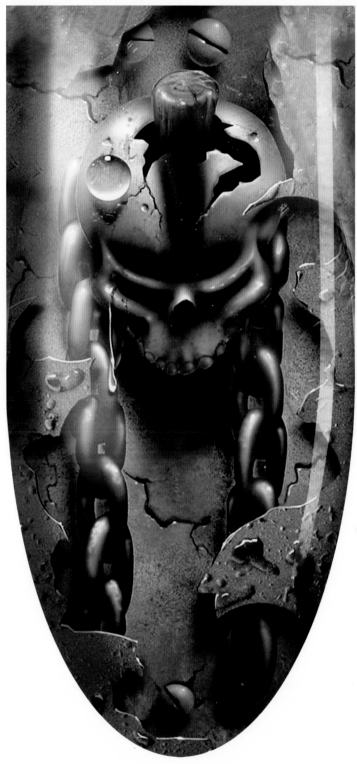

Opposite and above Back fenders (details). Combination brushwork and airbrush using House of Kolor and Spies Heckor paints

ZEAKS CUSTOMS

Zeaks Customs in Mira Loma, California, is operated by second-generation custom painter Zeak McPeak. Zeak has been around custom paint culture since his birth in 1967. His skills were refined with the help of his father, Richard McPeak of McPeaks Painting, who has been painting and pinstriping since the '50s. Zeak forged his own path in the '90s and began focusing on motorcycles. Since then Zeaks has completed more than 15,000 motorcycle paint sets, painting projects for some of the top builders in the industry.

Zeaks has been featured in all the major motorcycle publications and was recently featured on the cable show *American Thunder*. At Zeaks Customs the focus is on the details from start to finish, through faith, spirit, and discpline, transforming visions into reality. The goal is to give life to the motorcycle, pushing the boundaries of what people will accept, creating something truly unique.

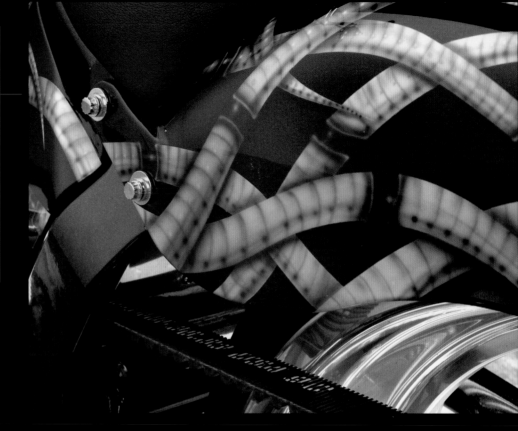

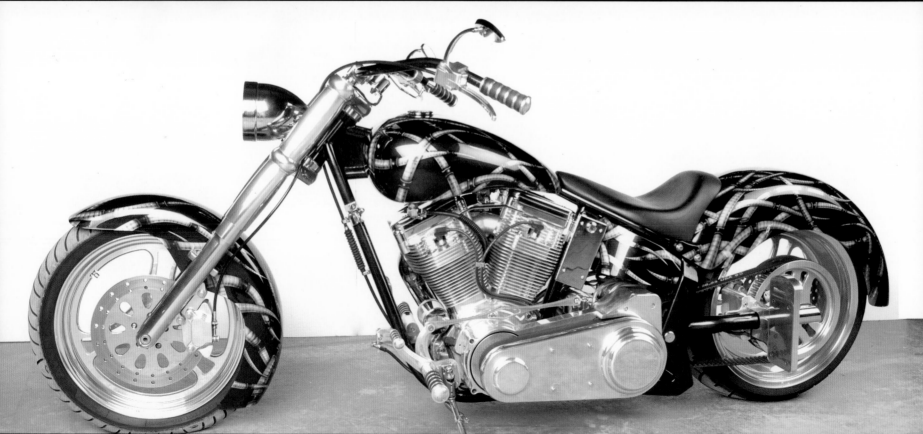

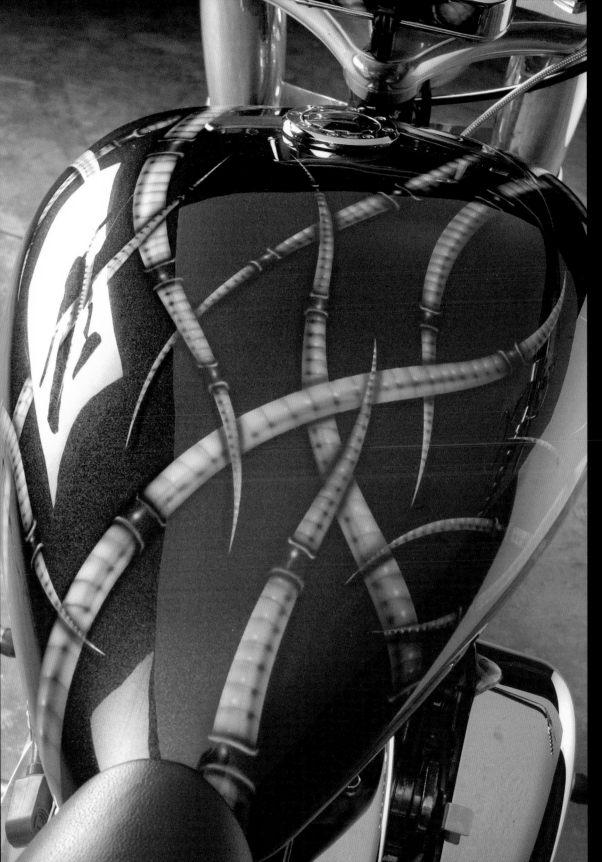

BLACK BIKE WITH ALIEN TENTACLES
Frame: Daytech
Wheels: American-made
Builder: HBS Hell Bound Steel

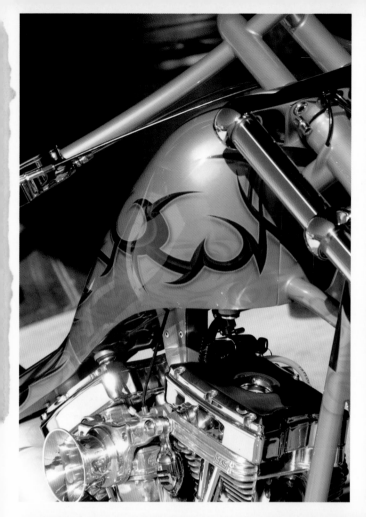

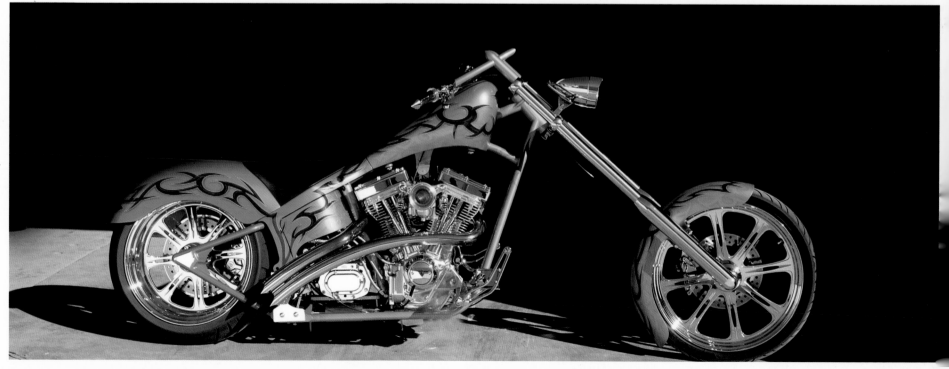

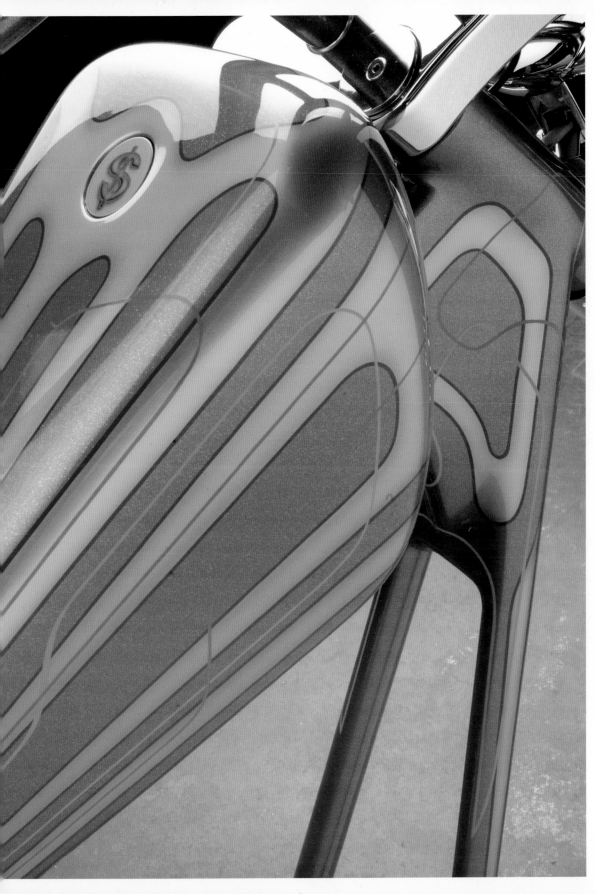

Opposite GREEN CHOPPER WITH BLACK TRIBAL GRAPHICS
Frame: Xtreme
Sheet metal: Matrix
Motor: 113 cu. in. (1852cc) S&S
Belt drive: BDL
Headlight: Headwinds
Wheels: Performance Machine
Seat: Bitchin Rich
Builder: Terry Gregorio, Matrix Cycle Works

Left GREEN CHOPPER WITH GREEN AND GOLD GRAPHICS
Frame: 5 out 8 up by Killer Chopper
Front end: forks by Frank
Handlebars: Cash Money Customs
Gas tank: Pat Keneady
Oil tank: Cash Money Customs
Wheels: 120-spoke DNA
Front fender: Fat Cat, Vegas
Rear fender: Exile
Builder: Steve Green of Cash Money Customs

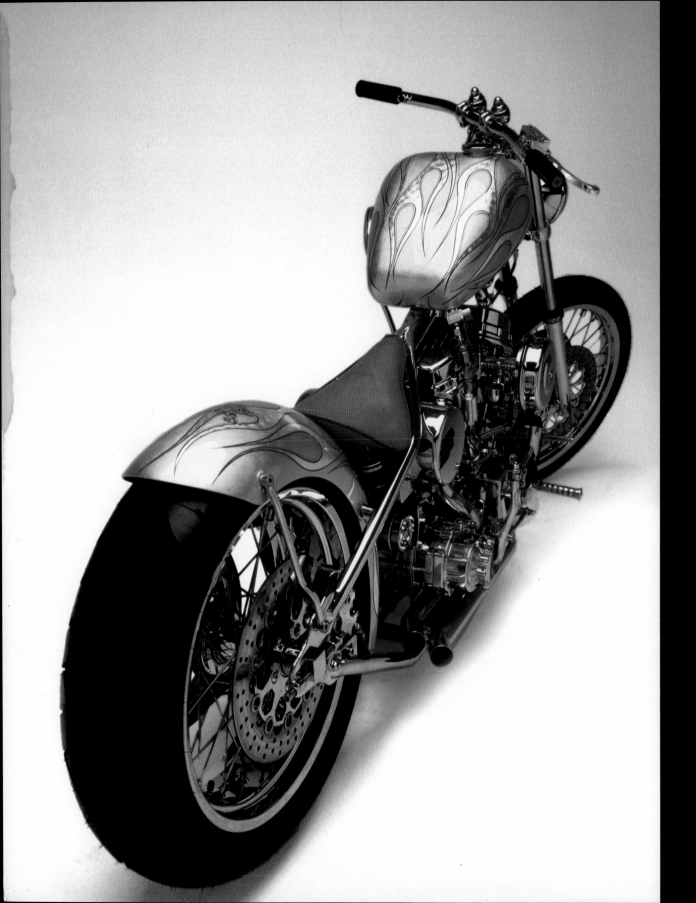

The motorcycle art industry has exploded and with it some very talented people have come to light. To call some of them "artist" is no stretch. Taking what was a mode of transportation and turning it into a two-wheeled rolling art exhibit is today's agenda, each medium and aspect pushed one step further than the last. Whether it's a time restraint, product limitation, or a mental roadblock, these things need to be pushed through and worked out. For that is what sets your piece apart from the rest—what makes it stand out and excel in the true rideable art form. In no other way I know of do so many art forms come together in such an extreme manner—extreme not only in the art sense, but in testing one's ability, mentally and physically. It's not uncommon to work a sixty-hour stretch getting only an hour or two of sleep at a time while waiting for something to dry; or to receive a phone call in Connecticut from a bike builder in Tennessee asking for some help on a special project, only to find out after a short conversation that you need to be on a plane in a day or two and you have only a base color in mind—you arrive at the shop totally out of your own environment, work three days straight to finish, and never regret a thing. That type of extreme. The type that comes from the heart. The type that makes us do what we need to do to stand apart from the crowd. To manipulate a traditional concept so that it becomes something it never was, to use a product and stretch its capabilities right to the limit. To blend old techniques with today's technology. I have been fortunate enough to be a part of this. The sleepless nights either working or thinking of the thirty-plus coats of clear over candy. Learning how to pinstripe and letter with a brush; the traditional methods of leaf application; blending airbrush with paintbrush; the countless hours molding until your fingers bleed; and being lucky enough to come into contact with some of the best people in the world. This is a great trip, a culmination of mediums and techniques to make one extreme piece of art.

With special thanks to SATA Spray Equipment and NEXA AUTOCOLOR.
CHEMICAL SKIN at its best
Robert E. Pradke Jr.
customautodesign.com

It is so appropriate that this book of motorcycle art be dedicated to Indian Larry, because he was truly a motorcycle artist. Larry was on a mission to take the entire chopper existence to a whole other level of art. He knew that once his builds were finished and all the fine details were in place the paint played a big role in completing the look. If you build ole skool, then the paint which the bike wears must be ole skool. The same goes for tricked-out, chopped-out, sleek low designs, and any other style of bike building. The paint must complement the lines of the bike in order to pull it all together.

One can believe that it was Indian Larry's ole skool style of bike building that is responsible for bringing back the aged art of silver and gold leaf, freehand pinstriping, and heavy flake designs. These techniques were famous during the custom culture scene of the '50s and '60s and were first resurrected when Indian Larry's famous Rat Fink chopper made its debut on the Discovery Channel's *Biker Build-Off* series. All Larry's bikes proudly wore ole skool art and since then these styles of paint and design are being used more and more today. When Indian Larry spoke, people listened; when Indian Larry's builds were unveiled, people watched; when Indian Larry died, thousands wept. Indian Larry has been referred to as The Myth, The Legend, The King of Cool, and The Ole Skool Master Builder, and rightly so: but there is one title that pretty much sums up the man who has touched so many—"Indian Larry."

Lee Sheridan
Editor/Publisher

DIRECTORY

AIRBRUSH PERRE	www.go.to/airbrushperre.com
AIRBRUSH WORKZ	www.airbrushworkz.com
AIREA 5150	www.airea5150.com
ALLIGATOR BOB	www.alligatorbob.com
BERT BALLOWE	www.balloweartistry.com
BATTISTINIS	www.battistinis.co.uk
RICK BAZZANELLA	www.warpaintbyrich.com
	www.artarmy.org.
MITCH BERGERON	www.mitchbergeroncustoms.com
BIG BOAR CUSTOMS	www.bigboarmotorcycles.com
BIKES BY BOYCE	www.bikesbyboyce.com
BOLLT/HAMBLIN	www.customworld.com
	www.davidbollt.com
CENZI MOTORCYCLES	www.tonycenzicustoms.com
COUNTY LINE CHOPPERS	www.countylinechoppers.com
CYCLE BOYZ	www.cycleboyz.com
CYCLE-DELICS	www.cycledelics.com
DEANO'S	www.custompainting.com
DROZD DESIGN	www.drozddesign.com
DUSOLD DESIGNS	www.dusolddesigns.com
EAST COAST CHOPPER	www.eastcoastchopperworks.com
RICK FAIRLESS	www.strokersdallas.com
RON FINCH	www.finchscustoms.com
FITTO	www.airbrushfitto.com
FOUR HORSEMEN	www.fourhorsemenmotorcycles.com
VINCE GOODEVE	www.goodevestudio.com
HABERMANN-PERFORMANCE GMBH	www.habermann-performance.com
BIANCA HENNIG	www.bianca-hennig.de
CYRIL HUZE	www.cyrilhuze.com

INDIAN LARRY	www.indianlarry.com
INFINITI CUSTOMS	www.infiniticustoms.com
JAY'Z CUSTOM PAINT	www.jayzcustompaint.com
DOUG KEIM	www.dougkeim.com
FRED KODLIN	www.kodlin.com
MIKE LAVALLEE	www.killerpaint.com
MIKE LEARN	www.mikelearn.com
LOTTEN BOYZ CUSTOMZ	www.trueflames.com
LUCKY CHARM CHOPPERS	www.luckycharmchoppers.com
MGS CUSTOM BIKES	www.mgscustombikes.com
NEW YORK CITY CHOPPERS	www.nycchoppers.com
PANTALEON	www.jpantaleon.com
PASTRANA UNLIMITED	www.pastranaunlimited.com
PETER PENZ	www.penz-custombikes.com
DAVE PEREWITZ	www.perewitz.com
PERRY MICHAEL DESIGNS	www.perrymichael.com
PFEIL-DESIGN	www.marcuspfeil.com
ROBERT E. PRADKE JR	www.customautodesign.com
JESSE ROOKE	www.rookecustoms.com
JAVIER SOTO	www.javiersoto.com
MIKE TERWIILIGER	www.visualimpactmiket.com
VON DUTCH KUSTOM CYCLES	www.vondutchcustomcycles.com
VOODOO CHOPPERS	www.voodoochoppers.com
SHAWN WILKEN	www.shawnwilken.com
WILLOUGHBY	mwillodesign@sbcglobal.net
WIZARD	11497½ Yopitt Road,
	New Middletown, Ohio 41442
	phone: +1 330 542 4444
ZEAKS CUSTOMS	www.zeakscustoms.com

IN RECOGNITION

Spencer Drate and Judith Salavetz would like to thank Ned Davis, Alexis, Justin, and Ariel. Special thanks to Joan Brookbank, Hugh Merrell, Julian Honer, Nicola Bailey, Michelle Draycott, Anthea Snow, and everyone at Merrell Publishers. Thank you Mark Barnett and *Barnett's Motorcycle Showcase* magazine, Ernie Lopez and *Hot Bike/Street Chopper* magazines, Lee and Greg Sheridan at *Full Throttle Magazine*, Robert E. Pradke Jr., Penny Osiecki, Diana Learn, Hörst Rosler, Alex and Mike at Von Dutch Motorcycles, and Rob Moore. A huge thank you to all the bike builders, custom bike shops, and motorcycle artists who participated in the creation of this book, and to all the photographers who contributed to it. Additional thanks to Dino Petrocelli, Timothy White, Ron and Ruth Finch, Marcus Pfeil, Don Clady, Brad Bloch, the spirit of Indian Larry, and everyone at Indian Larry Inc. Without you we would not have been able to do this remarkable work of art. This book is a record of, and testament to, the incredibly talented motorcycle artists who in the past have not been given their due recognition.

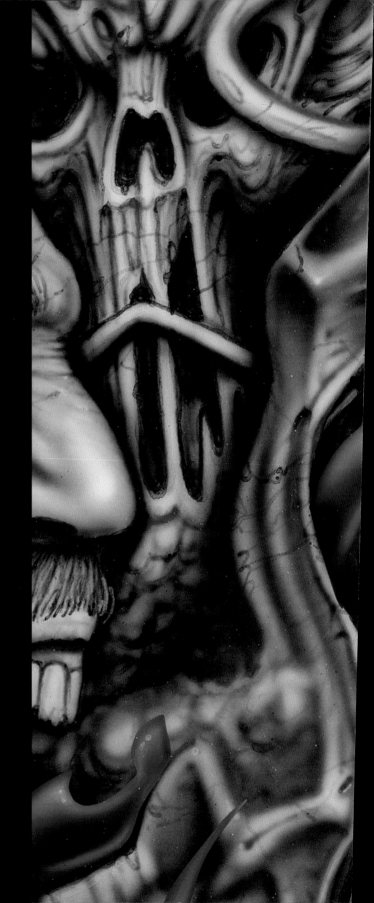

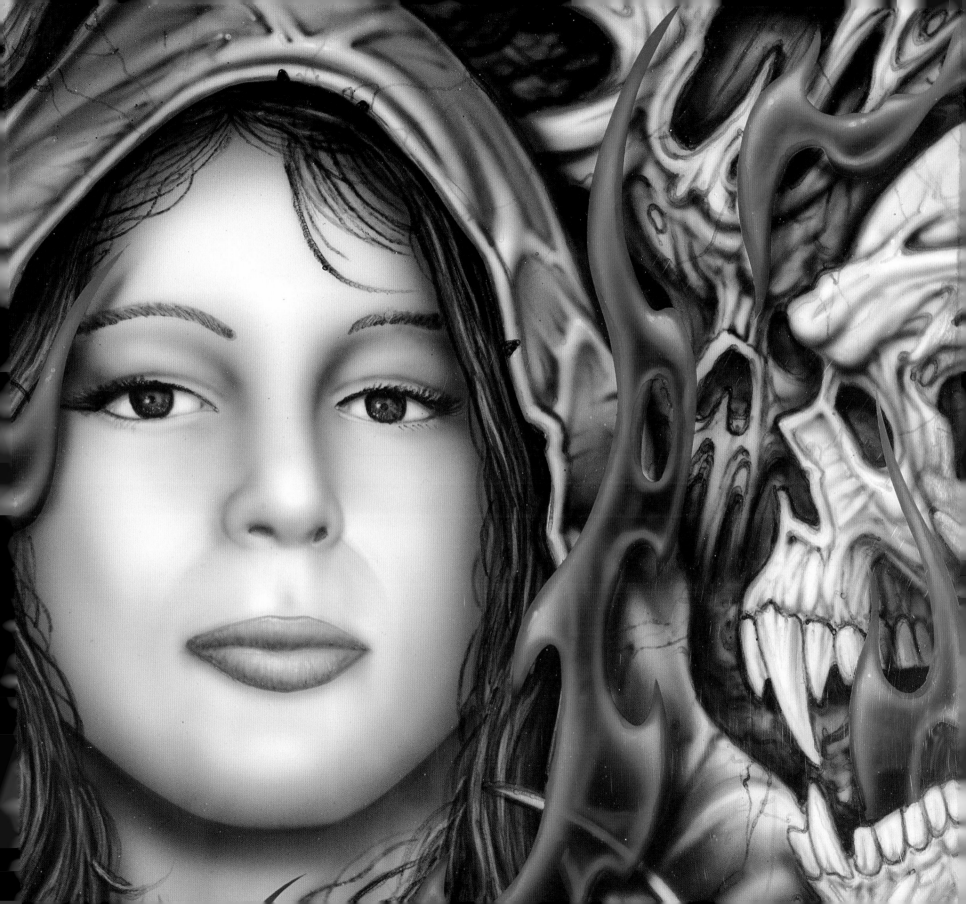